French
Nineteenth-Century
Drawings and
Watercolors

AT THE BROOKLYN MUSEUM

French Nineteenth-Century Drawings and Watercolors

AT THE BROOKLYN MUSEUM

LINDA KONHEIM KRAMER

KARYN ZIEVE

SARAH FAUNCE

HUDSON HILLS PRESS, NEW YORK

in association with The Brooklyn Museum

FIRST EDITION

© 1993 by The Brooklyn Museum

Editor-in-Chief: Elaine Koss

Editor: Joanna Ekman

Published in the United States by Hudson Hills Press, Inc., Suite 1308, 230 Fifth Avenue, New York, NY 10001-7704.

Editor and Publisher: Paul Anbinder

Proofreader: Lydia Edwards

Indexer: Gisela S. Knight

Designer: Betty Binns Design

Composition: U.S. Lithograph, typographers

Manufactured in Japan by Toppan Printing Company

Distributed in the United States, its territories and possessions, Canada, Mexico, and Central and South America by National Book Network, Inc.

Distributed in the United Kingdom and Eire by Art Books International.

Distributed in Japan by Yohan (Western Publications Distribution Agency).

The publication of this catalogue was made possible, in part, by the National Endowment for the Arts, a federal agency, and the Iris and B. Gerald Cantor Foundation and the Andrew W. Mellon Foundation.

Library of Congress Cataloguing-in-Publication Data

Brooklyn Museum.
French nineteenth-century drawings and watercolors at the Brooklyn Museum / Linda Konheim Kramer, Karyn Zieve, Sarah Faunce. — 1st ed.
p. cm.
 Includes bibliographical references and index.
 ISBN 1-55595-087-6
 1. Drawing, French—Catalogues. 2. Drawing—19th century—France—Catalogues. 3. Drawing—New York (N.Y.)—Catalogues. 4. Watercolor painting, French—Catalogues. 5. Watercolor painting—19th century—France—Catalogues. 6. Watercolor painting—New York (N.Y.)—Catalogues. 7. Brooklyn Museum—Catalogues. I. Kramer, Linda Konheim. II. Zieve, Karyn. III. Faunce, Sarah. IV. Title.
NC246.B73 1993
759.4′09′03407474723—dc20 93-19564
 CIP

Contents

Foreword

In 1900 THE MORE THAN five hundred gouaches and ink drawings made by Tissot for his *Life of Christ* were purchased by public subscription by The Brooklyn Museum, and in 1992 a sketchbook by Tissot, related to this series, was also purchased for the collection. Over the intervening years nearly one hundred other works on paper by nineteenth-century French artists entered the collection. Many of them are by artists now considered to be the major masters of their time; but there are also works by other artists, less familiar to the American public today, who deserve recognition. This collection, which spans a century of creativity and a subsequent century of collecting, is one of the significant holdings of works on paper in The Brooklyn Museum.

It is a principal mission of the Museum to research, document, and make accessible through publication its most important collections. Publication takes on an additional meaning in the case of works on paper, which can only be exhibited for limited periods of time to avoid damage by overexposure to light and, unlike other collections in the Museum, are never on permanent view. Therefore a series of catalogues of our most comprehensive holdings of works on paper is planned. This significant group of French nineteenth-century watercolors, pastels, and drawings has been culled from two separate holdings in the Museum. The watercolors and pastels are housed in the Department of Painting and Sculpture, and the drawings in black and white are in the collection of the Department of Prints and Drawings. Bringing these two separate holdings together in this one volume involved a collaborative effort of the two departments.

In 1988 the works were identified, researched, conserved, and exhibited under a grant from the National Endowment for the Arts, with an eye to future publication. After four years of research, study, and preparation, these works are finally available to a wide audience through this fully documented and illustrated publication. The catalogue was prepared under the supervision of Sarah Faunce, Curator of European Painting and Sculpture, and Linda Konheim Kramer, Curator of Prints and Drawings. Karyn Zieve, Assistant Curator in the Department of Prints and Drawings, was responsible for much of the research and cataloguing.

This publication was made possible in part by grants from the National Endowment for the Arts, the Iris and B. Gerald Cantor Foundation, and the Andrew W. Mellon Foundation.

Robert T. Buck
DIRECTOR
THE BROOKLYN MUSEUM

Introduction

THROUGH AN EXAMINATION of the nineteenth-century French drawings and watercolors in the collection of The Brooklyn Museum and their documentation, we can gain an understanding not only of the aesthetic attitudes of each artist and his society, but also of the history, politics, and social mores of the time and place in which each work was created. In addition, a museum collection, because it is formed over time by many different people, including donors, curators, directors, and trustees, reveals a history of fluctuations in taste—in this case over the course of the last hundred years, during which the collection was built.

The Brooklyn Institute of Arts and Sciences, the parent institution of The Brooklyn Museum, was established in 1890 with the stated purpose of educating the people of Brooklyn in natural history and art history, with an emphasis on the moral improvement of the public.[1] In the Museum's early years, the art of the past was most readily available through the study of "photographs of paintings" and plaster casts of "important sculptures" that had been acquired in quantity around the turn of the century.[2] One of the first purchases of original art was more than five hundred nineteenth-century French drawings and gouaches by James Tissot illustrating the Life of Christ (cat. no. 86). These works, which date from between 1886 and 1894, had been exhibited in Paris and London in 1895 and 1896 and toured the United States in 1898 and 1899 to great acclaim. They were purchased for The Brooklyn Museum in 1900, largely by public subscription.[3] "Tissot's Bible" is a tour de force, consisting of meticulously detailed paintings in gouache on cardboard created from studies made in Palestine. Faithfully conveying the stories of the New Testament in intricate detail against accurately rendered landscape and architectural structures, the scenes met the Museum's didactic and moral requirements and suited perfectly the aesthetics and interests of the Victorian age.

Another group of works, purchased at auction in 1910 by Friends of the Museum, consists of thirteen drawings and watercolors by the sculptor Antoine Louis Barye (cat. nos. 1–13). These studies of wild animals, which Barye had observed in the Jardin des Plantes in Paris, were very likely of interest to the Museum in 1910 because of their potential relationship to the natural-history collections of the institution. Today, however, they are admired not as naturalistic renderings of wild beasts, but for the qualities of power and majesty through which Barye transformed his subjects into sometimes violent, sometimes regal, romantic statements.

A change in the generally conservative attitudes of The Brooklyn Museum took place in the early 1920s as the institution began to acquire

modern French paintings. When the exhibition *Paintings by Modern French Masters: The Post-Impressionists and Their Predecessors* opened in March 1921, *Art News* described it as "the most talked of art show of the season because of the fact that it is the first time that a great public museum in this country has taken official cognizance of Modernist art."[4] Apparently in preparation for this show, a number of Impressionist works were purchased by the Museum at auction. Among them was a large and impressive pastel by Edgar Degas, *Woman Drying Her Hair* (cat. no. 34), which was bought at a time when Impressionism was greeted with protest by the conservative New York public. Out of the works in the 1921 exhibition, the Museum acquired Paul Gauguin's *Tahitian Woman* (cat. no. 42), a pastel perhaps even more alien to the taste of the day than the Degas: "This close-up, looming figure, powerfully female, with her brooding secretive gaze directly fixed on the viewer and her sexuality underlined by the aggressive emblematic leaf shape by her head, surely embodies much of what alarmed people about Gauguin."[5] These once controversial works are today considered to be among the outstanding pieces in the collection.

If the works purchased reflect the collecting attitudes of the Museum, the works acquired by gift or bequest during the first two decades of the twentieth century characterize general trends in private collecting in America in the late nineteenth and early twentieth centuries. The donations from this period are almost all watercolors by the Salon artists who were popular in the later nineteenth century. Louis-Robert de Cuvillon's two watercolors of costumed ladies in demure poses, painted in the late 1880s and early 1890s (cat. nos. 30, 31), and Léo Herrmann's *Cardinal Taking Tea* (cat. no. 58), both bequests to the Museum in 1906, are, like the Tissots, reflections of Victorian taste. These fashionable subjects, rendered in minute detail, speak of pretty or amusing fancies that have little to do with the real world. Of a similar aesthetic are the watercolors bequeathed in 1921 from the collection of William H. Herriman, an American collector who spent most of his life in Europe. *Shepherd and Flock in the Mountains* (cat. no. 19), a romantic mountainous landscape by Félix-Saturnin Brissot de Warville; an atmospheric Marseilles harbor scene by Félix Ziem (cat. no. 91); and the Roman view *Figures on a Terrace* (cat. no. 57) by Ferdinand Heilbuth are all representative of popular subject types in their day. The popularity of these often charming and skillfully executed genre and landscape pictures reflects a change in taste away from the ideals of the Academy to more mundane subject matter, which ultimately led to a renewed interest in seventeenth-century Dutch naturalism and realism.

Seventeenth-century Dutch landscape is clearly a source for the only crayon drawing in the Herriman bequest, *Landscape with Two Figures, Herd of Sheep, and a Cow* (cat. no. 60), by the Barbizon artist Charles-Émile Jacque, whose drawings and prints were his most successful works. The delicately described landscape spoke especially to the contemporary

American affinity for landscape painting, and it was ahead of its time in its almost impressionistic rendering of an idealized farm scene.

Léon Lhermitte, a popular Realist painter who achieved success in the Salon and was admired by the Impressionist and Post-Impressionist painters, was recognized in particular for his innovative use of the media of charcoal and pastel. His sharply detailed records of peasant life were sought by collectors, both public and private, throughout his career. Lhermitte's large and exquisitely rendered pastel *Old Harvester's Meal*, 1886 (cat. no. 65), was part of a bequest of 1903 to the Museum. First exhibited in 1887, the pastel was enthusiastically received in its day for its glorification of rural life in the face of the Industrial Revolution. Throughout most of the twentieth century, Lhermitte's earthy Realism was overlooked in favor of Impressionism, but in recent years his work has been reconsidered, with renewed interest in his technical virtuosity and in his influence on artists such as van Gogh in both technique and social consciousness.

Frank L. Babbott, President of the Board of Trustees from 1920 to 1928 and a true connoisseur, in 1920 donated to the Museum a small gem of a gouache by Jean-Louis Forain. This scene, identified recently as *Le Bar aux Folies-Bergères* (cat. no. 38), was painted in 1878 and is now considered a prototype for Manet's famous painting of the same title. Two other masterworks, a beautiful small watercolor by Manet, *L'Amazone* (cat. no. 67), and Pissarro's gouache on silk of 1889, the vibrant *Vue de Bazincourt* (cat. no. 77), were donated by Babbott in 1923 and 1927, respectively.

Until the mid-1930s, no department for drawings existed in the Museum; all the works mentioned above were acquired by the Department of Fine Arts, which also included oil paintings and sculpture. A Print Department had been established in 1913 by Susan Hutchinson, the Museum's Librarian from 1899 to 1934, as part of the Library. In 1935 Carl Schniewind was appointed Curator of Prints and Librarian, and in 1936, during his four-year tenure, the Print Department was separated from the Library and the drawings in black and white were made part of the new department. At that time watercolors and pastels were retained in a newly defined Department of Painting and Sculpture.

Schniewind's acquisition policy greatly shaped the character of the present collection of prints and drawings. In a policy statement of 1937, this influential curator suggested that the most significant direction that The Brooklyn Museum could take, considering its already strong collection of American prints and the limited funds available, would be to acquire "contemporary" European prints covering a cross section of "trends and developments" in Europe since the French Revolution. According to Schniewind, this approach was financially viable and educationally defensible, since "the various movements in Europe had great influence on the American artists of the last century." In the same report, Schniewind recommended that drawings acquisitions be limited to the same histori-

cal periods, but noted that, because of the higher prices of drawings in general, only occasional purchases could be made. He further suggested that large drawings be purchased, since they would have to be installed with paintings until there was enough material to make an exhibition in the Print Study Room.[6]

Only five drawings in this catalogue entered the drawings collection during Schniewind's tenure, but they number among the masterpieces. All five, whether acquired by gift or purchase, reflect the curator's knowledge and foresight. Schniewind noted in his 1937 report that there was no work by Ingres in the collection (which, alas, remains true), but in 1939 he was able to purchase for the Museum a superb pencil portrait of 1858 by Théodore Chassériau, a student of Ingres, depicting the artist's friend Jules Monnerot (cat. no. 27). The Museum's Chassériau holdings were subsequently enriched by a gift of an 1839 pencil portrait of Madame Monnerot, the mother of Jules (cat. no. 26). This portrait was donated to the Museum in 1958 by John S. Newberry, an avid drawings collector from Detroit who felt strongly that the two companion drawings should remain together. The two demonstrate how successfully Chassériau, using only a pencil, could convey his extraordinary sense of the character of his sitter.

Paul Cézanne's delicate watercolor *Study of Trees and Rocks* (cat. no. 24) and his large pencil study of a statuette of Cupid (cat. no. 23) were also purchased by the Museum in 1939. The study of a statuette is one of a number of studies after a plaster cast of a sculpture that the artist owned and used as a prop for several still-life paintings. It is one of the finest examples of this important subject.

In 1937 Schniewind enlisted the aid of the Rembrandt Club, a Brooklyn-based private club that generously supported the Museum, in the purchase of an impressive charcoal study of dancers by Edgar Degas (cat. no. 35). This drawing, in keeping with Schniewind's policy, holds its own in the company of any painting. The following year, Henri de Toulouse-Lautrec's sensitive and powerful charcoal drawing of his mother (cat. no. 88), executed in 1882, entered the collection. This revealing portrait, made while the artist was still a student, conveys his tender feelings for his mother and a familiarity with Degas's sensitive and relaxed portrait style.

Una Johnson succeeded Schniewind in 1941 as Curator of Prints and Drawings. Although she is best known for her work in twentieth-century prints, she also continued to strengthen the drawings collection. Perhaps because of her interest in prints, the three nineteenth-century French drawings that she chose for the collection in the 1940s were closely related to prints or done by important printmakers: Jean-Baptiste Camille Corot's beautiful, wispy pencil landscape *Willows and White Poplars* (cat. no. 28) is a study before or after the print of the same name and composition; Honoré Daumier's small but incisive double-sided conté drawing of the head of an old woman (cat. no. 32, recto), although not related to a print, is by a great printmaker; Suzanne Valadon's commanding char-

coal drawing of a nude (cat. no. 89) is rendered in the firm graphic line she used in her prints.

Gifts presented to the collection throughout the forties and fifties reflected the change in sensibility as the century progressed. More private collectors began to acquire black-and-white drawings, as well as sketches or study sheets, which were increasingly appreciated for their inherent merit apart from their role as studies for paintings and sculpture. An example is *Study of Two Men* (cat. no. 70), in which the assured hand of the master draftsman Jean-François Millet reveals itself as his rapid conté line brings to life two men relaxing by a haystack—a subject unrelated to any known painting or print.

Pablo Picasso's *Nude Standing in Profile*, 1906 (cat. no. 72), is a study for the painting *Two Nudes* (The Museum of Modern Art, New York),[7] a transitional painting that immediately preceded Picasso's revolutionary *Demoiselles d'Avignon*. This study and a number of other preparatory drawings are of exceptional interest in tracing Picasso's experiments in geometric simplification. However, Brooklyn's work is also a powerful drawing in its own right. The sensibility and aesthetic that lay behind the acquisition of this forward-looking modern image was far removed from the mandate under which Tissot's *Life of Christ*, created not even twenty years earlier, was acquired.

With the growing taste for modern art, interest in the art of the past did not diminish. In 1957 the trustee and generous supporter of many of the Museum's collections Alastair B. Martin and his wife, Edith, donated Jean Honoré Fragonard's pencil-and-wash drawing *The First Riding Lesson*, circa 1778 (cat. no. 39). (In the case of this work and cat. nos. 40, 41, 45, and 72, the nineteenth-century boundaries for this volume have been extended slightly to include five superb works executed in the late eighteenth and early twentieth centuries.) This charming genre scene has a humor and warmth that speak of eighteenth-century French manners, but the exquisite composition and softly rendered forms lift it above the potential sentimentality of the subject.

During the 1940s and 1950s John I. H. Baur, Curator of the Department of Painting and Sculpture, made American art the main focus of his purchasing program. Nevertheless, three major nineteenth-century French works on paper were gratefully accepted as gifts. Odilon Redon's *Anémones et tulipes* (cat. no. 81), a pastel of 1902–3, came from the highly regarded collection of Mrs. Horace Havemeyer in 1942, along with several paintings by Corot and Gustave Courbet. (In 1971 the Havemeyer family maintained their legacy at The Brooklyn Museum with the gift of another Redon pastel [cat. no. 82].) The Impressionist collection was further strengthened in the 1950s with two important donations: Degas's pastel of a bather (cat. no. 36), in 1954, and Pissarro's fan-shaped gouache, *Girl in Field with Turkeys*, 1885 (cat. no. 76), in 1959.

A 1985 review of the department's holdings revealed the unique qualities and idiosyncrasies of the collection of nineteenth-century French drawings. These works gained even greater significance when combined

with the watercolors and pastels held in the Department of European Paintings.

Since 1985 fourteen more nineteenth-century drawings and one watercolor have been acquired, mostly by purchase. It is hoped that with the perspective gained from reviewing the vagaries of nearly a century of collecting and the new vision engendered by contemporary aesthetics and revised scholarly criteria, these works will add a different dimension to the holdings in the collection.

Juan Gris's charcoal drawing *The Coffee Grinder*, 1911 (cat. no. 45), is an early work by the artist that draws from the past and looks forward to the future, foreshadowing Gris's mature style. Its sense of volume, angularity, and spatial ambiguity derive from Cézanne, while the work looks forward to Cubism. Like Picasso's nude and Toulouse-Lautrec's charcoal portrait, it is an important early drawing by an artist who absorbed developments of the previous century in the course of becoming a seminal figure of twentieth-century Modernism.

On the other hand, two drawings by Fragonard (cat. nos. 40, 41), illustrations executed in the 1780s for Ariosto's *Orlando Furioso*, are the work of a late eighteenth-century artist who looks ahead to the developments of the early nineteenth century. Their heroic and romantic subject matter, conveyed dramatically with loose and expressive line, points to the Romanticism of the nineteenth century. These drawings were acquired with funds donated by Karen B. Cohen, whose own collection focuses on nineteenth-century French drawings.

Among the other works purchased with Karen Cohen's assistance are two pencil drawings by Puvis de Chavannes, *Portrait de Madame Montrosier*, circa 1890 (cat. no. 80), and a study of a standing male nude (cat. no. 79). Together with the unfinished study for a mural at Amiens (cat. no. 78), acquired in 1922, these drawings span the artist's career and demonstrate his pervasive influence on the work of the early Modernists. A rapidly sketched, small, but fully realized pencil study for a lost ceiling decoration by Millet (cat. no. 68) also makes a wonderful complement not only to Puvis's mural study, but also to the two Millet drawings already in the collection (cat. nos. 69, 70). As with the group of works by Puvis, the three by Millet characterize the versatile and prolific output of a pivotal artist.

When a work is purchased for the collection, it is usually selected either to reinforce an area of strength, as in the case of the works by Puvis de Chavannes and Millet, or to add artists or styles not already represented in the collection. A fine example of Romantic landscape that complements other holdings in the collection is the watercolor of the Fontaine de Vaucluse by Paul Huet (cat. no. 59), purchased for the Department of Painting and Sculpture. As noted previously, Lhermitte's innovations in the medium of charcoal were as important as his achievements in pastels. Since he was already represented in the collection by a superb pastel, a fine example of this artist's fully detailed and sharply lit charcoal drawings, *L'Église de Saint-Eugène*, 1884 (cat. no. 66), was

acquired in 1989. In order to place Lhermitte in the context of Realism, drawings by Albert Lebourg and Jules Bastien-Lepage, artists new to the collection, were also acquired recently (cat. nos. 61, 14). An unusual sketch purchased for the collection in 1991 of a shipwrecked boat, in the excited hand of the sculptor Jean-Baptiste Carpeaux (cat. no. 20), adds yet another dimension to the collection and another foreshadowing of Impressionism.

Drawings are valued for their aesthetic qualities and for what they reveal of an artist's method of working. Their intimacy and directness, not found in the more formal medium of oil painting, help us to understand better the art and the artist's thoughts at the moment of creation. The Brooklyn Museum's collection of nineteenth-century French drawings and watercolors offers these riches and also preserves a slice of our cultural and artistic heritage, revealing changes in collectors' tastes from the late nineteenth century on, and in artists' attitudes and styles since the end of the eighteenth century.

Linda Konheim Kramer

NOTES

1 *The Brooklyn Museum Handbook*, Brooklyn, 1967, p. 13.

2 Ibid.

3 This appears to be the first instance of a museum purchase by public subscription in New York and possibly in the country.

4 Quoted in Sarah Faunce, "Collecting in the 1920s: Modern French Painting," *Apollo* (April 1982), p. 276.

5 Ibid., p. 281.

6 Carl Schniewind's Collection Policy memo, 1937, The Brooklyn Museum Archives.

7 Pierre Daix and Georges Boudaille, *Picasso, The Blue and Rose Periods: A Catalogue Raisonné of the Paintings, 1900–1906*, Greenwich, Connecticut, 1966, p. 318.

French
Nineteenth-Century
Drawings and
Watercolors

AT THE BROOKLYN MUSEUM

Antoine Louis Barye
1796–1875

1 *Jaguar découvrant un serpent (Jaguar Discovering a Snake)*,
circa 1840

Watercolor on cream-colored wove paper, 11½ x 16¹³⁄₁₆ (29.2 x 42.7); signed in red in lower right

10.93, Gift of Friends of the Museum

Provenance Collection Charles Noel; Sale, Hôtel Drouot, Paris, February 23, 1891; Collection Cyrus J. Lawrence; Estate Sale, American Art Galleries, New York, January 21–22, 1910; Gift of Friends of the Museum, 1910.

Exhibitions Paris 1889, cat. no. 703. New York 1909. Brooklyn 1921, cat. no. 2. Detroit 1950, cat. no. 43C. Minneapolis 1962, cat. no. 1.

References Tschudy 1932, p. 87. Zieseniss 1954, p. 71, cat. no. C20, illus. pl. 20.

2 *Tigre se roulant (Rolling Tiger)*,
circa 1840

Watercolor on cream-colored wove paper mounted on thin paperboard, 9⅝ x 11¹¹⁄₁₆ (23.7 x 29.4); signed in red in lower center

10.96, Gift of Friends of the Museum

Provenance Collection X. Binder; Sale . . . Binder, Hôtel Drouot, Paris, April 8, 1873, no. 4; Collection Cyrus J. Lawrence; Estate Sale, American Art Galleries, New York, January 21–22, 1910; Gift of Friends of the Museum, 1910.

Exhibitions New York 1889–90, cat. no. 504. New York 1909. Detroit 1950, cat. no. 43B. Brooklyn 1988–89.

References Tschudy 1932, p. 87. Zieseniss 1954, p. 65, cat. no. B20, illus. pl. 12.

3 *Cerf marchant (Stag Walking)*,
undated

Watercolor on wove paper, 5⁹⁄₁₆ x 9¹⁄₁₆ (14.2 x 23.0); signed in blue in lower left

10.97, Gift of Friends of the Museum

Provenance Collection Cyrus J. Lawrence; Estate Sale, American Art Galleries, New York, January 21–22, 1910, illus. A; Gift of Friends of the Museum, 1910.

Exhibitions New York 1909. Brooklyn 1988–89.

References Tschudy 1932, p. 87. Zieseniss 1954, p. 74, cat. no D12, illus. pl. 13.

BARYE'S WATERCOLORS AND DRAWINGS are less renowned than his sculpture, but they add another dimension to the understanding of his aesthetic. In both the works on paper and the sculpture he maintained a strict attention to anatomical detail, but the works on paper focus on a single animal or the static interaction of two, as distinct from the more complex sculptural compositions of twisted combat. Barye's sketches and watercolors are studies, or after studies, that he drew at the Jardin des Plantes, where he often went with his friend Eugène Delacroix. The Brooklyn Museum's collection of eight watercolors[1] and five pencil drawings reflects the quality and range of Barye's ability as well as the principles of his drawing aesthetic.

Barye never dated or documented his drawings and watercolors. Consequently, it is difficult either to establish a chronology of these works or to identify their function for Barye. Charles Zieseniss based his chronology for the watercolors on the contrast between the styles of the five exhibited at the Salon of 1834 and the nine exhibited in Paris in 1860.[2]

Zieseniss also dated the watercolors according to changes in Barye's signature. Of the Brooklyn watercolors, seven are signed in capital letters and one is signed in script. Zieseniss believes that before 1833–34 Barye signed his name in cursive script, not found in the watercolors of his Romantic period. Later, however, he printed his name in capital letters, and his family signed many of his works in a similar fashion after his death.

The recorded arrival of certain animals in Europe provides another source for dating Barye's work. While tigers, for instance, were present in France as early as 1828, none was in the Jardin des Plantes, where Barye worked about 1847–50.[3]

The Museum formed its collection, except for two watercolors, in 1910, when it purchased all the work by Barye from the estate of Cyrus J. Lawrence. Along with Henry and William T. Walters and Samuel Avery, Lawrence was one of a group of prominent American collectors and dealers who were avid patrons of Barye's. Together they formed an American committee to raise funds and build a monument to the artist in Paris. Most of the group was introduced to Barye and his work by the expatriate dealer George Lucas.[4] Although Barye rarely exhibited his work on paper, he evidently sold a great number of watercolors and drawings to private collectors and dealers. Some of his American patrons established a personal relationship with him and bought directly from his studio.

As a group, the Museum's watercolors illustrate various stages in Barye's stylistic development. Loose, undulating curves in works such as *Tiger Reclining* become swirling, craggy hills, twisting trees, and mossy

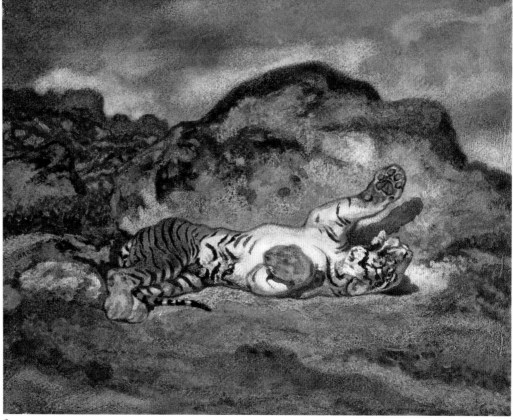

1

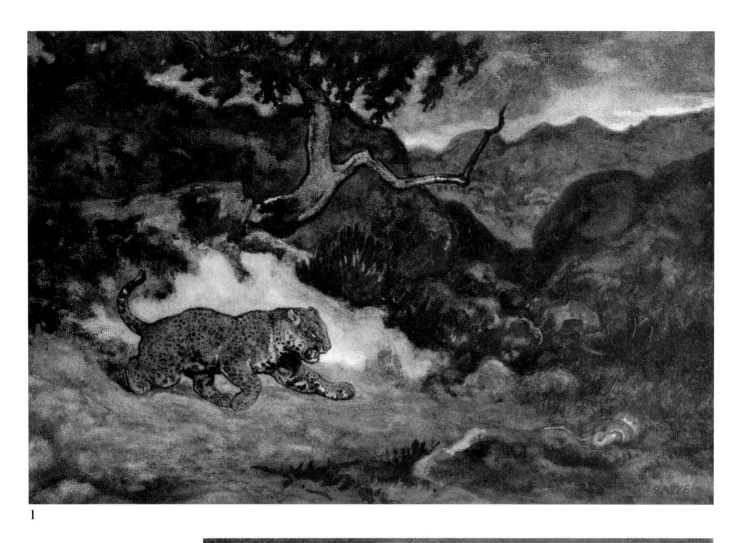

2

4 *Daims auprès d'un arbre (Bucks near a Tree)*, undated

Watercolor on cream-colored laid paper, 6¾ x 13⅞ (17.2 x 35.3); signed in red and blue-black in lower right

21.88, Bequest of William H. Herriman

Provenance Collection William H. Herriman, Rome; Bequest of William H. Herriman, 1921.

Exhibitions Brooklyn 1924–25, cat. no. 52. Brooklyn 1988–89.

References Tschudy 1932, p. 87. Zieseniss 1954, p. 75, cat. no. D27, illus. pl. 26.

5 *Lion au repos (Lion Reclining)*, undated

Watercolor on cream-colored wove paper, 9¹³⁄₁₆ x 13⅛ (24.9 x 33.3); signed in brown in lower right

10.94, Gift of Friends of the Museum

Provenance Collection Cyrus J. Lawrence; Estate Sale, American Art Galleries, New York, January 21–22, 1910, illus. D; Gift of Friends of the Museum, 1910.

Exhibitions New York 1909. Brooklyn 1988–89.

References Tschudy 1932, p. 87. Zieseniss 1954, p. 58, cat. no. A13, illus. pl. 3.

6 *Lion debout (Standing Lion)*, undated

Watercolor on cream-colored wove paper, 9¹³⁄₁₆ x 13⅛ (24.9 x 33.3); signed in red in lower right

10.98, Gift of Friends of the Museum

Provenance Galeries Durand-Ruel, Paris; Collection Cyrus J. Lawrence; Estate Sale, American Art Galleries, New York; January 21–22, 1910; Gift of Friends of the Museum, 1910.

Exhibitions New York 1909.

References Tschudy 1932, p. 87. Zieseniss 1954, p. 59, cat. no. A26, illus. pl. 4.

rocks in *Bucks near a Tree*. Barye maintains a high horizon line in all the watercolors, but as the landscape becomes more elaborate, the animals begin to interact with the environment, no longer serving simply as models in an unarticulated setting. The animal figures, although diminished in size, adopt a greater sense of volume as they begin to engage in activity. For instance, the imposing and grand beast in *Tiger Reclining* has a flat, almost iconic appearance with its elongated, curving body and large head. In contrast, *Bucks near a Tree* presents a more lyrical image of animals at play among rocks and trees.

What is striking about the watercolors is their sense of color. Saturated hues belie the medium, though the effect depends on the thin paint surface combined with the paper's texture.

While Barye's drawings are even less well documented than the watercolors, they provide a more immediate sense of Barye's process and initial approach. Again, animals are depicted in static positions, without settings, and indicate Barye's interest in the form of one or two animals entwined or in mirrored poses. The frequency of reclining animals depicted could also be explained by the fact that Barye sketched them at the Jardin des Plantes or from drawings executed there. Like the watercolors, the drawings possess a steady, clean line and do not correlate with any of the sculptures. According to Zieseniss, Barye would sketch the contour and features of his subject on a kind of tracing paper and then transpose the image onto watercolor paper, never hesitating to use the same image repeatedly in different compositions.[5] In The Brooklyn Museum drawings, one finds the same animals repeated, even in the same composition.

Barye devoted his art to one specific field, that of the *animalier* (animal painter), to explore the aesthetic issues of the time. His art, viewed as a whole, nevertheless presents an accurate mirror of a tumultuous time in Paris for both art and politics, with its odd mix of classicism, romanticism, and realism. KZ

1 Zieseniss 1954 is the catalogue raisonné of the watercolors. It documents 217 works.

2 Ibid., introduction. Many of the watercolors in the 1860 exhibition were already in private collections. Zieseniss's approach to chronology is problematic, since there is no documentation upon which to determine when these watercolors entered private collections, nor is there anything in the contemporary criticism to indicate that these were new works.

3 The use of this factor in dating is problematic as well, for it can only be used as an ending date, before which the work could probably not have been executed.

4 The Brooklyn Museum Archives, Records of the Office of the Director, Bequests; C. J. Lawrence Estate and Records of the Department of Painting and Sculpture, Artist's File: Barye.

5 Zieseniss 1954, p. 27.

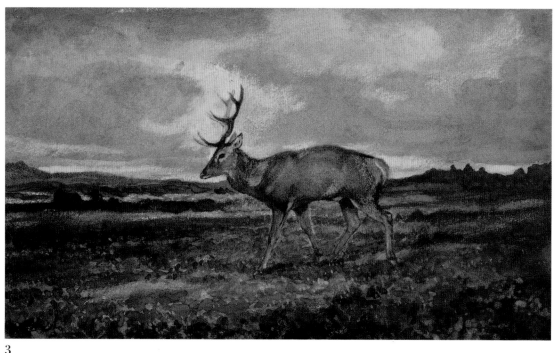

3

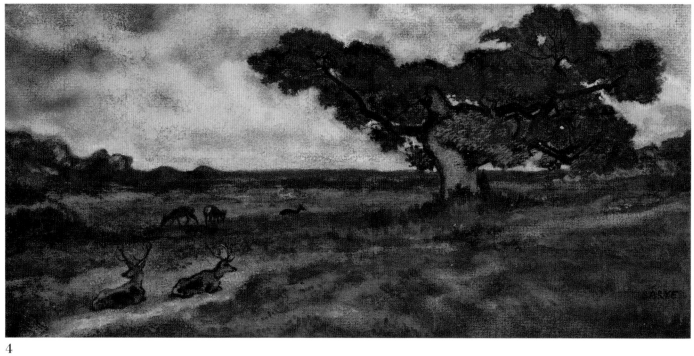

4

7 *Tigre couché (Tiger Reclining)*, undated

Watercolor on thin cream-colored wove paper mounted on thick pulpboard, 12¾ x 20 (32.4 x 50.8); signed in red in lower left

10.99, Gift of Friends of the Museum

Provenance Sale, Paris, Hôtel Drouot, February 1876, no. 174; Collection Brame; Collection Samuel Avery; Collection Cyrus J. Lawrence; Estate Sale, American Art Galleries, New York, January 21–22, 1910; Gift of Friends of the Museum, 1910.

Exhibitions Paris, École des Beaux-Arts, *Antoine-Louis Barye*, 1875, catalogue with text by A. Genevay, cat. no. 447. Paris, Galeries Durand-Ruel, *Exposition retrospective de tableaux et dessins des mâitres modernes*, 1878, cat. no. 3 *(Tigre au repos)*. New York 1889–90, cat. no. 479. Brooklyn 1988–89.

References De Kay, Charles, *Life and Works of Antoine-Louis Barye*, 1889. Tschudy 1932, p. 87. Zieseniss 1954, p. 63, cat. no. B5, illus. pl. 9.

8 *Tigre marchant vers la gauche (Tiger Walking to the Left)*, undated

Pastel and watercolor on cream-colored wove paper mounted on thin paperboard, 10⅝ x 14⅞ (27.0 x 37.8); signed in reddish brown in lower right

34.482, Executors of the Estate of Michael Friedsam through The Metropolitan Museum of Art

Provenance Private Collection, Paris; Sale, Collection..., Hôtel Drouot, Paris, June 16, 1894, p. 19, no. 50; Collection Dellesert; Knoedler and Co.; Collection Benjamin Altman; Collection Michael Friedsam; Executors of the Estate of Michael Friedsam through The Metropolitan Museum of Art, 1934.

Exhibitions Brooklyn 1988–89.

References Zieseniss 1954, p. 66, cat. no. B32, illus. pl. 14.

9 *Head of a Bull*, undated

Pencil on white laid paper, 4¼ x 5¼ (10.8 x 13.3)

10.216, Gift of Friends of the Museum

Provenance Collection Cyrus J. Lawrence; Estate Sale, American Art Galleries, January 21–22, 1910; Gift of Friends of the Museum, 1910.

Exhibitions Brooklyn 1988–89.

References Tschudy 1932, p. 161.

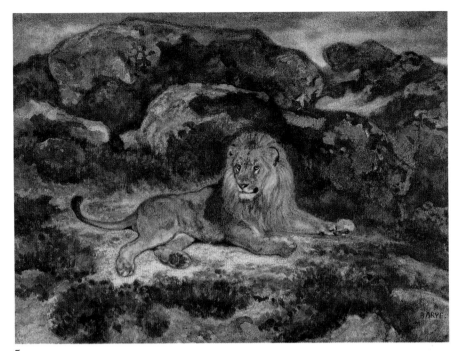

5

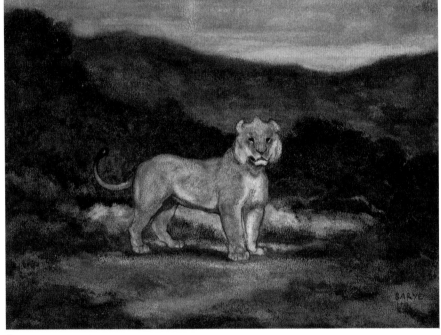

6

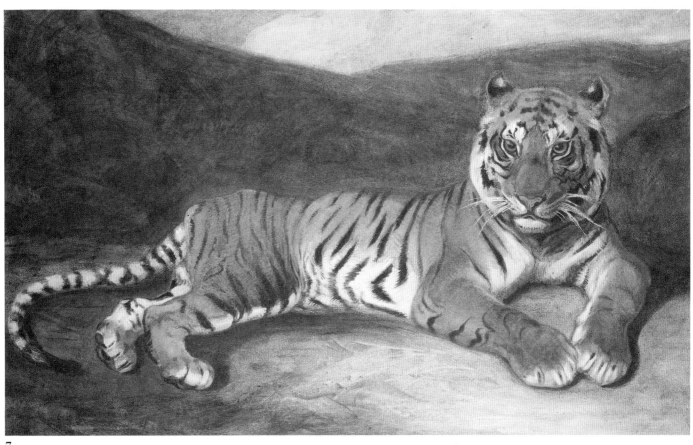

7

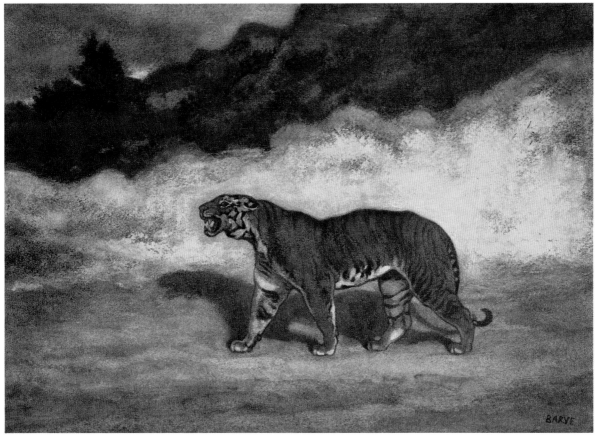

8

10 *Studies of a Lion*, undated

Pencil on heavy gray wove paper, 8⅝ x 11⅜ (21.8 x 28.9)

10.219, Gift of Friends of the Museum

Provenance Collection Cyrus J. Lawrence; Estate Sale, American Art Galleries, New York, January 21–22, 1910; Gift of Friends of the Museum, 1910.

Exhibitions Brooklyn 1988–89.

11 *Two Lionesses Facing Left*, undated

Pencil on laid paper, 5⅛ x 7⁹⁄₁₆ (13.0 x 19.2)

10.218, Gift of Friends of the Museum

Provenance Collection Cyrus J. Lawrence; Estate Sale, American Art Galleries, January 21–22, 1910; Gift of Friends of the Museum, 1910.

Exhibitions Brooklyn 1988–89.

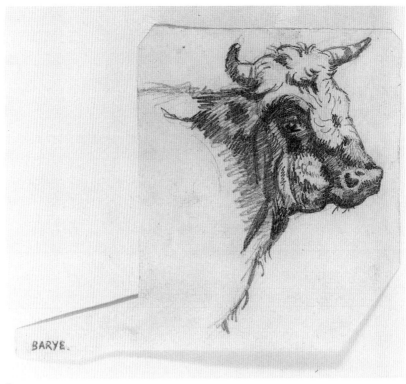

9

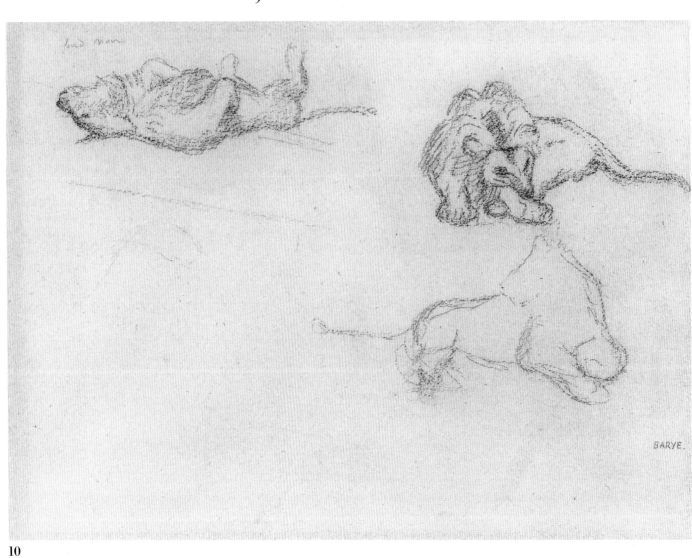

10

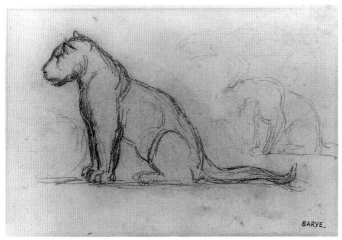

11

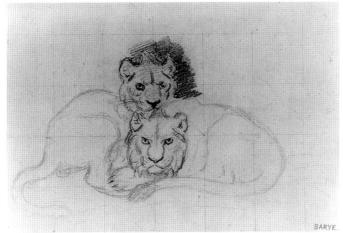

12

12 *Two Lions*, undated

Pencil on laid paper, 5⅛ x 7⁹⁄₁₆ (13.0 x 19.2)

10.220, Gift of Friends of the Museum

Provenance Collection Cyrus J. Lawrence; Estate Sale, American Art Galleries, New York, January 21–22, 1910; Gift of Friends of the Museum, 1910.

Exhibitions Brooklyn 1969. Brooklyn 1988–89.

13 *Two Standing Lionesses and a Horse*, undated

Pencil on laid paper, 8⅝ x 11⅜ (21.9 x 28.8)

10.217, Gift of Friends of the Museum

Provenance Collection Cyrus J. Lawrence; Estate Sale, American Art Galleries, New York, January 21–22, 1910; Gift of Friends of the Museum, 1910.

Exhibitions Brooklyn 1988–89.

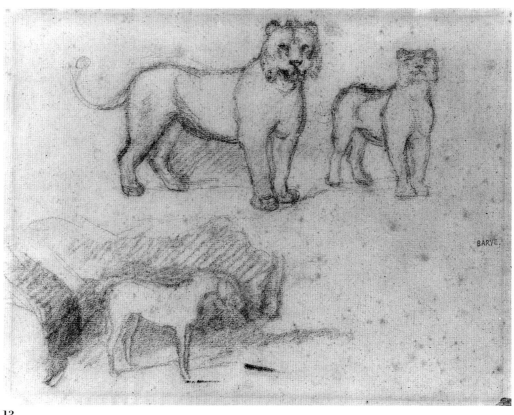

13

Jules Bastien-Lepage
1848–1884

14 *Petite Fille assise (Girl Seated in the Grass)*, undated

Graphite and oil crayon on brown wove paper, 11⅞ x 15¼ (32.0 x 38.86); signed in pencil in lower right, "J. Bastien-Lepage"

87.167, Alfred T. White Fund

Provenance Paris, private collection (acquired in Paris art market, circa 1975); David and Constance Yates, New York, 1987; Museum Purchase, 1987.

Exhibitions Brooklyn 1988–89.

References Aubrun, Marie-Madeleine, *Jules Bastien-Lepage 1848–1884*, Paris, 1985, p. 338, cat. no. D627, illus.

J ULES BASTIEN-LEPAGE entered the École des Beaux-Arts, where he studied with Alexandre Cabanel, in 1868. He was respected early in his career for his talents in drawing, receiving two prizes in this area while he was still a student. After failing to win the Prix de Rome in 1875, he gave up all pretensions to official success in the Academy and turned to peasant subjects in the open air. He was part of a group of Third Republic artists who employed both independent and academic stylistic elements, moving away from the tight, polished surfaces of the academicians while not totally accepting the complete freedom of the Impressionists.

This charming drawing of a child seated in the grass is not a study for any known painting. It appears to be a sketch from life that captures in a direct and straightforward manner the essence of a child's demeanor without any of the sentimentality found in the artist's paintings of children. LKK

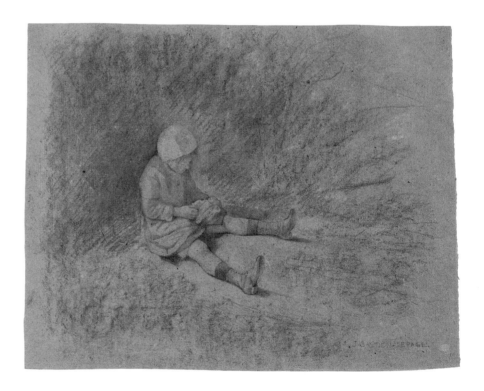

Joseph-Louis-Hippolyte Bellangé
1800–1866

BOTH BELLANGÉ AND Nicolas Toussaint Charlet dedicated their art to Napoleonic subjects (for The Brooklyn Museum's Charlet, *Bonaparte aux Tuileries*, see cat. no. 25). Bellangé befriended Charlet while they were both studying in the studio of Antoine Gros. Charlet, inspired by his political leanings, first chose Napoleonic subjects as his artistic domain. Bellangé, the younger artist, was infected by Charlet's enthusiasm and followed his lead. Both worked most extensively and successfully in prints and drawings.

The Museum's drawings reveal each artist's graphic ability. In the small format of each, subtle washes and shallow strokes create both an intimate composition and expansive space. Although each drawing depicts Napoleon in a private and casual moment—in contemplation or with a soldier—we sense the din of the battlefield in the distance. Both artists emphasize the humanity, popularity, and power of the famous leader; at the same time, their work possesses an element of humor or caricature characteristic of popular imagery. Both drawings came to the Museum as part of the Marion Reilly Napoleonic collection (see cat. no. 93). KZ

15 *Napoleon Standing with a Soldier*, 1831

Pencil and watercolor on wove paper, 4⅝ x 3¹⁵⁄₁₆ (11.8 x 9.9); signed and dated in lower right

29.1411, Bequest of Marion Reilly

Provenance Collection Marion Reilly, Bryn Mawr, Pennsylvania; Bequest of Marion Reilly, 1929.

Exhibitions Brooklyn 1969. Brooklyn 1988–89.

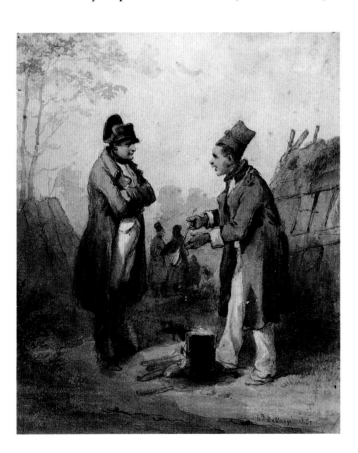

Étienne Prosper Berne-Bellecourt
1838–1910

16 *The Lover,* 1869
Watercolor on heavy wove paper, 14⁷⁄₁₆ x 10³⁄₁₆ (36.7 x 25.9); signed and dated in brown in lower left
38.734, Gift of Frederic B. Pratt

Provenance Collection Frederic B. Pratt, New York; Gift of Frederic B. Pratt, 1938.

Exhibitions Brooklyn 1988–89.

ÉTIENNE BERNE-BELLECOURT was a student of François Picot and Félix-Joseph Barrias at the École des Beaux-Arts and a successful Salon painter from his debut in 1861. In the sixties he painted landscapes, portraits, and genre subjects, but after the Franco-Prussian War he concentrated almost exclusively on military themes, including scenes from that traumatic conflict. Painted with a high degree of exactitude and finish, these works were very well received by the public. Like many other painters of the period, he employed watercolor for the same naturalistic ends of high polish and accurate detail that were sought in oil painting. In *The Lover* we see a type of picture much in vogue in the Second Empire: a simple, often sentimental genre subject enacted by figures depicted in the settings and costume of a bygone historical period. The eighteenth century, with its decorative silks and satins, its décolletage, and, in the case of the men, its well-turned legs, was a favorite period in which to set these often anachronistic scenes. It is doubtful that an eighteenth-century man of the status implied by the dress depicted here would have scratched his sentiments on a tree like a rustic youth; but the buyers of these pictures might have liked to think so, and in any case the main attraction of the image lay then, as it does now, in the meticulously executed textures and costume details. This fascination with costume pictures—whether the dress was drawn from history or the exotic Near East, from the military or the Church—was the result of the widespread idea that modern dress, particularly that of men in their *habit noir,* was too ugly or too commonplace to be worthy of inclusion in a work of art. It was the role of the Realists and Impressionists to struggle against this tenacious notion for much of the second half of the nineteenth century. SF

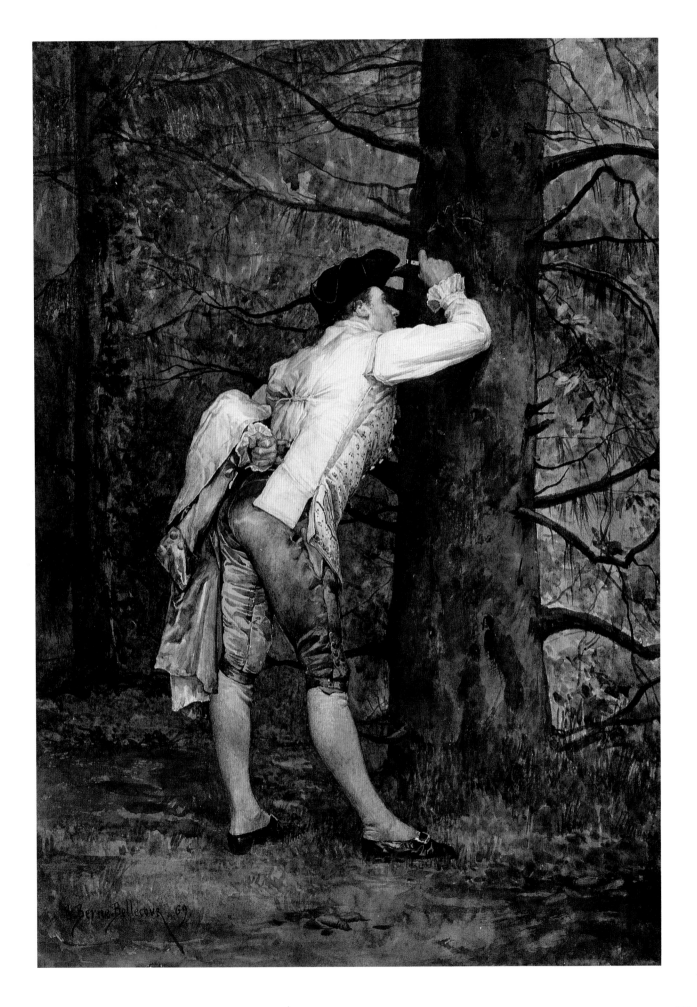

Rosa Bonheur
1822–1899

17 *Head of a Bull,* undated

Watercolor and pencil on cream wove paper, 4¹⁵⁄₁₆ x 6⅞ (12.5 x 17.5); signed in lower left

22.80, Gift of John Hill Morgan

Provenance Sale, Atelier Rosa Bonheur, Galerie Georges Petit, Paris, June 5–8, 1900, vol. II, p. 8, no. 917; Collection John Hill Morgan, New York; Gift of John Hill Morgan, 1922.

Exhibitions Brooklyn 1988–89. Dallas, Meadows Museum, Owen Fine Arts Center, Southern Methodist University, *Rosa Bonheur: Academic Artist*, August 21–October 31, 1989.

References Shriver, Rosalia, *Rosa Bonheur with a Checklist of Works in American Collections,* Philadelphia, London, and Toronto, 1982, p. 55, illus. p. 96. Tschudy 1932.

ROSA BONHEUR WAS ONE of the most famous *animaliers* of the second half of the nineteenth century. Whereas Barye's sculptures depicted wild beasts, her paintings were mostly concerned with domestic and farm animals. Her father, who was an artist, encouraged this interest when she was young by allowing her to keep various domestic animals at home. She also studied animals in the fields, slaughterhouses, and marketplaces to gain a better grasp of their anatomy, movement, and characteristics. This little watercolor, one of her many studies from nature, has not been identified with a particular painting. LKK

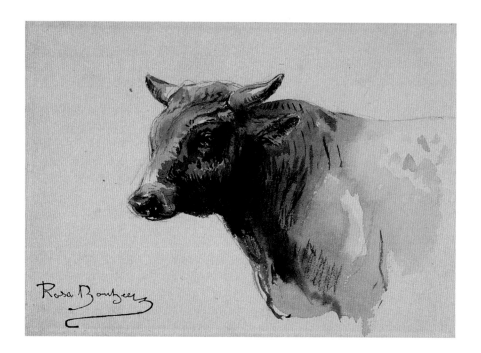

Louis-Maurice Boutet de Monvel
1851–1913

MAURICE BOUTET DE MONVEL was conventionally trained as an academic painter in the studios of Alexandre Cabanel and Émile-Auguste Carolus-Duran and was successful at the Salon beginning with his debut in 1874, but his true gifts and memorable achievement lay in quite another area than conventional Salon painting. Perhaps in part because of his success as a portrait painter of children, he began in the early 1880s to make illustrations for children's books. This was a moment when the illustrated children's book as an object of aesthetic and imaginative interest was just coming into its own, and the works of Walter Crane and Kate Greenaway from the previous decade were entering the French market. Boutet de Monvel eventually became the leading French artist in this genre, during the period that was later known as its golden age. His first book, *La France en zig-zag*, attracted commissions not only for further books, but also for illustrations in such noted children's magazines as *Saint Nicholas* and in the fledgling business of advertising. The first book wholly designed by the artist was *Vieilles chansons pour les petits enfants* in 1883, followed the next year by *Chansons de France pour les petits français*. These books reveal the artist's ability to synthesize the most sophisticated aesthetic elements of his time (the flowing linearism and asymmetry of the Japanese print; the taste for friezelike, two-dimensional pictorial construction being developed in an entirely different context at this time by Seurat; and the transparent clarity of color that was the aim of the Post-Impressionist generation) and to fuse this aesthetic with an extraordinary feeling for the reality of the world of the child. These qualities would continue to be manifest throughout his career, during which his work became well known outside of France—not only in England and central Europe, but also in America.[1]

Like others of his generation, Boutet de Monvel was attracted to Brittany, the region of France that clung most tenaciously to the ancient folkways that were fast being dissolved by the modern world. He was able to depict traditional Breton costume in his books of old songs, as well as in watercolors such as *In Brittany*. This work is remarkable in the way that spatial depth is indicated by foreshortened and overlapping figures overlooking rooftops and out to the horizon, while the flatness of silhouette and horizontally banded structure are still maintained. The delicacy

18 *In Brittany*, undated

Pencil and watercolor on wove paper, image, 14%₁₆ x 23¼ (37.0 x 59.1); sheet, 18¹⁵⁄₁₆ x 23¼ (48.1 x 59.1); signed in pencil in lower left

24.87, Gift of Edward C. Blum

Provenance Collection Edward C. Blum, Brooklyn; Gift of Edward C. Blum, 1924.

Exhibitions Brooklyn 1924–25, cat. no. 55. The Brooklyn Museum, *Exhibition of Watercolor Paintings, Pastels and Drawings by American and European Artists*, April 14– May 10, 1925, cat. no. 74. Brooklyn 1988–89.

References Tschudy 1932, p. 92, illus.

and subtlety of the colors are characteristic of the artist, whose color is always clear and distinctively local but never saturated. Also typical of the artist is the solid dignity of the figures, which possess a sense of individuality that is nevertheless always in the service of the overriding style of the work. SF

1 Cf. Frederich C. Heller, "Maurice Boutet de Monvel, illustrateur de livres d'enfant," *Revue de la Bibliothèque Nationale* (Spring 1988), vol. 27, pp. 14–25, for full bibliography of illustrated books, including international editions.

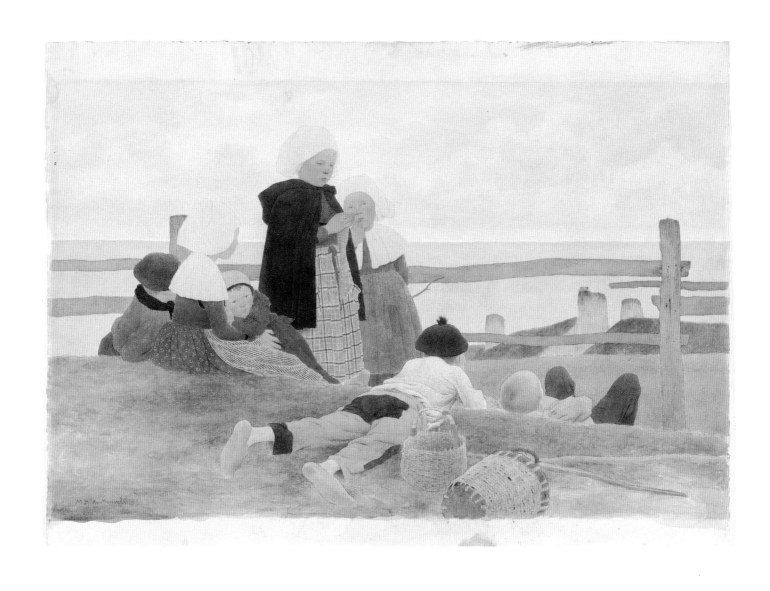

Félix-Saturnin Brissot de Warville
1818–1892

19 *Shepherd and Flock in the Mountains,* early 1870s

Watercolor on wove paper, 7⅝ x 10⅛ (19.3 x 25.7); signed in brown in lower right

21.276, Bequest of William H. Herriman

Provenance Collection William H. Herriman, Rome; Bequest of William H. Herriman, 1921.

Exhibitions Brooklyn 1988–89.

Brissot de Warville studied with Léon Cogniet and made his Salon debut in 1840 as a painter of landscapes. A member of the Barbizon generation, he worked much in the manner of Charles-Émile Jacque, concentrating on the painting of cattle and sheep. These subjects continued to be popular with collectors throughout his long and prolific career. During the Second Empire, Brissot de Warville was the manager of the emperor's Château de Compiègne and drew his themes from the local countryside. His calm fields and cottages of northern France are varied in the early 1870s by subjects drawn from travels to the Pyrenees, possibly initially undertaken because of the downfall of the emperor in 1871. The Brooklyn watercolor is clearly a Pyrenees subject: a herd of mountain sheep with a shepherd in Basque beret. SF

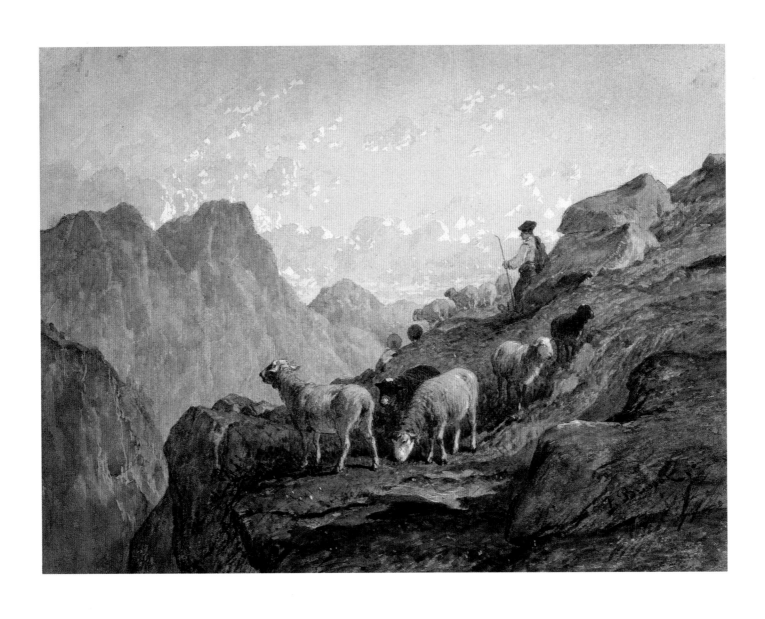

Jean-Baptiste Carpeaux
1827–1875

20 *Shipwreck*, undated

Brown ink and wash on laid paper, 6½ x 9¼
(16.5 x 23.5)

1991.66, Helen B. Saunders Fund

Provenance Atelier Carpeaux; Estate
Sale, Collection artist's widow, Paris,
December 19, 1913, part of no. 248; Collection
Launay Family, Paris; Jill Newhouse, New York.

References New York, Jill Newhouse, *Jean-
Baptiste Carpeaux: A Selection of Drawings*,
essay by Colin Eisler, Spring 1991, catalogue
XII, cat. no. 21.

I N THE 1880S, after Carpeaux's death, his sketchbooks were cut up when
selections were made for gifts to the École des Beaux-Arts and the Musée
des Beaux-Arts in Valenciennes. This drawing comes from an *album factice*
in which a range of drawings have been collected from some of the sketch-
books. The drawings in this album, which span Carpeaux's career from
the 1850s to 1874, remained in the hands of his widow, who was twenty
years his junior, until her death; the album was sold with the rest of her
estate in 1913.

The works that were preserved in this album before it was recently
broken up—including drawings after Michelangelo's sculpture and fres-
coes, four sketches based on Dante's *Divine Comedy*, and two transcrip-
tions from Baroque paintings—demonstrate some of the sculptor's
interests.[1] This drawing of ships tossed on a stormy sea is thought to be
after a painting of the Dutch School, although the specific source has not
yet been discovered. The emotionally charged and dramatic content is char-
acteristic of Carpeaux's work in all media. LKK

1 New York, Jill Newhouse, *Jean-Baptiste Carpeaux: A Selection of Drawings*,
essay by Colin Eisler, Spring 1991, catalogue XII.

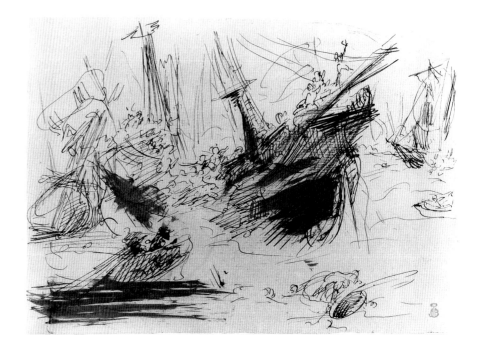

Jean Charles Cazin
1841–1901

THE MUSEUM'S TWO DRAWINGS by Jean Charles Cazin reflect the artist's mature synthesis of the many styles and arts he had employed throughout his life. Cazin was a painter, engraver, and ceramist. In addition, he taught, curated, and promoted the decorative arts in France.[1]

Brooklyn's *Landscape* and *Study of a Woman Sweeping* possess the simplicity and sincerity characteristic of Cazin's work. They also reveal his straddling of many of the century's artistic trends. The brief, evocative line recalls the emphasis on atmosphere and the exacting but momentary vision of his friend James McNeill Whistler, as well as the aesthetic

21 *Study of a Woman Sweeping*, undated

Conté crayon on laid paper, 12⅛ x 9¼ (30.8 x 23.5); signed in lower left, "J.C. Cazin"

64.101.133, Gift of Louis E. Stern Foundation

Provenance Collection Louis E. Stern, New York; Gift of Louis E. Stern Foundation, 1964.

22 *Landscape*, circa 1876

Conté crayon on laid paper, 9⅜ x 12⅛ (23.8 x 30.8); signed in lower right, "J.C. Cazin"

64.101.134, Gift of Louis E. Stern Foundation

Provenance Collection Louis E. Stern, New York; Gift of Louis E. Stern Foundation, 1964.

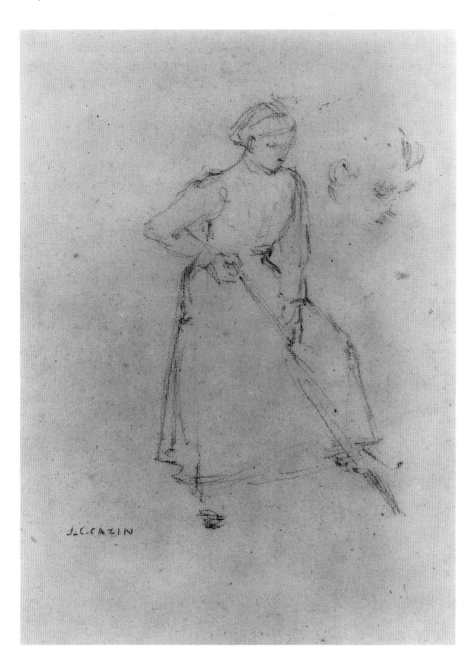

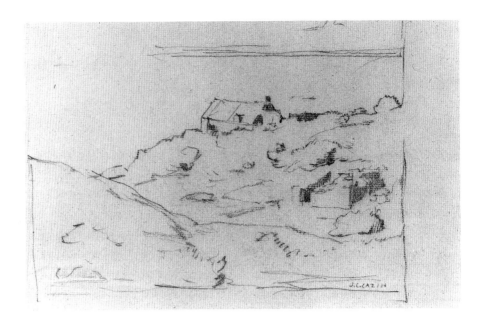

of many Impressionist painters. At the same time, the unaffected naturalism of the woman sweeping reflects the concerns of artists such as Jean-François Millet, whom Cazin admired early in his career.

Cazin began his artistic career in the early 1860s at the École Gratuite de Dessin in Paris, among a circle of artists that included François Bonvin, Henri Fantin-Latour, and Léon Lhermitte. He was extremely receptive to the insistence of his teacher, Horace Lecoq de Boisbaudran, on the accurate observation of nature and "memory training," and because of Lecoq de Boisbaudran's high regard for him, Cazin became curator of the museum in Tours and director of its École de Dessin. At the suggestion of his former student Alphonse Legros, Cazin moved to London in 1871, to teach and to escape the destruction of the Franco-Prussian War.[2]

Landscape depicts the countryside around Equihen, a small fishing village near Boulogne-sur-Mer, where the artist settled on his return from England in 1875. The view of houses clinging to the cliffs relates to Cazin's painting *L'Orage (The Storm)*, 1876, in the Louvre, dating the drawing to around the same time.[3]

In *Study of a Woman Sweeping*, Cazin points the figure's head down, to show the nobility of calm simplicity rather than suggest fatigue.

Drawings by Cazin are rare, as he seldom executed preparatory sketches. However, as these two drawings show, his technique brings together many aspects of French drawings explored by the artists in this catalogue. KZ

1 Cazin's wife, Marie Guillet, a painter and ceramist who studied in the atelier of Rosa Bonheur, introduced him to ceramics.

2 Henri Fantin-Latour and Auguste Rodin were other famous students of Cazin.

3 Jean-Claude Lesage, a Cazin scholar, suggested that the notation "MIDI" in the upper-right margin of the landscape drawing may mean that the drawing is a study for the painting, although, as noted above, Cazin rarely made such studies. Letter to the author, August 7, 1992, The Brooklyn Museum, Department of Prints and Drawings, Artist's File.

Paul Cézanne
1839–1906

CÉZANNE LEFT AN EXTENSIVE BODY OF WORKS in watercolor over pencil that are almost exclusively independent studies, rather than preparatory drawings for his oil paintings.[1] Pencil drawings most frequently appear in his small sketchbooks.

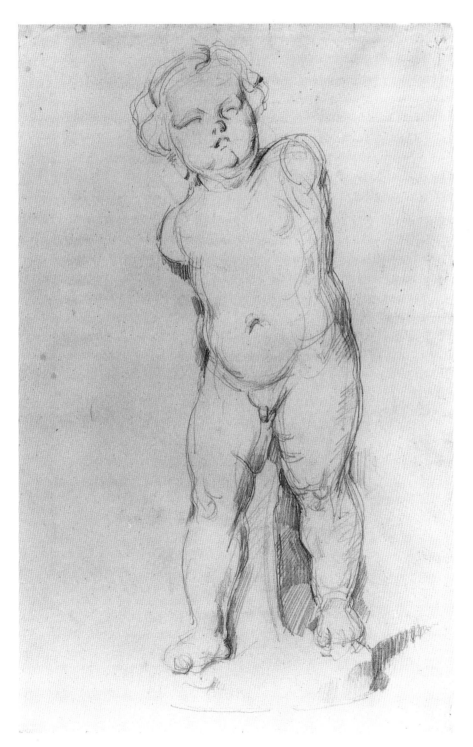

23 *Étude de l'Amour Plâtre* (*Study from a Statuette of a Cupid*) (verso: *Drapery Study*), circa 1890

Pencil on laid paper (recto and verso), 19⅜ x 12¹³⁄₁₆ (48.8 x 37.5)

39.623, Museum Purchase

Provenance Cézanne fils; Bernheim-Jeune, Paris; Hugo Perls, Berlin; Jacques Seligmann, Paris; Sale, Hôtel Drouot, November 22, 1933, no. 4; Collection Lionello Venturi, Paris; Galerie Rosengart, Lucerne; Knoedler and Co., Inc., New York, 1939; Museum Purchase.

Exhibitions Basel, Kunsthalle, *Paul Cézanne*, August 30–October 12, 1936, cat. no. 42, illus. San Francisco Museum of Fine Arts, *Paul Cézanne, Exhibition of Paintings, Watercolors, Drawings and Prints*, September 1–October 4, 1937, catalogue with text by Gerstle Mack, cat. no. 66, p. 35, illus. Paris, Grand Palais, *50e Exposition de la Société des Artistes Indépendants, Centenaire du Peintre Indépendant Paul Cézanne*, March 17–April 10, 1939, catalogue with text by Maurice Denis, cat. no. 71. Traveled to Musée de Lyon, May–June, 1939. San Francisco, 1947, cat. no. 113, p. 67, illus. The Art Institute of Chicago, *Cézanne, Paintings, Watercolors and Drawings*, February 7–March 16, 1952, catalogue with introduction by Theodore Rousseau and text by Daniel Catton Rich and Patrick T. Malone, cat. no. 92. Traveled to The Metropolitan Museum of Art, New York, April 1–May 16, 1952. Washington, D.C., The Phillips Collection, *Cézanne, An Exhibition in Honor of the Fiftieth Anniversary of The Phillips Collection*, February 27–March 28, 1971, catalogue with text by John Rewald and Duncan Phillips, cat. no. 81, p. 109, illus. Traveled to The Art Institute of Chicago, April 17–May 16, 1971; Museum of Fine Arts, Boston, June 1–July 3, 1971. Newcastle-upon-Tyne, England, Laing Art Gallery, *Watercolors and Pencil Drawings by Paul Cézanne*, September 19–November 4, 1973, catalogue with text by Lawrence Gowing and R. W. Ratcliffe, cat. no. 76. Traveled to Hayward Gallery, London, November 13–December 30, 1973. Brooklyn 1988–89. Brooklyn 1990–91 (exhibited January 15–June 3, 1991).

References Berthold, Gertrude, *Cézanne und die alten Meister*, Stuttgart, 1958, p. 98, no. 133. Bourges, M. R., and A. Chappuis, *Cézanne en son atelier*, Aix-en-Provence, 1977, unpaginated. The Brooklyn Museum, *The Brooklyn Museum Handbook*, Brooklyn, 1967, pp. 400–401. Chappuis, Adrien, *The Drawings of Paul Cézanne, A Catalogue Raisonné*, Greenwich, Connecticut, 1973, 2 vols., vol. 1, p. 229, vol. 2, illus. no. 990. Cogniat,

Raymond, *Le Siècle des impressionistes*, Paris, 1959, p. 82. Gasquet, Joachim, *Cézanne*, 1930, p. 160. Jewell, E. A., *Paul Cézanne*, New York, 1944 (Wiesbaden and Berlin, 1954), illus. Klingsor, Tristan, *Cézanne*, Paris, 1923, illus. pl. 38. Murphy, Richard, *The World of Cézanne 1839–1906*, New York, 1968, p. 132. Neumeyer, Alfred, *Cézanne Drawings*, New York, 1958, p. 41, no. 19. Venturi, Lionello, *Cézanne, son art, son oeuvre*, Paris, 1936, 2 vols., vol. I, cat. no. 1457, vol. II, p. 374, illus.

24 *Étude d'arbres* (*Study of Trees and Rocks*) (verso, *Study of Trees*), 1890–95

Pencil and watercolor on wove paper (recto); pencil (verso), 19½ x 12⅝ (49.0 x 32.0)

39.16, Carll H. De Silver Fund

Provenance Collection R. Stroelin, Lausanne; Sale, Gutekunst & Klipstein, Bern, 1939; Museum Purchase, 1939.

Exhibitions Brooklyn 1962. Pasadena Art Museum, *Cézanne Watercolors*, November 10– December 10, 1967, catalogue with text by John Coplans, cat. no. 29, p. 46, illus. College Park 1977, fig. 18. Brooklyn 1988–89.

References Rewald, John, *Paul Cézanne: The Watercolors*, New York, 1983, p. 185, cat. no. 406.

This large pencil study of a statuette of *L'Amour* is exceptional for its size and finish, and because it is an exact study for a major still-life painting, *L'Amour en Plâtre* (circa 1895) in the Nationalmuseum, Stockholm.[2] Unlike the many pencil studies after masterpieces of sculpture in the Louvre, drawn from the antique or from Michelangelo, Puget, Pigalle, and Houdon, among others, and which were not used directly in any paintings, the statuette in The Brooklyn Museum drawing had a special significance for the artist. The plaster cast of *L'Amour* (previously thought to be by Puget but now attributed to Francois de Quesnoy) that was used for this study belonged to Cézanne and is still in his studio in Aix-en-Provence.[3] This same plaster cast was also the subject of four watercolors, three oils, and ten other drawings by the artist.[4]

Although Cézanne's watercolor *Study of Trees and Rocks* was not a study for a particular painting, his oil paintings of the period recall the extraordinary technique exemplified by this work. Thin, transparent, and diluted strokes of color were laid down sparingly over a pale, sketchy pencil drawing, allowing the remaining negative spaces of white paper to emerge as the positive three-dimensional shapes of rocks and foliage. Barely defined and hardly differentiated from each other, rocks rise up into trees in an almost abstract pattern.

Cézanne did not make distinctions of importance among oil paint, watercolor, or pencil, but "found in them . . . different avenues to self-expression, . . . dissimilar means to achieve the conquest of his relentlessly pursued *sensations*."[5] LKK

1 Rewald 1983, p. 19.

2 Venturi 1936, no. 707.

3 A photograph of the statuette as it appears today, taken by John Rewald, can be found on p. 227 of Rewald 1983.

4 Rewald 1983, nos. 556–58 and 560; Venturi 1936, nos. 711, 1608, and 1609; Chappuis 1973, 980 bis–989.

5 Rewald 1983, p. 19.

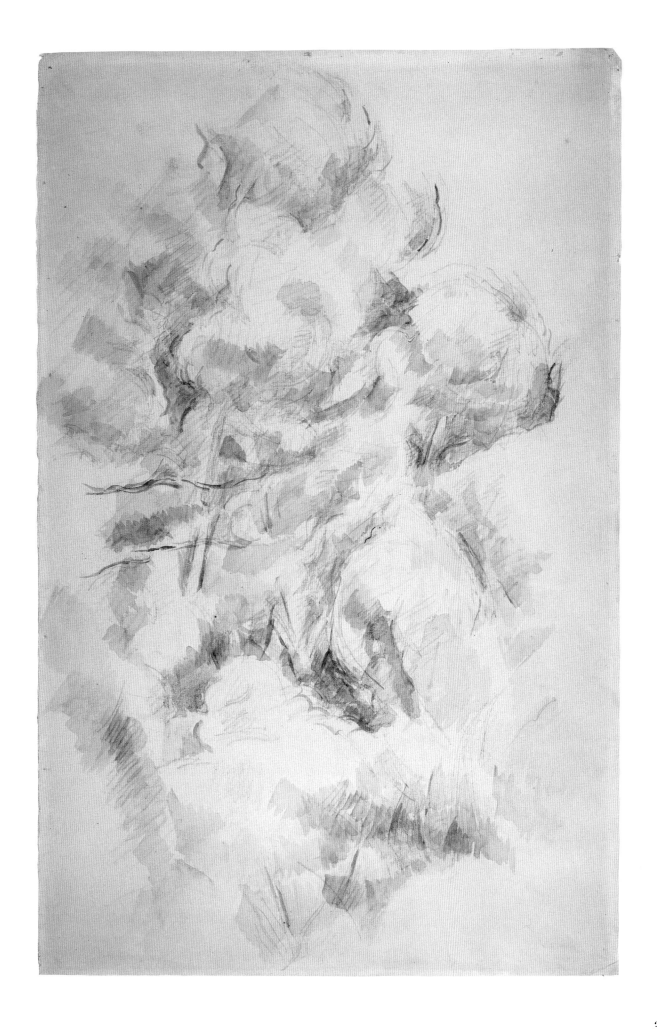

39

Nicolas Toussaint Charlet
1792–1845

25 *Bonaparte aux Tuileries,*
undated

Pencil and watercolor on heavy wove paper, 9¹⁵⁄₁₆ x
6¾ (25.2 x 17.1); signed in lower center

29.234, Bequest of Marion Reilly

Provenance Collection Marion Reilly, Bryn
Mawr, Pennsylvania; Bequest of Marion Reilly,
1929.

Exhibitions Brooklyn 1969. Brooklyn 1988–89.

See cat. no. 15.

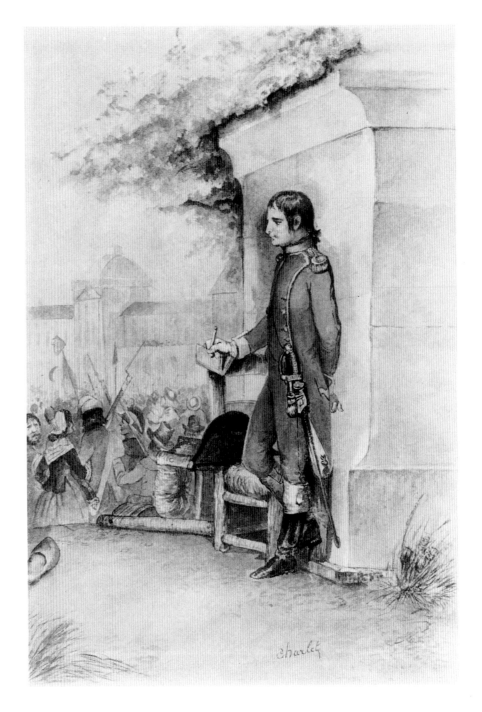

Théodore Chassériau
1819–1856

CHASSÉRIAU was a student of Ingres who, like his teacher, is particularly admired for his fine pencil portraits. These two drawings are especially significant because they are portraits of close friends of the artist. John S. Newberry, who donated the portrait of Mme Monnerot to The Brooklyn Museum so that the two works could be together, thought they were portraits of husband and wife,[1] but we now know them to be of mother and son.[2] Mme Monnerot, née Lucia Victoire du Tourolles, was the mother of Jules Monnerot. Her portrait is dated 1839, whereas that of Jules, who was clearly a young man at the time the portrait was made, is dated 1852.

According to a letter written in 1893 by Jules's sister, the comtesse de Gobineau, née Clémence Monnerot, her family became acquainted with the Chassériaus in the 1830s. Jules was a close friend of Théodore's, and Clémence was an intimate of Théodore's two sisters. From 1837 to 1840, Chassériau spent every evening at Clémence's mother's house;[3] the date of 1839 is therefore a logical one for the portrait of Mme Monnerot. The dedication "a mon ami Jules" indicates that it was a gift from the artist to his friend.

Stylistically these works lie somewhere between the fine, classical, slightly cool touch of Ingres and the expressive technique of Delacroix. The warmth of both portraits conveys intimately the personalities of the artist's close friends. The portrait of Mme Monnerot suggests the charm and directness of this rather severe but kindly woman, who looks full face at the artist while seated at home. The three-quarter view of Jules Monnerot, on the other hand, describes the subject's rather impish and lively expression with the sure hand of a mature and sophisticated artist.

These two drawings span the range of Chassériau's professional career. The portrait of Mme Monnerot is an early example of his mature work; that of Jules was drawn four years before the artist's death at the age of thirty-seven. LKK

1 Newberry 1950, p. 161.
2 Sandoz 1986, nos. 7, 47.
3 Léonce Bénédite, *Théodore Chassériau, Sa Vie et son oeuvre*, Paris, 1931, p. 101.

26 *Portrait de Madame Monnerot,* 1839

Pencil on wove paper, 10¼ x 8¼ (26.0 x 20.9); signed and dated in pencil in center right, "a mon ami Jules/Th. Chassériau 1839"

58.163, Gift of John S. Newberry, Jr.

Provenance Collection Monnerot Family; Collection Mme Serpeille de Gobineau, Paris; Jacques Seligmann, New York; Collection John S. Newberry, Jr.; Gift of John S. Newberry, Jr., 1958.

Exhibitions Paris 1933, cat. no. 230. The Detroit Institute of Arts, *Fifty Drawings from the Collection of John S. Newberry, Jr.*, June 1–September 6, 1949, catalogue with introduction by John S. Newberry, Jr., cat. no. 7, p. 14, illus. Detroit 1950, cat. no. 42, illus. The Brooklyn Museum, *Twelve Years of Collecting Drawings and Prints; 1953–1965*, June 21–December 26, 1965. Brooklyn 1988–89.

References Brooklyn 1988, p. 184, no. 137A. *The Brooklyn Museum Bulletin* (Winter 1960), vol. 21, p. 40, illus. p. 33. Paris, Musée du Louvre, *Exposition d'une selection de dessins de la collection Bonnat*, Paris 1979, no. 2. Newberry 1950. Sandoz 1986, p. 19, no. 7, illus.

27 *Portrait de Jules Monnerot,* 1852

Pencil on wove paper, 9½ x 7⅞6 (24.1 x 18.9); signed and dated in pencil in lower left, "a mon ami Jules/Th. Chassériau 1852"

39.622, Frank L. Babbott Fund

Provenance Collection Monnerot Family; Collection Mme Serpeille de Gobineau, Paris; Jacques Seligmann, New York; Museum Purchase, 1939.

Exhibitions Paris 1933, cat. no. 229. San Francisco 1947, cat. no. 64. Newark 1961, cat. no. 7, illus. Brooklyn 1969. Brooklyn 1988–89.

References Brooklyn 1988, p. 185, no. 137B, illus. Newberry 1950. Sandoz 1986, p. 61, no. 47, illus.

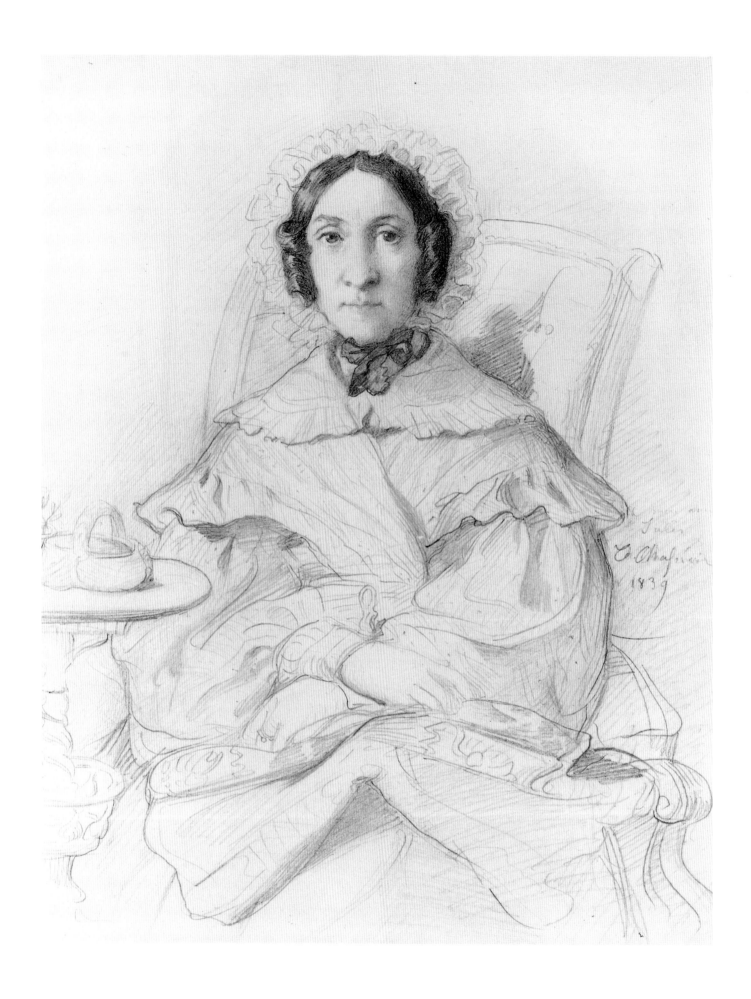

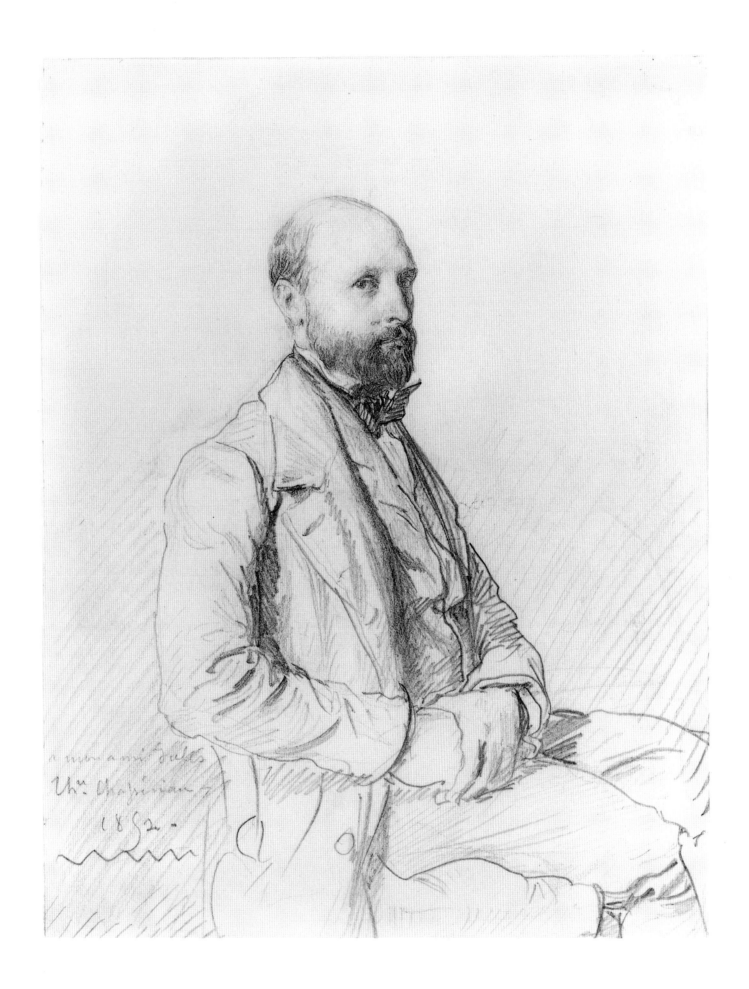

à mon ami Jules
Th. Chassériau
1852

43

Jean-Baptiste Camille Corot
1796–1875

28 *Saules et peupliers blancs* (*Willows and White Poplars*), 1865–72

Crayon and pencil on wove paper, 9⅞ x 15 (25.0 x 38.0); signed in pencil in lower left

42.227, Henry Batterman Art Fund

Provenance Collection Quincy Adams Shaw, Boston; I. Podgoursky, Boston; André Seligmann, Inc., New York; Museum Purchase, 1942.

Exhibitions New York 1953, cat. no. 37. New York, Charles E. Slatkin Gallery, *French Master Drawings, Renaissance to Modern*, February 10–March 7, 1959, cat. no. 82. The Art Institute of Chicago, *Corot 1796–1875*, October 6–November 13, 1960, catalogue with text by S. Lane Faison, Jr., and James Merrill, cat. no. 165. Minneapolis 1962, cat. no. 20. Boston 1963, cat. no. 20, p. 97, illus. Brooklyn 1988–89.

References Shoolman, Regina, and Charles E. Slatkin, *Six Centuries of French Master Drawings in America*, New York, 1950, p. 133, pl. 79. Tietze, Hans, *European Master Drawings in the United States*, New York, 1947, p. 266, cat. no. 133, illus.

WILLOWS AND WHITE POPLARS closely resembles the lithograph by Corot of the same title, dated 1871.[1] The drawing was probably executed after the print: if the print had been executed from the drawing, it would have been reversed in the printing process, yet both have the same orientation; moreover, the lithograph possesses a freer line than the drawing even though they share much the same lines and details.

This drawing, typical of many of Corot's landscapes, depicts a tranquil scene of willows and poplars—trees he knew intimately from his family home in Ville d'Avray—complemented by a barely perceptible river and a small boat. Also characteristic are the figures embedded in the landscape on a miniature scale, enhancing the power of the towering trees.

By the late 1860s, Corot's drawings had evolved from the precisely rendered, classically detailed landscapes of his youth, influenced by Pierre-Henri de Valenciennes (1750–1819), to a looser, impressionistic style that marked his growing use of the qualities of a sketch in a finished work of art. The Museum's landscape is an apt demonstration of how Corot's career spanned the century, representing trends in landscape painting of both halves of the 1800s. Corot chose a traditional composition, with horizontal registers of clearly defined foreground and background, bordered by tall trees on both sides, and incorporating a winding river leading the eye from one register to another. At the same time, he rendered the landscape with loosely drawn lines. He varied texture, shadow, and form by simply changing the angle or pressure of his pencil. Corot combined artistic conventions, verisimilitude, and new atmospheric effects to produce his own classical landscape: a timeless composition evoking the ephemeral quality of nature. KZ

1 Loys Delteil, *Le Peintre graveur illustré*, Paris, 1923, vol. 1, Delteil 30.

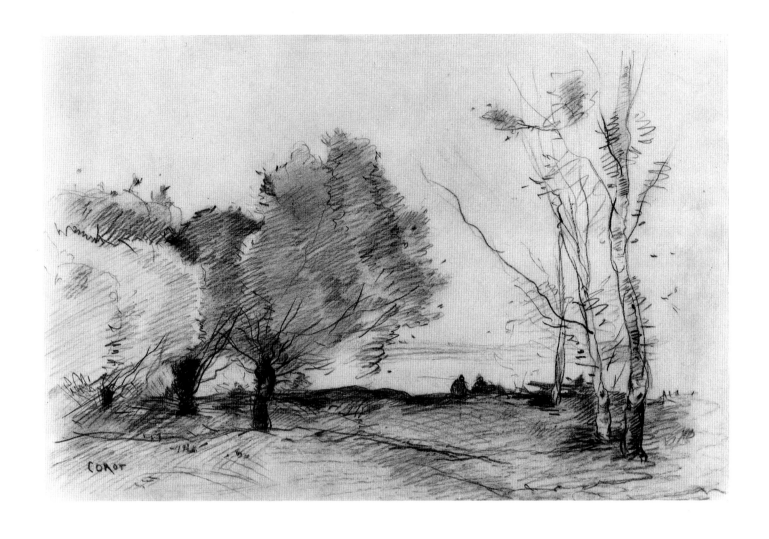

Henri-Edmond Delacroix Cross
1856–1910

29 *Surf*, undated

Watercolor and charcoal on wove paper mounted on paper, 6¹¹⁄₁₆ x 9¾ (17.0 x 24.8); signed in lower left, "HE. C"

20.660, Gift of Hamilton Easter Field

Provenance Collection Hamilton Easter Field, Brooklyn; Gift of Hamilton Easter Field, 1920.

Exhibitions Brooklyn 1922–23, cat. no. 151. Brooklyn 1988–89. Brooklyn 1990–91 (exhibited January 15–June 3, 1991).

IN THE LATER YEARS OF HIS CAREER, Henri-Edmond Cross used watercolor as much for recording observations as for finished works. The heavy use of pencil in the Museum's drawing suggests that it is a study, although it could also be an underdrawing for a watercolor.[1] The landscape is most likely one of the artist's many views of the Provençal coast, perhaps Antibes or Cap Nègre from yet another perspective.

The aesthetic of Cross's watercolors from the 1890s on differs from the Neo-Impressionist style of most of his work. Writing about his own art, he identified watercolor as a release from oil painting: "The absolute need to be speedy, bold, even insolent brings to the work a type of beneficial fever, after months of languor passed on paintings."[2]

In Brooklyn's watercolor one can see how Cross organized his landscapes through the repetition of line and color. Especially at the end of his life, he became obsessed with the conflict between nature's beautiful "details" and the organization of the sensations it stimulates—the struggle between the ecstasy and emotion that the landscape stirred in him and the emphasis on structure and order of his Neo-Impressionist circle. In this light sketch, he conveys the wildness of the waves and the power of the wind whipping through the shore reeds with the same pattern of varied line and tone with which he orders the composition. KZ

1 In many finished watercolors, underdrawing of pencil and wash similar to the technique of the Museum's drawing can be seen. See for instance *Landscape in the South of France Seen through Trees* (The Metropolitan Museum of Art, New York).

2 Isabelle Compin, *Henri Edmond Cross*, catalogue raisonné, Paris, 1964, p. 68. Author's translation.

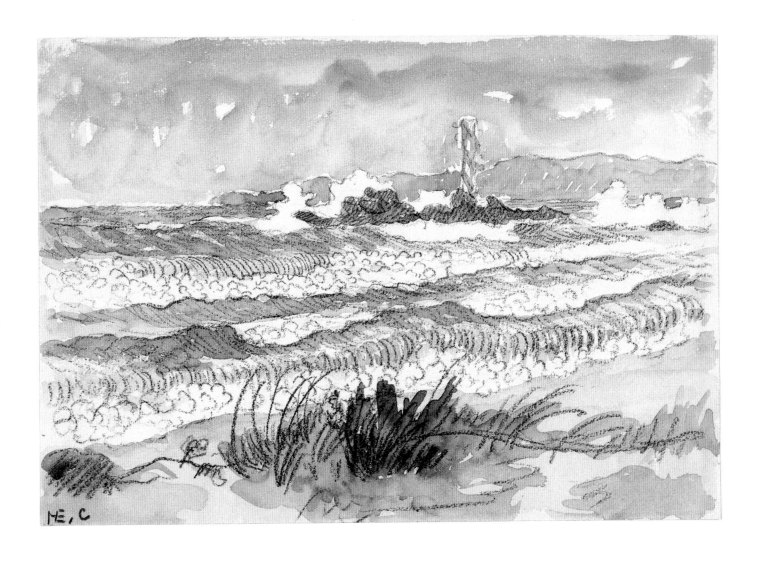

ME, C

47

Louis-Robert de Cuvillon
1848–1931

30 *Renaissance Woman Reading a Letter,* 1886

Watercolor on illustration board, image, 10 1/16 x 7 11/16 (25.5 x 19.5); sheet, 12 5/8 x 10 (32.0 x 25.4); signed and dated in lower right

06.325, Bequest of Caroline H. Polhemus

Provenance Collection Caroline H. Polhemus, Brooklyn; Bequest of Caroline H. Polhemus, 1906.

Exhibitions Brooklyn 1988–89.

References Goodyear 1910, cat. no. 112, p. 24.

31 *Harem Woman with Ostrich Fan,* 1892

Watercolor on illustration board, 10 13/16 x 7 5/8 (27.5 x 19.4); signed and dated in lower left

06.327, Bequest of Caroline H. Polhemus

Provenance Collection Caroline H. Polhemus, Brooklyn; Bequest of Caroline H. Polhemus, 1906.

Exhibitions Brooklyn 1988–89.

References Goodyear 1910, cat. no. 114, p. 24.

V ERY LITTLE IS KNOWN of Louis-Robert de Cuvillon beyond the fact that he was born of a titled family in Paris, studied with Alexandre-Louis Leloir, and was a longtime participant in the Salons des Aquarellistes. He also showed in 1877 and 1881 at the Société des Artistes Françaises, and at the Exposition Universelle of 1900, but his medium was always watercolor. The two watercolor figure studies in the Brooklyn collection could well serve as illustrations of the very different types of exoticism that were popular in the last decades of the nineteenth century. *Renaissance Woman* takes the viewer into an ideal past of innocence and harmony; de Cuvillon uses his naturalistic techniques to depict the period costume in charming detail, and places the figure in a setting of wildflowers based on the similar meadows of Jules Bastien-Lepage (1848–1884), whose influence was at its

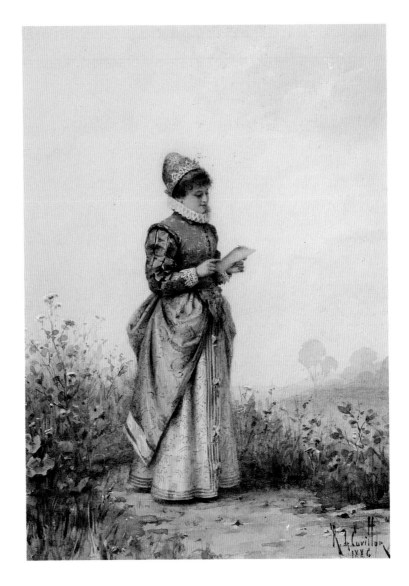

height in the mid-1880s. *Harem Woman*, on the other hand, represents a faraway world of the present: the mysterious Middle East, with its easily fantasized sultans and harems. The watercolor is typical of the popular imagery of this period in its combination of veiled and overt sexuality. The closest thing to a harem that a Parisian could have imagined would be a brothel, and indeed the woman here is depicted with the pose and gaze of a professional. As in the other painting, the costume, in this case North African, is depicted in careful detail, with great mastery of the watercolor medium. Two works by de Cuvillon that use the same models as the Brooklyn pieces appeared recently on the auction market: *Harem Woman with Ostrich Fan*, in which the model has a different costume and raises the fan above her head;[1] and a work called *A Quiet Moment*, in which the Renaissance model in the same costume is seated in a meadow, joined by a male companion.[2]　SF

1　Sale catalogue, Sotheby's, New York, December 5, 1988, no. 102.
2　Sale catalogue, Christie's, New York, March 1, 1984, no. 337.

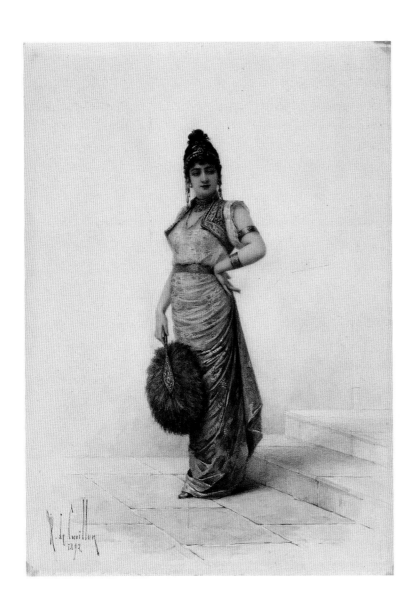

32 *Tête de vieille femme de profil à gauche* (recto), *Étude de têtes* (verso), (*Head of an Old Lady in Profile* [recto], *Study of Heads* [verso]), late 1850s

Conté crayon on wove paper (recto); pen and ink over conté crayon (verso), 5⅛ x 7 (13.0 x 17.8); signed in ink in lower right on recto, "h.D."

40.527.A,B, Carll H. de Silver Fund

Provenance Collection Paul Bureau; Sale, Galerie Georges Petit, Paris, May 20, 1927, p. 40, no. 49; Collection Jerome Stonborough; Sale, Parke-Bernet Galleries, New York, October 17, 1940, no. 42; Museum Purchase, 1940.

Exhibitions Paris, École des Beaux-Arts, *Exposition Daumier*, May 1901, catalogue with text by Gustave Geffroy, cat. no. 162 (*Une Vieille Femme*), p. 33. The Brooklyn Museum, *Three Centuries of Drawing*, February–August 1961. Brooklyn 1969. Brooklyn 1988–89.

References Fuchs, Edouard, *Der Maler Daumier*, Munich, 1930 (second edition), p. 18, pl. 21, illus. Klossowski, Erich, *Honoré Daumier*, Munich, 1923 (second edition), p. 114, cat. no. 302B (*Une Vieille Femme*). Laughton 1991, p. 110, illus. 7.24 (verso). Maison 1967, vol. 2, pp. 65, 70, pl. 39 (recto), pl. 35 (verso). Passeron, Roger, *Daumier/ Témoin de son temps*, Fribourg, 1979, p. 170, illus. (verso).

THE BROOKLYN MUSEUM's double-sided drawing by Honoré Daumier illustrates the power and poignancy of the artist's swift, economical line.

The verso of the Brooklyn drawing, often associated with the studies of third-class carriage travel that Daumier made around the 1860s, is more likely an unidentified study of his favored composition of a group of figures cropped at the bust.[1] In his studies of railway-car travelers, theatergoers, and actors, Daumier rearranged the overlapping heads and shoulders, repeating shadows or faces to tighten or loosen the space for varied effects—from a forlorn sense of impoverished existence to an amusing evocation of urban life. In the Brooklyn study, Daumier started to depict anatomy and space just with shadow, maintaining an ephemeral quality that creates an eerie, even mournful rhythm of sullen physiognomy. He then used ink to give the figures at left and center expression, either comic or bitingly forlorn. Lacking the details of caricature, the grouping has an air of anonymity and despair rather than the wit or irony that usually balances Daumier's social satire.

The study of a head of an old woman seen in profile, on the other side of the sheet, is similar to other studies by Daumier of hunched-over crones.[2] The drawing has an element of the same anonymous despair seen on the other side, but here it is tempered by the heavy ink line, which provides a greater degree of finish and accents the caricatural air of the pointy nose and gooselike neck. KZ

1 His watercolors and paintings of judges, actors, and audiences leaving the theater, for example, share the same composition.

2 Maison 1967, cat. nos. 186, 191–92.

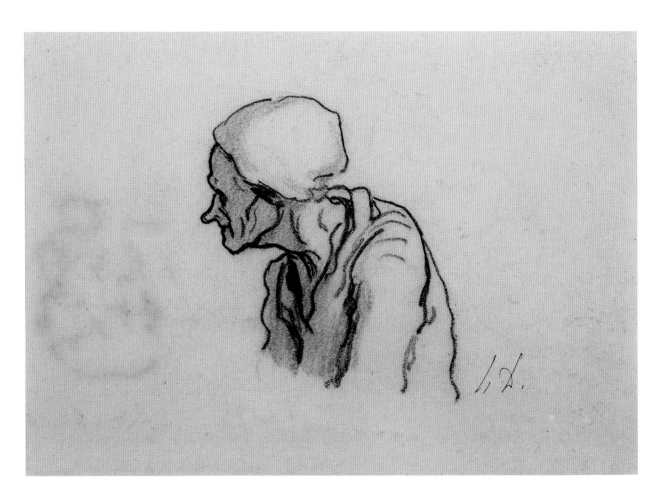

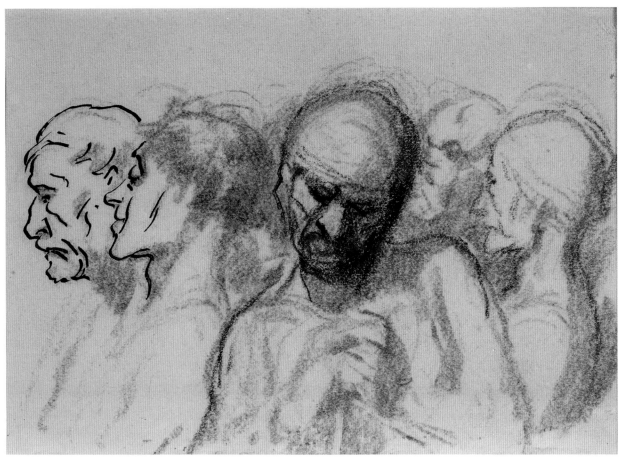

51

Alexandre-Gabriel Decamps
1803–1860

33 *Fuite en Égypte (The Flight into Egypt)*, 1850–53

Watercolor on wove paper mounted on paperboard, 11¼ x 16 (28.5 x 40.8); signed in lower right

22.86, Gift of Frank L. Babbott

Provenance Collection Frank L. Babbott, Brooklyn; Gift of Frank L. Babbott, 1922.

Exhibitions The Art Institute of Chicago, *Seventh International Watercolor Exhibition*, 1927. Williamstown 1984, cat. no. 41, pp. 55–56, illus. Brooklyn 1988–89.

References Mosby 1977, cat. no. 69.

Decamps's *Flight into Egypt*, executed late in his life, encompasses all of the artist's interests and ambitions throughout his career: a biblical or "historical" subject, a Middle Eastern landscape and costume, and a vast landscape. Although Decamps treated this subject two other times in oil, neither of those compositions shares the specific Middle Eastern landscape or eerie setting seen here.[1] Stark and silent, pyramids and sand dunes loom in the exaggeratedly distant and vast setting.

The work, dated 1850–53, was executed during a period when Decamps began to paint less because he was intermittently fighting illness and depression.[2] Most of his works from this period are biblical subjects of increasingly stark composition.

Decamps, one of the first artists to travel to Asia and North Africa, used his observations to place his paintings of religious or historical narrative in more believable settings.[3] This fusion of "real life" observations of the Middle East with biblical subject matter and classical elements was a valued characteristic of Decamps's work even in his own time, and it constituted a new approach to religious scenes. It also reflects the orientalist view of the time, which regarded the East as a historical landscape, remaining as it had been in an earlier century. In his Salon review of 1846, Charles Baudelaire praised Decamps for his ability to "capture nature in the very act, in her simultaneous moments of fantasy and reality." He found Decamps's compositions "full of poetry, and often of reverie . . . achieved by intimacy of detail."[4]

Although Decamps began his career as a painter of orientalist scenes, he sought, like most artists of his time, to establish himself as a history painter—then the most highly regarded category, deemed worthy of monumental commissions. Despite his ambitions and attempts to gain such status, he never concerned himself with a proper classical art education or the use of classical composition. Elements he developed in his early landscape and genre work, however, continued to play a large role in his compositions—even in those of elevated subject matter, of which this watercolor is a prime example. Although spare, the rocky landscape and its warm yellow-brown tones dominate the composition, with figures embedded in a depression between foreground and background, and only the Virgin's dark robe standing out against the desert. The composition is broken by an acute angle formed by the shadow diagonals of the sand hills in the foreground and middle ground.

Decamps used the same saturated hues in his oil paintings, which have thick layers of pigment. The use of color here also reflects the influence of the watercolors of Richard Parkes Bonington, Eugène Delacroix, and

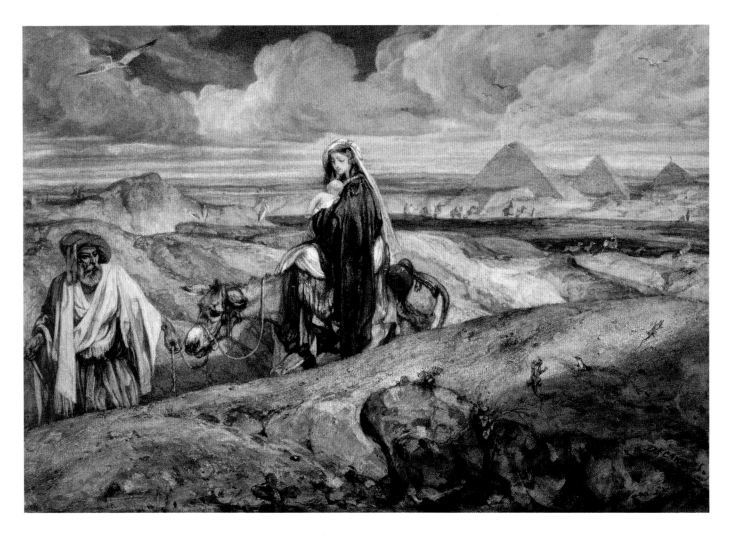

Paul Huet, which were highly regarded during Decamps's time. Despite the Middle Eastern garb, the figure of the Virgin also reveals Decamps's respect for Raphael's art, an influence frequently noted by the nineteenth-century critics. KZ

1 One oil is in the Ackland Art Center Collection, Chapel Hill, North Carolina, dating from circa 1856–57, and the location of the other painting, dated 1846, is unknown.

2 Mosby 1977, vol. 1, p. 239. According to Mosby's catalogue of Decamps's work, the artist moved to Fontainebleau in 1853 but apparently had no contact with other artists working there.

3 Decamps traveled to the Middle East in 1828.

4 Charles Baudelaire, "Salon of 1845," in *Art in Paris 1845–1862*, trans. by Jonathan Mayne, Oxford, 1981, p. 9, and "Salon of 1846," p. 74.

Hilaire-Germain-Edgar Degas
1834–1917

34 *Femme s'essuyant les cheveux (Woman Drying Her Hair)*, circa 1889

Pastel and pencil on brown wove paper mounted on board, 33⅛ x 41½ (84.1 x 105.4)

21.113, Museum Collection Fund

Provenance Atelier Degas; Sale I, Galerie Georges Petit, Paris, May 6–8, 1918, no. 250; Galeries Durand-Ruel, Paris; Jacques Seligmann, Paris; Sale, American Art Association, New York, January 27, 1921, no. 54; Museum Purchase, 1921.

Exhibitions Brooklyn 1921, cat. no. 73. Brooklyn 1922–23, cat. no. 160. Brooklyn 1924–25, cat. no. 89. The Brooklyn Museum, *Leaders of American Impressionism*, October 17–November 28, 1937, catalogue with text by John I. H. Baur, cat. no. 1. Brooklyn 1944–45. Newark 1948. Brooklyn 1988–89. Brooklyn 1990–91.

References Faunce, 1982, illus. p. 280. Lemoisne 1946, vol. III, cat. no. 953. Tschudy 1932, p. 194, illus. Wegener 1954.

35 *Danseuses (Dancers)*, circa 1900

Charcoal touched with white chalk and Chinese white on brown laid paper, 18⅞ x 24¹³⁄₁₆ (48.0 x 63.0)

37.3, Gift of the Rembrandt Club

Provenance Atelier Degas; Sale III, Galerie Georges Petit, Paris, April 7–9, 1919, no. 375; Galeries Durand-Ruel, Paris; Durand-Ruel Galleries, New York, January 23, 1920; Gift of the Rembrandt Club, 1937.

Exhibitions New York, Durand-Ruel Galleries, *Exhibition of Pastels and Drawings by Degas*, March 11–27, 1920, cat. no. 29. New York, Durand-Ruel Galleries, *Exhibition of Drawings by Constantin Guys, Puvis de Chavannes, Degas, Cassatt, André and Others*, February 1–13, 1930, cat. no. 35. The Brooklyn Museum, *Nineteenth-Century Drawings*, February–March 1938. The Brooklyn Museum, *Examples from the Work of Edgar Degas, Mary Cassatt's Friend and Mentor*, Summer 1946. Washington, D. C., The Phillips Memorial Gallery, *Degas*, March 30–April 30, 1947. Brooklyn 1962. Brooklyn 1969. Brooklyn 1988–89.

References Browse, Lillian, *Degas Dancers*, London, 1949, p. 411, no. 235. "Degas Drawings Now on Exhibition at Durand-Ruel's," *Art News* (Saturday, December 28, 1935), pp. 5, 12.

THE THREE DRAWINGS by Edgar Degas in The Brooklyn Museum's collection are all examples of the artist's interest in working method and unguarded movement. The charcoal study of three poses of a dancer, though not linked with a specific painting, reflects his many studies of dancers as they dress, rehearse, and perform. The three figures, at various stages of articulation, illustrate Degas's ceaseless study of the effect of even small changes in line and color on a pose, space, and mood. The pose at the upper left is the most worked sketch. The shading on the skirt, arms, and head gives the figure volume and a sense of the space she occupies. The studies of a similar pose at the right and of a dancer facing right and adjusting her hair (below) are more roughly sketched. They reveal a greater concern for the attitude, how the dancer moves into that pose, and where the dancer can move from it. Although Degas's dancers are often noted for their awkward movement, these three delicate figures possess grace and litheness in their slender frames. The anonymous faces give each a silence and composure, as well as the intense concentration one would expect of a young dancer. Seemingly independent studies, the three drawings compose a soft, rhythmical pattern with a surprising unity.

Degas employed radical techniques in his drawings, especially later in his career. Pinholes at the edges of this drawing indicate that at some point it was probably attached to a stretcher, a frequent device of the artist's, often used in combination with the addition to, or cropping of, the sheet.[1] Such techniques underline Degas's high regard not only for draftsmanship, but also for the drawing itself—the paper and materials.

Brooklyn's two pastels, part of Degas's series of bathers, are extremely close in pose, both depicting women drying their hair. Degas's repeated examinations of the same pose of about 1890–1900 often began with the tracing of another drawing. At this time, too, Degas's drawings became increasingly abstract, with less attention to the towel, tub, or "props," as

he reduced and simplified settings. Hatching often followed the body and adopted an ornamental life of its own, adding to the sense of abstract or ambiguous space.[2] This is particularly apparent in the later pastel, *Seated Nude Woman Drying Her Hair.* In the earlier pastel, one can also see how Degas manipulated the space and composition by adding strips at the top and bottom to enlarge the composition and alter the perspective. In both works, as in the charcoal drawing, Degas worked on different parts of the composition to varying degrees. He was interested not only in the process itself, but also in revealing the process, and the insights glimpsed along the way, to others. KZ

1 The lighter perpendicular lines, making a cross through the drawing's center, indicate the placement of the stretcher.

2 Jean Sutherland Boggs, "1890–1912," in *Degas*, exhibition catalogue, The Metropolitan Museum of Art, New York, 1988, pp. 599–601.

36 *Femme nue assise s'essuyant les cheveux (Seated Nude Woman Drying Her Hair)*, circa 1902

Pastel on wove paper mounted on board, 25¼ x 27½ (64.2 x 69.9); signed in lower left

54.54, Gift of Mrs. Leo Smith

Provenance Atelier Degas; Sale II, Galerie Georges Petit, Paris, December 11–13, 1918, no. 66; Ambroise Vollard, Paris; Collection Mrs. Leo Simon, New York; Gift of Mrs. Leo Simon, 1954.

Exhibitions The Brooklyn Museum, *French Impressionists from the Museum's Collection*, October 4, 1953–January 2, 1954. Brooklyn 1988–89.

References Lemoisne 1946, vol. III, cat. no. 1413, illus. p. 813. Rosenblum, Robert, "Varieties of Impressionism," *Art Digest* (October 1, 1954), p. 7, illus. Wegener 1954. *The Brooklyn Museum Bulletin* (Spring 1954), vol. 15, no. 3, illus. on cover.

35

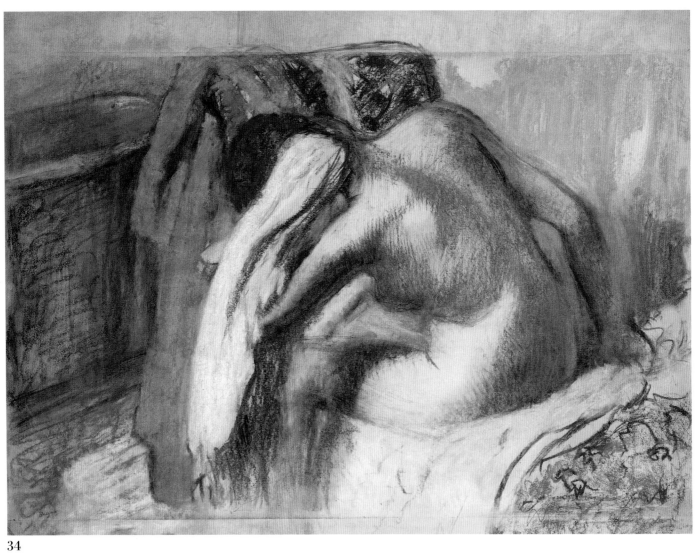

34

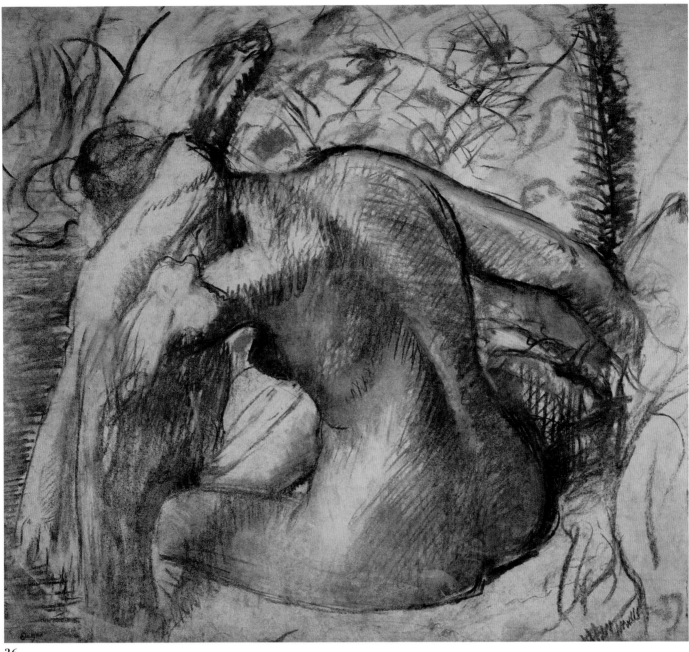

36

Auguste Delacroix
1809–1868

37 *Figures on a Boat,* 1843
Watercolor on wove paper, 5⁵⁄₁₆ x 8 (13.5 x 20.3);
signed and dated in brown in lower left, "A.
Delacroix/1843"

33.280, Gift of Cornelia E. and Jennie A.
Donnellon

Provenance Collection Cornelia E. and Jennie
A. Donnellon, New York; Gift of Cornelia E.
and Jennie A. Donnellon, 1933.

Exhibitions Brooklyn 1988–89.

AUGUSTE DELACROIX was born and died in Boulogne-sur-Mer, on the coast of the English Channel, and was known primarily as a painter of marine subjects. He showed oils and watercolors at the Salon from 1835 to 1865. After 1850 he showed some North African pictures, reflecting the trip he took to Morocco in that year. In addition to views of the Channel coast and harbor, he painted genre scenes of the working life of the fishing villages along the shore south of Boulogne. This stretch of France's northeastern coastline, from Dunkirk down to Dieppe, had been given brilliant pictorial form in the 1820s by Richard Parkes Bonington, working especially in watercolor. Delacroix would undoubtedly have known his work from a publication such as *Excursions sur les côtes et dans les ports de France,* the first of the *Voyage pittoresque* publications to focus on this region, later to become such a magnet for artists. Bonington was clearly a model for this modest painter; his influence is apparent in the pale transparency of the waves and the distant boat, as well as in the generally open and luminous use of the watercolor medium. Unlike Bonington but like most of his own contemporaries, Delacroix seems more comfortable with an anecdotal subject, in this case the interest of the attentive little cat in the contents of the man's handsome delft bowl. A salient feature of the picture is the stack of round, solid barrels— whether containing wine, cider, ale, or salted fish, it is impossible to tell —that have occasioned the boat's voyage. SF

Jean-Louis Forain
1852–1931

38 *Le Bar aux Folies-Bergère,*
1878

Gouache on wove paper, 12½ x 7¾ (31.8 x 19.7); signed and dated in lower right, "A Sari/bien cordialement/8 janvier 1878/Forain"

20.667, Gift of a friend

Provenance Collection Roger Marx, Paris; Sale, Galerie Manzi, Paris, May 11–12, 1914, no. 140; Collection Frank L. Babbott, New York; Gift of a friend, 1920.

Exhibitions Ann Arbor, The University of Michigan Museum of Art, *The Crisis of Impressionism: 1878–1882*, November 2, 1979– January 6, 1980, catalogue with text by Joel Isaacson, with the collaboration of Jean-Paul Bouillon et al., cat. no. 19, p. 102, p. 103, illus. Brooklyn 1988–89. Brooklyn 1990–91 (exhibited September 14, 1990–January 15, 1991). Boston, Museum of Fine Arts, *Pleasures of Paris: Daumier to Picasso*, June 5–September 1, 1991, catalogue with text by Barbara Stern Shapiro with essays by Susanna Barrows, Phillip Dennis Cate, and Barbara K. Wheaton, cat. no. 137, illus. Traveled to IBM Gallery of Science and Art, New York, October 15– December 28, 1991.

References Browse, Lillian, *Forain: The Painter*, London, 1978, pp. 24, 96, p. 118, illus. Faxon, Alicia, *Jean-Louis Forain: Artist, Realist, Humanist*, Washington, D.C., 1982, p. 16, illus. New York, The Museum of Modern Art, *Henri de Toulouse-Lautrec, Images of the 1890s*, exhibition catalogue, 1985, p. 54, illus. Reff, Theodore, *Manet and Modern Paris*, Chicago and London, 1982, exhibition catalogue for the National Gallery of Art, Washington, D.C., December 5, 1982–March 6, 1983, p. 97, illus. fig. 50. Tschudy 1932, p. 95, illus.

After training in the studio of Carpeaux and subsequently with the noted caricaturist André Gill, Forain entered the Parisian art scene in the early 1870s, primarily as a draftsman and illustrator. His work as illustrator for Rimbaud and Huysmans led to further acquaintance with the circle of advanced artists that included Degas and Manet. Forain admired the work of both painters, whose concern for the depiction of modern life had led them to the study of the world of cafés and popular entertainment in Paris. Degas in turn responded to the young Forain's lively gifts as a popular illustrator, and invited him to exhibit at the fourth Impressionist exhibition in 1879. There Forain showed one oil and a large number of watercolors. One of these, entitled *Femme au café*, is thought to have probably been the Brooklyn gouache.[1] Our work appeared in the Roger Marx sale of 1914 with the title *Le Bar aux Folies-Bergère*. By 1920, the year of its donation to the Museum, it had lost its specific title and was known simply as *Café Scene*. In recent years, however, the site depicted has been recognized as the bar of the Folies-Bergère, which in the late 1870s, during the recovery following the Franco-Prussian War, was approaching the height of its popularity. The identification is further supported by the artist's inscription at the bottom right to Sari, who was the successful director of the Folies at the time. In the painting we can see the barmaid behind her marble-topped counter with its bottles and compotes, reflected in the large mirror behind her along with the tiered balconies of the theater where the musical entertainments took place. These elements are familiar to us from the composition of Manet's great painting of the same subject, dated 1881–82. Manet of course had firsthand knowledge of the place; but one can assume that Forain's lively little painting, together with novelistic descriptions and popular journal illustrations, had an effect on Manet's conception of the imagery of his last large painting. Forain's gouache is a vivid work, combining the saturation of color usually found in oil paintings with the rapid hatching strokes and calligraphic drawing of watercolor. SF

1 Washington, D.C. 1986, p. 268. The painting was no. 97 in the fourth Impressionist exhibition.

61

Jean Honoré Fragonard
1732–1806

39 *La Première Leçon d'équitation* (*The First Riding Lesson*), circa 1778

Graphite and brown wash on cream antique laid paper, 13¹¹/₁₆ x 17¾ (34.8 x 45.2)

57.189, Gift of Mr. and Mrs. Alastair B. Martin

Provenance Collection Duc de Ch . . .; Sale, Hôtel Drouot, Paris, December 20, 1787, no. 274; Collection M. Le Brun; Sale (anonymous), Paris, July 8, 1793, no. 69; Collection Baron de Silvestre, Paris; Sale, Paris, December 4–6, 1851, no. 258; Collection Hippolyte Walferdin, Paris; Sale, Hôtel Drouot, Paris, April 12–16, 1880, no. 224; Collection Baron Edmond de Rothschild, Paris; Given to his son, Baron Maurice de Rothschild, 1888; Collection Mr. and Mrs. Alastair B. Martin (The Guennol Collection); Gift of Mr. and Mrs. Alastair B. Martin, 1957.

Exhibitions Paris, Galerie Martinet, *Catalogue de tableaux et dessins de l'école français, principalement du XVIIIe siècle tirés de collections d'amateurs*, 1860, catalogue with text by Philippe Burty, cat. no. 8. Paris, Galerie Georges Petit, *Exposition Chardin et Fragonard*, 1907, cat. no. 198. Paris, Jacques Seligmann et fils, *Dessins de Fragonard*, May 9–30, 1931, catalogue with text by Louis Reau, cat. no. 223. Rotterdam 1958, cat. no. 54, illus. pl. 72. Washington, D.C. 1978–79, cat. no. 44, p. 117, illus. Tokyo 1980, cat. no. 29, illus. Paris 1987–88, cat. no. 243, p. 492, illus. Brooklyn 1988–89.

References Ananoff 1961, vol. I, p. 37, cat. no. 12. Brooklyn 1988, pp. 182–83, no. 136, illus. *The Brooklyn Museum Handbook*, Brooklyn, 1967, pp. 378–79. Dayot, Armand, and Leandre Vaillat, *L'Oeuvre de J-B-S Chardin et de J-H Fragonard, deux cent treize reproductions*, Paris, 1908, cat. no. 164, illus. De Goncourt, Edmond and Jules, *L'Art français du dix-huitième siècle*, Paris, 1882, vol. II, p. 374, vol. III, 1906, p. 332. Grappe 1913, vol. 1, p. 1. Mrozinska, M., "Dwa Rysunki J. H. Fragonarda Natematy Z Zycia Rodzinnego Rocznic," Museum Narodowego w. Warszawie (1960), vol. V, p. 10, illus. fig. 2. Nolhac, Pierre de, *J.-H. Fragonard*, Paris, 1906, p. 83. Portalis, Roger de, *Fragonard, sa vie et son oeuvre*, Paris, 1889, 2 vols., pp. 114, 310, 330. Portalis, Roger de, "La Collection Walferdin," *Gazette des Beaux-Arts* (April 1880), vol. 21, p. 313. Reau, L., *Fragonard, sa vie et son oeuvre*, Brussels, 1956, p. 205. Wildenstein, Georges, *Fragonard: Aquafortiste*, Paris, 1956, p. 42.

Тhis work was traditionally thought to have been a depiction of the artist's family, including his son Evariste, who was born in 1780. However, an etching made after it by the artist's sister-in-law, Marguerite Gérard, was recently dated 1778.[1] Moreover, even though the dog appears in other works and may have been a household pet, the faces in the drawing are generalized and not portraits, and the family, unlike Fragonard's, is barefoot and simple. As is often the case with Fragonard's work, this is not a portrait of his family or a simple genre scene, but reaches further "to suggest something timeless and universal."[2] Stylistically this work fits more comfortably with the works of the late 1770s than with those dating to 1780.

Two other versions of this drawing are known. One is now considered to be after Fragonard and the other, much smaller than the Brooklyn drawing, is now in the National Museum, Warsaw.[3] LKK

1 Sarah Wells-Robertson, "Marguerite Gérard, 1761–1837," Ph.D. diss., New York University, Institute of Fine Arts, 1978.

2 Washington, D.C. 1978–79, p. 116.

3 Paris 1987–88, p. 493, figs. 1, 2.

FRAGONARD MADE APPROXIMATELY 160 drawings illustrating the sixteenth-century epic poem *Orlando Furioso*, by Ludovico Ariosto. One hundred thirty-seven of these were in American collections in 1945, when they were published by Elizabeth Mongan, Philip Hofer, and Jean Seznec.[1] The remainder were distributed in European collections.[2] There is no known documentation of these works in the eighteenth century and no evidence of a commission, although editions of *Orlando Furioso* were published in England in 1775 and in Paris between 1775 and 1783. Pierre Rosenberg and Marie-Ann Dupuy suggest the possibility that the artist intended to have the drawings engraved, and postulate that Fragonard may have set about this project in response to criticism of the illustrations in recently published editions.[3] His personal interest in illustrating Ariosto's epic poem may also have derived from his strong affinity for the exuberant style of his Venetian contemporary Tiepolo, whose work he studied and copied assiduously during his visits to Italy in 1761 and 1773.[4]

There is no date firmly established for the series, although Eunice Williams proposes the 1780s, based on stylistic comparisons with other works of the period such as *The First Riding Lesson* of circa 1778 (cat. no. 39). Although the *Orlando Furioso* drawings lack the polish and deliberate execution of that work, she notes that the sense of composition of the series "is certainly that of a mature artist who is graced with rich powers of narrative invention, control over his media, and confidence in his draughtsmanship."[5] To substantiate this late dating, Rosenberg and Dupuy note that in 1879 Théophile, Fragonard's grandson, commented in his reminiscences of his grandfather that in his last twenty-five years Fragonard made the illustrations for the poem "Roland furieux."[6]

Ariosto's *Orlando Furioso* contains forty-six cantos. More than 126 of Fragonard's drawings are of scenes from the first sixteen cantos. The rest of the cantos are thinly illustrated; some have no illustrations at all.[7]

In *Orlando Furioso*, based on *Les Chansons de Roland*, Ariosto turned the traditional heroic knight into a romantic hero who went mad because of his love for Angelica, and continued the tale with new episodes.

Fragonard interprets the text faithfully, as one can see in the lines that Jean Seznec has identified as those illustrated by The Brooklyn Museum's drawings:

> Poi che mutato ebbe d'Almonte
> Le Gloriose insegne, andò alla porta
> E disse all'orecchio: "Io sono il conte"

40 *Illustration for Ariosto's "Orlando Furioso": Orlando Leaves Paris in Disguise*, 1780s

Black conté crayon and brown wash on white laid paper, 15⅜ x 9⅞ (39.2 x 25.1)

87.210.1, Purchased with funds given by Karen B. Cohen

Provenance The artist's family; Collection Hippolyte Walferdin; Sale, Hôtel Drouot, Paris, April 12–16, 1880; Collection Louis Roederer, Rheims; Collection Léon Olry-Roederer (by descent from his uncle), 1922; Collection Dr. A. S. Rosenbach, Philadelphia, 1955; Collection Norton Simon, 1978; Thomas Agnew and Sons, Ltd., London, 1987; Purchased with funds given by Karen B. Cohen, 1987.

Exhibitions London 1978, cat. no. 29. Tokyo 1980, cat. no. 148. Brooklyn 1988–89.

References Ananoff 1961, vol. I, p. 193. Mongan 1945, pl. 45.

41 *Illustration for Ariosto's "Orlando Furioso": Orlando Returns Bireno to Olimpia*, 1780s

Black conté crayon and brown wash on white laid paper, 15¾ x 10⅝ (40.0 x 27.0)

87.210.2, Purchased with funds given by Karen B. Cohen

Provenance Collection Hippolyte Walferdin; Sale, Hôtel Drouot, Paris, April 12–16, 1880; Collection Louis Roederer, Rheims; Collection Léon Olry-Roederer (by descent from his uncle), 1922; Collection Dr. A. S. Rosenbach, Philadelphia, 1955; Collection Norton Simon, 1978; Thomas Agnew and Sons, Ltd., London, 1987; Purchased with funds given by Karen B. Cohen, 1987.

Exhibitions London 1978, cat. no. 13. Tokyo 1980, cat. no. 149. Brooklyn 1988–89.

References Ananoff 1961, vol. I, p. 193. Mongan 1945, pl. 51.

A un capitan che vi facea la scorta;

E fattosi abassar subito il ponte,

Per quella strada che più breve porta

Agl'inimici, se n'ando diritto . . . (canto VIII, st. 91)

(After he had changed into the disguise of d'Almonte, he went to the gate and told the captain who guarded it, "I am the count," and having commanded that the drawbridge be lowered, he charged down the road to the battle [Text for *Orlando Leaves Paris in Disguise*].[8])

Bireno al conte con parole grate

Mostra conoscer l'obligo che gli have.

Indi insieme e con molte altre brigate

Se na vanno ove attende Olimpia in nave . . .

. . . Lungo sarebbe a raccontarvi quanto

Lei Bireno conforti, et ella lui;

Quai grazie al conte rendano ambidui. (canto IX, st. 84–85)

(Bireno with grateful words shows the count how obliged he is to him. Afterward they go together with many other people to where Olimpia is waiting on the ship. . . . It would take too long to tell you how much comfort they gave each other and how many thanks they gave the count [Text for *Orlando Returns Bireno to Olimpia*].) LKK

1 The catalogue of the Walferdin sale, Hôtel Drouot, April 12–16, 1880, lists 136 drawings in lot 228, although another work from this series was sold on April 5.

2 Ananoff 1961 lists twenty-seven examples in European collections.

3 Paris 1987–88, p. 510.

4 Mongan 1945, pp. 14, 15.

5 Washington, D.C. 1978–79, p. 153.

6 C. Valogne, "Fragonard, mon grand-père, par Théophile Fragonard," *Les Lettres françaises* (February 17, 1955), pp. 1, 9. Quoted in Paris 1987–88, p. 508.

7 Mongan 1945, p. 41, in Seznec's chapter "Fragonard as an Interpreter of Ariosto, The Letter and the Spirit."

8 Translations by Serena Rattazzi.

Paul Gauguin
1848–1903

TAHITIAN WOMAN manifests both the compelling symbolic language drawn from Gauguin's exotic travels and the artist's ability to bend or invert the characteristic qualities of his graphic technique. In this pastel he used thick, saturated color, but instead of the dense, scumbly texture typical of pastel, he produced a flat, washed surface of long vertical strokes. To achieve this, Gauguin stumped and wet the paper in places, perhaps even using a brush to work the pastel well into the surface. Often Gauguin used this technique to make a counterproof, but no identical composition for this pastel is yet known.[1]

The washed effect contributes to the crude and dreamy appearance of the drawing. Because the body of the figure is generalized and the setting is not articulated, the head seems to loom in the space, rendered a silhouette by the harsh yellow background. The woman becomes an ideal rather than a portrait—an emblem, along with the stylized leaf.

This pastel has been dated anywhere between 1891 and 1894, though in recent years it has been more convincingly dated to 1894.[2] This latest dating suggests that the pastel was made during Gauguin's return to Paris, and not while he was in Tahiti, which may explain the replacement of a naturalistic setting with a vague, abstract background.[3] The pastel does not relate to any painting or drawing dated to the time that Gauguin was in Tahiti, though it does share a likeness with a watercolor transfer of a Tahitian woman, signed and dated 1894, with the same head and hair arrangement.[4]

Gauguin rounded the upper right corner of the drawing. Frequently he would crop his drawings, though his reasons for this habit do not always seem either consistent or clear. Perhaps in this instance Gauguin wanted to accent the breadfruit leaf—or perhaps just to remove a frayed or torn edge. The drawing was then mounted onto bright yellow paper,

42 *Jeune Femme (Tahitian Woman)*, 1894?

Charcoal and pastel, selectively stumped and worked with brush and water on wove "pastel" paper, glued to yellow wove paper and mounted on gray millboard, 22¼ x 19¼ (57.0 x 49.5); board, irregular, 23½ x 19⅝ (60.5 x 50.5); signed in upper left in black pastel, "PGO"

21.125, Museum Collection Fund

Provenance Gustave Bollag, Zurich. Museum Purchase, 1921.

Exhibitions Brooklyn 1921, cat. no. 128. Brooklyn 1922–23, cat. no. 162. Brooklyn 1924–25, cat. no. 95. Washington, D.C., Phillips Collection, *Emotional Design in Painting*, April 7–May 5, 1940, catalogue with text by C. Law Watkins, cat. no. 17. Brooklyn 1944–45. New York, Wildenstein and Co., Inc., *A Loan Exhibition of Paul Gauguin for the Benefit of the New York Infirmary*, April 3–May 4, 1946, catalogue with introduction by Georges Wildenstein and text by Raymond Cogniat, cat. no. 42, p. 65, illus. San Francisco 1947, cat. no. 142, p. 87, illus. Newark 1948. The Minneapolis Institute of Arts, *Gauguin in Tahiti*, April 1–May 14, 1950. New York, Fine Arts Associates, *French Art around 1900—from Van Gogh to Matisse*, October 26–November 21, 1953, cat. no. 12. New York, Wildenstein and Co., Inc., *A Loan Exhibition of Gauguin for the Benefit of the Citizens' Committee for Children of New York City, Inc.*, April 5–May 5, 1956, catalogue with text by Robert Goldwater and Carl Schniewind, cat. no. 70. Washington, D.C. 1988, cat. no. 163, p. 310, illus. Brooklyn 1990–91 (exhibited January 15–June 3, 1991).

References Faunce 1982, pp. 276–81, p. 281, illus. "Gauguin's Monotypes," *Minneapolis Institute of Arts Bulletin* (April 29, 1950), vol. 39, p. 82. Goldwater, Robert, *Paul Gauguin*, New York, 1928, p. 49, illus. Leymarie, Jean, *Gauguin: Aquarelles, pastels et dessins en couleurs*, Geneva, 1962, cat. no. 31. Monnier, Geneviève, *Pastels from the 16th to the 20th Century*, Geneva, 1983, p. 63, illus. Pickvance, Ronald, *The Drawings of Gauguin*, London, New York, Sydney, Toronto, 1970, pl. XI. Rewald, John, *Gauguin Drawings*, New York and London, 1958, no. 118, p. 39, illus. Tschudy 1932, p. 195, illus. Wegener 1954, vol. XVI, p. 21, illus. p. 20. Wildenstein, Georges, edited by Raymond Cogniat and Daniel Wildenstein, *Gauguin*, Paris, 1964, vol. I, p. 165, cat. no. 424, illus.

the same yellow paper Gauguin used for his zincographs, and pasted onto millboard, backed with newspaper that can be dated to 1894 (supporting the recent dating). Gauguin may have mounted it to the board himself to prepare it for the exhibition of his pastels in 1894–95 at Mouline.[5] KZ

1 Richard Brettell, Washington, D.C. 1988, p. 310, no. 163. This is the most recent catalogue to include the pastel, and this entry relies on its information and insights.

2 Ibid.

3 Ibid.

4 Ibid.; location unknown.

5 Notes on conversation between Peter Zegers and Toni Owen, Paper Conservator, January 20, 1987, The Brooklyn Museum, Department of Painting and Sculpture, Supplementary Accession File.

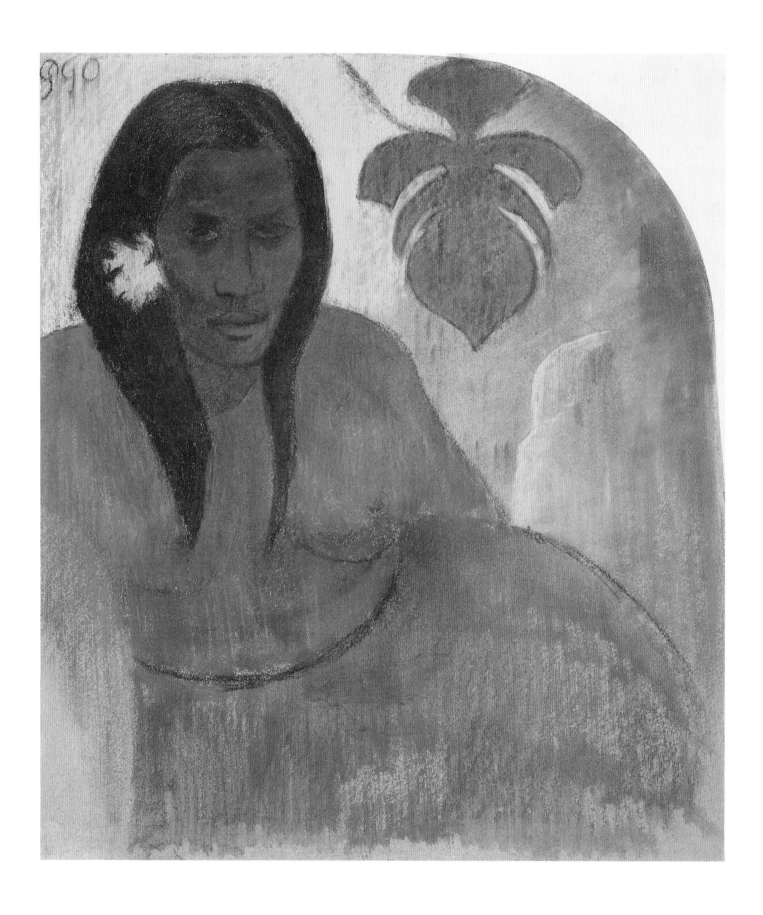

Ernest-Joseph-Angelon Girard
1813–1898

43 *Portrait of a Woman in Black,* 1855

Watercolor on paperboard, image, oval, 14¾ x 11¾ (37.5 x 29.9); sheet, uneven, 17¹⁵⁄₁₆ x 11¾ (45.6 x 29.9); signed and dated in black in center right

25.423, Caroline H. Polhemus Fund

Provenance Collection William H. Herriman, Rome; Museum Purchase, 1925.

Exhibitions Brooklyn 1988–89.

References Tschudy 1932, p. 99, illus.

44 *Young Woman at Her Toilette,* mid-1860s?

Watercolor on paperboard, image, oval, 13¹⁵⁄₁₆ x 11¼ (35.4 x 28.6); sheet, uneven, 16 x 12⅞ (40.7 x 37.7); signed in white in upper right

25.424, Caroline H. Polhemus Fund

Provenance Collection William H. Herriman, Rome; Museum Purchase, 1925.

Exhibitions Brooklyn 1988–89.

References Tschudy 1932, p. 99.

GIRARD BEGAN exhibiting at the Salon in 1835 and made his career essentially as a painter of portrait miniatures, mostly in watercolor. He was successful at meeting the demands of this genre, which required great exactitude of technique in manipulating the finest of brushes and the skill to render accurate likenesses of both the sitter and her costume. The subject of *Portrait of a Woman in Black* is a distinctive personality, with jet black hair, thick eyebrows, and large, black eyes that suggest Spanish nationality—much in fashion during the Second Empire, owing to Empress Eugénie's Spanish origin. She is shown dressed in the latest

style of the 1850s, with her hair braided over the ears and a hat modeled on the masculine top hat, or *chapeau haut de forme*. If this elegant all-black costume is not actually an outfit designed for horseback riding in the Bois de Boulogne (suggested also by the gold-topped stick held by the sitter), then it is modeled on the costumes designed for this newly fashionable ladies' recreation.

Though portrait miniatures form the majority of Girard's Salon entries, he made another type of painting in the miniature form: genre subjects with such titles as *Sortie de bain* and *Jeune Femme à sa toilette*. The second Brooklyn piece is a fine example of this latter genre, which had a steady and perfectly respectable market. The masterful depiction of fabrics, jewels, furniture, and flowers, together with the innocently bland middle-class face of the model, must have obscured or deflected the open eroticism of the partially bared and filmily revealed breasts. The somewhat gypsylike orientalism of the costume adds a flavor that was much in demand in this type of imagery. SF

45 *Le Moulin à Café (The Coffee Grinder)*, 1911

Charcoal on laid paper, 18¾ x 12½ (47.7 x 31.8)

86.64, Purchased with funds given by Henry and Cheryl Welt

Provenance Collection Georges Gonzalez (son of the artist), Paris, 1965; Galerie Louise Leiris, Paris, 1967; Saidenberg Gallery, New York; Private collection, New York, 1982; Sale, Sotheby's, New York, May 20, 1982, lot 17, illus.; Janie C. Lee Gallery, New York and Houston; Purchased with funds given by Henry and Cheryl Welt, 1986.

Exhibitions New York, Saidenberg Gallery, *Juan Gris, Drawings and Gouaches 1910–1927* (an exhibition commemorating the 40th anniversary of the artist's death on May 11, 1927), May 9–June 24, 1967, catalogue with introduction by Daniel-Henry Kahnweiler, cat. no. 9, illus. Houston, Janie C. Lee Gallery, *Cubist Drawings 1907–1929*, November 1982–January 1983, catalogue with text by Daniel Robbins and Margit Rowell, cat. no. 15, illus. New York, Janie C. Lee Gallery, *Charcoal Drawings 1880–1985*, October–November 1985, cat. no. 4, illus. Brooklyn 1988–89.

References Brooklyn 1988, p. 192, no. 144, illus. Gaya-Nuño, Juan Antonio, *Juan Gris*, 1974, p. 208, illus. fig. 231. Kramer, Linda Konheim, "Recent Acquisition: Modern Drawing," *The Brooklyn Museum Newsletter* (May 1986), p. 4, illus. Kramer 1987, pp. 104–6, p. 106, illus.

WHEN JUAN GRIS came to Paris from Madrid in 1906, he worked as an illustrator, submitting humorous drawings in an Art Nouveau style to various periodicals. He did not become a serious artist until 1910. Although Gris knew Picasso and Braque and was certainly aware of their work, he found his own way to Cubism through a personal appraisal of the sources of Cubist development in the work of Cézanne.[1]

In *The Coffee Grinder*, Gris's style is still strongly rooted in Post-Impressionism. The sense of volume, angularity, spatial ambiguity, and unusual perspectives seen in this drawing derive largely from Cézanne but point toward the more faceted and dislocated forms and broken contours that Gris was to develop in his subsequent Cubist works. It was not until 1912 that Gris's work became definitely Cubist and he had his first exhibitions in the Salon des Indépendants and the Section d'Or in Paris and at Der Sturm in Berlin. LKK

1 Douglas Cooper and Gary Tinterow, *The Essential Cubism, 1907–1920: Braque, Picasso and Their Friends*, exhibition catalogue, The Tate Gallery, London, 1983.

Jean-Antoine-Théodore Gudin
1802–1880

46 *Seascape*, 1844

Wash heightened with white on blue-gray paper,
6½ x 10¼ (16.5 x 26.0); signed and dated in
lower left in brown ink, "T. Gudin 1844 Borliss"

61.120.5, Gift of Dr. Lillian Malcove

Provenance Collection Dr. Lillian Malcove,
New York; Gift of Dr. Lillian Malcove, 1961.

Exhibitions Brooklyn 1988–89.

Théodore Gudin, renowned in his lifetime as the quintessential marine painter, received many royal commissions and was the official painter to the navy.

The artist initially enjoyed praise and comparisons to such masters of land- and seascape as Claude, Ruisdael, and the master of Gudin's era, Joseph Vernet. His work certainly displays the influence of all these artists, in addition to that of Joseph M. W. Turner, whose work he would have seen when in England.

After the July Monarchy, Gudin's work was scorned, perhaps because of the popularity of new styles, but also, according to the critics, because he compromised his reputation and talent in response to growing market demands. However, despite Gudin's vacillating reputation, alternately pleasing, shocking, and disappointing the public, he probably influenced many marine painters at the end of the century, including Félix Ziem.[1]

Brooklyn's tranquil wash drawing has none of the violent energy typically found in Gudin's dramatic paintings, particularly those celebrating French victories. Nevertheless, we can appreciate its subtle tonality and delicate but exacting detail, just as critics such as Jules Janin and Maxime du Camp did early in the nineteenth century. KZ

1 See cat. no. 91.

Constantin Guys
1802–1892

CONSTANTIN GUYS is perhaps best known as the subject of Charles Baudelaire's essay "The Painter of Modern Life."[1] In his essay, Baudelaire praised Guys for his concentration on contemporary life and his ability to capture its styles and personalities, disregarding—as Baudelaire viewed them— standards of antiquity and the academic hierarchy. Not only did Guys embrace contemporary society in his art, but he also established the reputation of a dandy in his life. The artist shied away from public recognition, however. He did not sign or date most of his work, and without Baudelaire's pivotal essay, Guys might have remained more obscure. Because Guys insisted that Baudelaire not use his name in the essay, the critic referred to him only as Monsieur G.

Guys's work consists of drawings, watercolors, and gouaches intended for publication in the most popular journals in England and France. Although today he is generally considered an illustrator and is not well known, he was greatly respected by his contemporaries, including not only Baudelaire, but also the photographer Félix Nadar, the critics Théophile Gautier and Roger Marx, the publisher André Marty, the writer J. K. Huysmans, and the artist J. L. Forain. Nadar's correspondence with Guys remains a major source of information about the artist and his role in Second Empire society.

While Guys did not begin drawing until late in his life, he left a prodigious oeuvre. The date of his earliest work is still debated;[2] we do know that by 1842 he was working in London for *The Illustrated London News*.

The nine unsigned and undated drawings in The Brooklyn Museum's collection record the fashions and habits of Parisian society in the Second Empire. They belong to the group of illustrations Guys drew after returning to Paris from the Crimean War, which he covered at the front for *The Illustrated London News*. Images of soldiers alone on horseback or of women promenading, often in carriages accompanied by soldiers, reflect Guys's fascination with costume and social ceremony, whether of female or military society. At this time his work became increasingly monochromatic, with broader lines, as opposed to the dark staccato contours of his earlier work.[3] He still focused on figures rather than a complete scene or landscape, and his figures, which Baudelaire praised for the sense of immediacy and contemporaneity that they conveyed, maintain a caricatural and sketchlike quality.

Guys depicted the grand and playful aspects of Paris's social parade by using a variety of media in multiple combinations. The dark washes of *Promenade* and *Two Women* contrast with the paler, more linear caricature of carriages and soldiers of his *Calèches*. In *Study of Two Women* and *Woman, Frontal View*, broader washes of translucent gray depict a grander,

47 *Calèche No. 1*, undated
Pencil and charcoal with India ink on white wove paper, 6¹¹⁄₁₆ x 9⁷⁄₁₆ (17.0 x 24.2)
29.73, Museum Purchase
Provenance Bernheim-Jeune et cie, Paris, 1926; Collection Hallie Davis, New York; Museum Purchase, 1929.
Exhibitions Brooklyn 1969. Brooklyn 1988–89.

48 *Cavaliers*, undated
Pencil and charcoal with India ink on white laid paper, 6⁹⁄₁₆ x 9⁵⁄₁₆ (16.6 x 23.6)
29.72, Museum Purchase
Provenance Bernheim-Jeune et cie, Paris, 1926; Collection Hallie Davis, New York; Museum Purchase, 1929.
Exhibitions Brooklyn 1969. Brooklyn 1988–89.

49 *Calèche et cavaliers*, undated
Pencil, charcoal, and wash on wove paper, 6¾ x 8⅛ (16.8 x 20.5)
29.75, Museum Purchase
Provenance Collection Hallie Davis, New York; Museum Purchase, 1929.
Exhibitions Springfield 1939, cat. no. 38. Brooklyn 1969.

50 *Calèche No. 2*, undated
Pencil, ink, and wash on laid paper, 7⅜ x 9⅜ (18.5 x 23.5)
29.74, Museum Purchase
Provenance Bernheim-Jeune et cie, Paris, 1926; Collection Hallie Davis, New York; Museum Purchase, 1929.
Exhibitions Brooklyn 1969.

51 *Calèche No. 3*, undated
Pencil, charcoal, and wash on wove paper, 6¾ x 9½ (17.1 x 24.1)
29.76, Museum Purchase
Provenance Collection Hallie Davis, New York; Museum Purchase, 1929.
Exhibitions Brooklyn 1969.

52 *Étude de deux femmes (Study of Two Women)*, undated
Pencil, charcoal, and wash on wove paper, 8 x 5⅞ (20.3 x 15.0)
29.78, Museum Purchase
Provenance Collection Hallie Davis, New York; Museum Purchase, 1929.

53 *Femme, vue de face (Woman, Frontal View)*, undated

Blue crayon and wash on wove paper, 9⅝ x 6⁷/₁₆ (24.5 x 16.7)

29.77, Museum Purchase

Provenance Bernheim-Jeune et cie, Paris, 1926; Collection Hallie Davis, New York; Museum Purchase, 1929.

Exhibitions Brooklyn 1969.

54 *Deux Femmes (Two Women)*, undated

India ink and wash on heavy board, 8¼ x 7¹⁵/₁₆ (20.9 x 20.2); signed in pencil in center right (?)

29.80, Museum Purchase

Provenance Bernheim-Jeune et cie, Paris, 1926; Collection Hallie Davis, New York; Museum Purchase, 1929.

Exhibitions Springfield 1939, cat. no. 38. Brooklyn 1969. Brooklyn 1988–89.

55 *Promenade*, undated

India ink and wash on white wove paper, 8⅛ x 11¼ (20.6 x 28.6)

29.79, Museum Purchase

Provenance Collection Hallie Davis, New York; Museum Purchase, 1929.

Exhibitions Springfield 1939, cat. no. 38. Brooklyn 1969. Brooklyn 1988–89.

more self-conscious display of the life of leisure. Guys's observations offer a view of the manners, fashions, and society of Second Empire "modern life" without the social sarcasm and political caricature of Daumier and Paul Gavarni—although, as Baudelaire pointed out, they are just as lively and perceptive. KZ

1 Charles Baudelaire, "The Painter of Modern Life," in *The Painter of Modern Life and Other Essays*, ed. by Jonathan Mayne, Greenwich, Connecticut, 1964.

2 Karen Woodbridge Smith, "Constantin Guys: A Chronological and Stylistic Analysis of His Work," Ph.D. diss., Case Western Reserve University, Cleveland, 1984, pp. 8, 32–51.

3 Ibid., pp. 84–89.

47

48

49

50

51

52

53

54

55

Jean-Louis Hamon
1821–1874

56 *Entomologist* (Design for a Fan), 1872

Watercolor and pencil on parchment, fan-shaped, 10⅝ x 21³/₁₆ (27.0 x 53.8); signed and dated on stone in lower center, "J. L. Hamon/Rome 1872"

21.445, Bequest of William H. Herriman

Provenance Commissioned by the fan-making house of Desrochers, Paris; Collection William H. Herriman, Rome; Bequest of William H. Herriman, 1921.

Exhibitions The Brooklyn Museum, *Narrative and Ornament*, December 24, 1975–March 1976. New York, Grey Art Gallery, New York University, *Charles Gleyre 1806–1874*, February–March 22, 1980 (not in catalogue). Brooklyn 1988–89.

References Adams, Charlotte, "Jean-Louis Hamon," *American Art Review* (1881), vol. 2, pp. 199–205. Blondel, S., *Histoire des Eventails*, Paris, 1875, pp. 181, 193.

Hamon studied in the 1840s with Paul Delaroche and Charles Gleyre, and made his Salon debut in 1847 with a painting called *Daphnis and Chloe*—an appropriate title for an artist whose reputation was made as a practitioner of the Néo-grec style that was so well received at midcentury. On the advice of Gleyre, he worked for the Manufacture de Sèvres from 1848 to 1853, inventing and painting designs for porcelain. The work was suited to his sensibility, and the light palette and decorative quality he employed in it carried over into his painting. His large painting *La Comédie humaine* of 1852 was bought by the State, but his greatest success was with a small work in the same antique mode, called *Ma Soeur n'y est pas*, which was bought by Empress Eugénie herself. Hamon showed at the Exposition Universelle of 1855 and that year received the Légion d'honneur. By the early sixties, however, the vogue for the Néo-grec, also somewhat more appropriately called the Pompeian style, had declined in Paris; in 1862 Hamon went to live in Rome, where the taste was still alive, especially among English and American collectors. For a number of years he lived even closer to the source of his inspiration, in Capri, where he joined a group of French artists who drew their subject matter from the picturesque island and its people. Visiting Rome regularly, he kept in touch with collectors such as the American William Herriman, and acquired such commissions as this design for the Parisian fan-making house of Desrochers. According to S. Blondel, the fan itself was owned by the comtesse de Grandville by 1875.[1] The theme of the butterfly goes back to the 1850s, when Hamon showed paintings at the Salon derived from his designs for Sèvres. In 1857 he showed a group of the Four Seasons: Spring was represented by a classically draped female figure improbably seated on a flower stem, palette in hand, in the act of painting a flying putto, who holds spread before him a butterfly whose wings are of the identical design as those of the fan composition. The beautifully executed but intrinsically absurd painting was suitably satirized by the noted caricaturist Cham in his *Salon de 1857*.[2] In the fan design, similar elements are combined in their proper milieu, that of the decorated object, to create a charming work. It is not certain whether Hamon had any particular entomologist in mind, because the inscription on the stele is illegible; more likely the image is a gentle spoof of the whole idea of collecting specimens and pinning down the delicate beauty of butterflies. SF

1 S. Blondel, *Histoire des Eventails*, Paris, 1875, pp. 181, 193.
2 Musée d'Orsay Documentation, Hamon file. See Philadelphia 1978.

Ferdinand Heilbuth
1826–1889

57 *Figures on a Terrace*, circa 1870

Watercolor and pencil on cream wove paper, 10 x 15⅝ (25.5 x 39.7); signed in lower right, "F. Heilbuth"

21.456, Bequest of William H. Herriman

Provenance Collection William H. Herriman, Rome; Bequest of William H. Herriman, 1921.

Exhibitions Brooklyn 1988–89.

THE SON OF A RABBI, Heilbuth was born in Hamburg and studied in Antwerp, Munich, and Düsseldorf before coming to Paris to study with Paul Delaroche and Charles Gleyre and to establish his artistic career. By 1861 he had been awarded the Légion d'honneur. He lived from 1865 to 1875 in Rome, where he concentrated his genre painting on the life of the Vatican, thereby acquiring the epithet "painter of cardinals." In fact he painted other genre subjects as well—from fetes and boating parties to the sites of archaeological discoveries—with which he made a successful Salon career. Critics regarded his paintings of prelates as his most characteristic, however. One of them, Louis Enault, wrote in *L'Exposition Universelle de 1867 illustré* that Heilbuth was the "painter-in-ordinary to these princes of the Church, clothed in the sacred purple, who give to the Eternal City its accent, its cachet, its physiognomy."[1]

Our watercolor depicts an encounter on a formal terrace, probably on the Pincian Hill, where Heilbuth set many of his subjects, between two groups of what appear to be ecclesiastics: two prelates of the Church in their long caped cloaks and tricornered hats, with their footmen at a respectful distance; and a group of four men dressed variously in robes or long black coats, with long beards and skullcaps and carrying umbrellas, who appear to be a rabbi and his attendants. Close study of the various attitudes and expressions of each of the figures reveals an implicit comedy of manners, giving weight to Enault's remark that Heilbuth is not carried away by the pomp of the Church, but rather "always finds on his palette the ironic note."[2]

A sizable (33 x 51 inches) oil painting of this composition, titled (incorrectly, given the distant view of Saint Peter's) *The Gardens of the Vatican* and dated 1870, was in Christie's New York nineteenth-century European painting sale of October 30, 1992 (lot 65). Apart from the fact that the watercolor is set in bare winter and the oil in leafy summer and that it lacks a city view over the parapet, the composition is the same with only minor changes or omissions. Given its greater simplicity, the watercolor is likely to be a study for the oil, but it could also be a reduction for the market. SF

1 *L'Exposition Universelle de 1867 illustré*, Paris, 1867, p. 339. Author's translation.

2 Ibid.

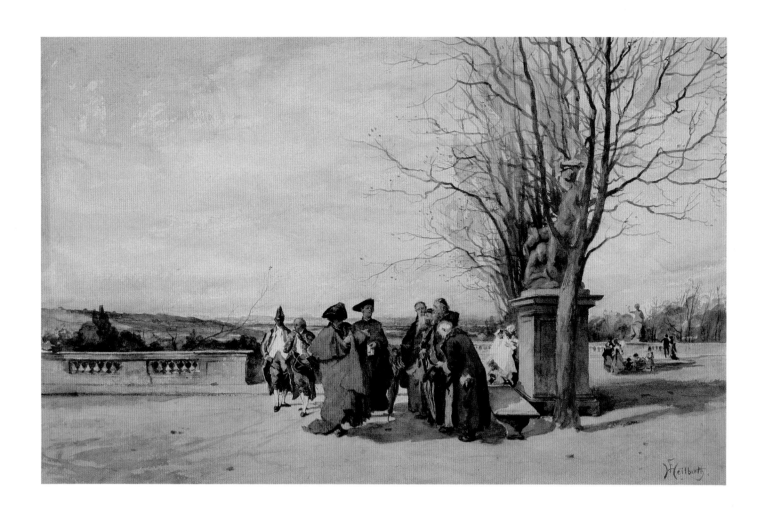

Léo Herrmann
1853–1927

58 *Cardinal Taking Tea*, undated

Gouache, watercolor, and pencil on wove paper mounted on board, image, 10¹³⁄₁₆ x 7⅞ (27.5 x 20.0); sheet, uneven, 11⁷⁄₁₆ x 8⅝⁄₁₆ (29.0 x 21.1); signed in lower right

06.72, Bequest of Caroline H. Polhemus

Provenance Collection Caroline H. Polhemus, Brooklyn; Bequest of Caroline H. Polhemus, 1906.

Exhibitions Brooklyn 1988–89.

References Goodyear 1910, p. 39, cat. no. 186. Thieme, Ulrich, and Felix Becker, *Allgemeines Lexikon der Bildenden Kunstler*, Leipzig, 1923, vol. 16, p. 501.

GIVEN THE SKILLFUL TECHNIQUE of his work and the great popularity of his subject matter during the Third Republic, it is strange that Herrmann is so sparsely documented. He exhibited at the Salon for only three years, from 1875 through 1877, showing small, anecdotal paintings with such titles as *Le Scandal du jour*. It is not known whether these were "cardinal pictures" like the Brooklyn work, but other paintings by Herrmann of ecclesiastics in informal situations are known. In these works, the richly robed prelate of the Church is depicted as an ordinary, often homely man, engaging in such everyday activities as dreaming on a park bench, feeding swans in a park, or, as here, taking afternoon tea on his own. The satire in these images is not really severe enough to qualify as seriously anticlerical. Here the painter takes a mild poke at the prelate by depicting him as a man of humble origins, making an effort at gentility by holding his teacup with an extended little finger in the classic gesture of one unaccustomed to the manners of the tea table. The artist's more compelling interest seems to be in the description of the priest's elaborate furnishings: the fine oriental rug, the Italian chair upholstered in cut velvet, the heavy table with its figured covering, and the wall-sized tapestry whose design provides an artificial landscape setting for the solitary tea drinker. Herrmann's meticulous watercolor style enables him to provide an inventory of early Third Republic taste in interior decoration and, at the same time, to call attention to the discrepancy between the richness of the decor and the pointedly absent austerity of the priestly calling. SF

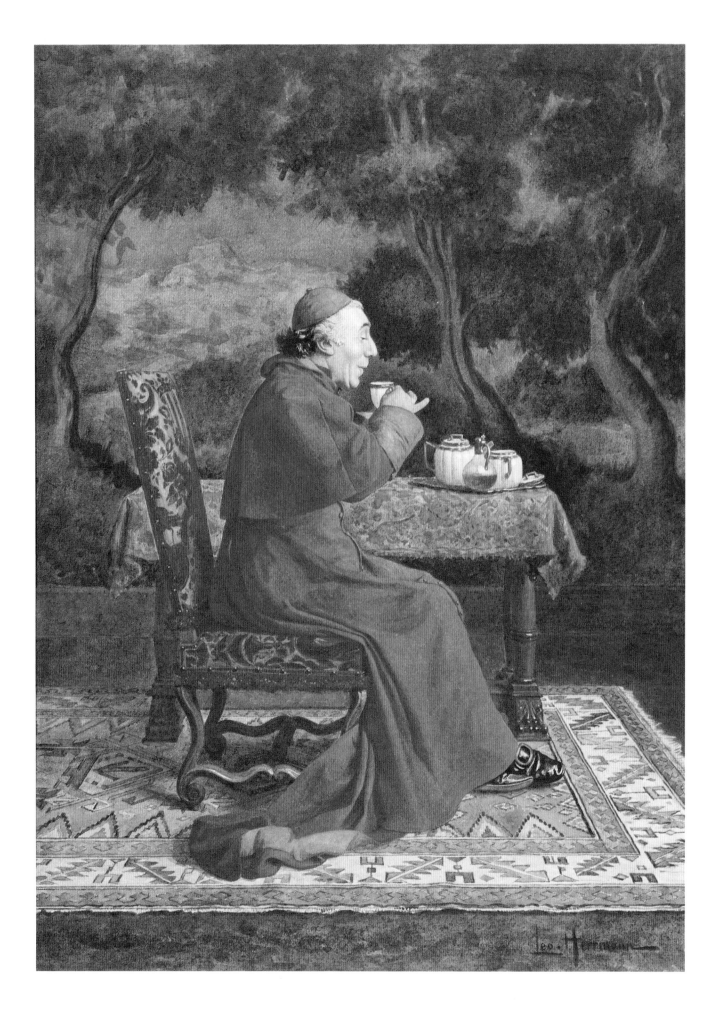

59 *Fontaine de Vaucluse*, 1839

Watercolor on cream wove paper, 11⁷⁄₁₆ x 17⅝
(29.0 x 44.7)

87.141, A. Augustus Healy Fund "B"

Provenance Collection duc d'Orléans;
Private collection; James MacKinnon and Henry
Strachey, London, 1987; Museum Purchase,
1987.

Exhibitions Brooklyn 1988–89.

Born in Paris, Paul Huet went on painting trips to the Normandy coast while still in his teens. By 1820 he had met Richard Parkes Bonington, whose watercolors of the Channel coast he admired greatly. Huet studied in the studios of the figure painters Pierre-Narcisse Guérin and Baron Gros, but he spent his life painting landscape. He remained true to the Romantic-picturesque aesthetic in which his style was formed, and his work stands as an example of essentially Romantic landscape. He traveled widely in France to make landscape studies, particularly in Normandy, the Auvergne, and Provence. In 1837 he stayed at the Château de Compiègne to act as drawing master to the duchesse d'Orléans. The following year, his wife fell ill with tuberculosis, and he took her to Nice, where he made drawings in the surrounding mountains. In March 1839 the duc d'Orléans offered him a commission so that he could stay in the warm south with his wife: he was to make a series of watercolor paintings of various towns and sites in the Midi.[1] The series remained with the Orléans family and their heirs, and even by the 1960s only a very few of the paintings were known; both Pierre Miquel in 1962 and Marion Spencer in 1969 remarked on the rarity of the examples known (which at that time did not include our painting) and on the reputed beauty of the whole series.[2]

It is not surprising that Huet chose the Fontaine de Vaucluse to be one of his subjects. Located about fifteen miles east of Avignon, it was known in the region as the site both of Petrarch's tomb and of an impressive natural phenomenon, the emergence from the steep rocks of the waters of the river Sorgue. Both features—the memorial to a famed medieval poet and the expression of the power of natural elements—were intrinsic to the Romantic sensibility. Almost certainly this finished painting was made in the studio, but it was also surely based upon open-air studies in which the artist observed the effects of the brilliant southern light and the clear, dry atmosphere, so different from the misty and softening air of the Channel coast. The high, broad point of view, the dramatic disposition of the rocks, and the placement of the two tiny figures at the lower left reveal the degree to which Huet was affected by the tradition of the picturesque. It was through such works as this one that the various regions of France, in all their particularities, began for the first time to enter into the realm of the visual imagination. SF

1 For the text of the commission, see R. P. Huet, *Paul Huet (1803–1869)*, Paris, 1911, p. 33.

2 Pierre Miquel, *Paul Huet*, Paris, 1962, p. 114; Marion Spencer, introduction to *Paintings by Paul Huet (1803–1869) and Some Contemporary French Sculpture*, Heim Gallery, London, 1969, p. 6.

Charles-Émile Jacque
1813–1894

60 *Landscape with Two Figures, Herd of Sheep, and a Cow,* undated

Charcoal and white chalk on blue laid paper, 8⁵⁄₁₆ x 15³⁄₁₆ (22.7 x 38.6); signed in crayon in lower left

21.485, Bequest of William H. Herriman

Provenance Collection William H. Herriman, Rome; Bequest of William H. Herriman, 1921.

Exhibitions Brooklyn 1988–89.

I*N LANDSCAPE WITH TWO FIGURES, Herd of Sheep, and a Cow,* Charles Jacque encourages the eye to move deep into the space of his drawing. The miniaturist scale of the animals and shepherdesses, the sparsely populated field on the left, and the empty sky evoke the feeling of vast, quiet landscapes. The spindly trees on the right, reaching above the edge of the top and side of the sheet (perhaps the edge of a forest), emphasize the emptiness of the rest of the composition and indicate that it is winter; the cool season is further evoked by the blue paper and white highlighting.[1]

Although the Museum's drawing cannot be directly related to a specific etching or painting by Jacque, it is typical of the artist's numerous, carefully observed studies of animals grazing in a landscape, characteristically divided between forest and pasture. Jacque is perhaps best known as an etcher, and his reliance on the use of thin, intricate line to depict shadow and space reveals his training in that technique.

Jacque's early etchings of animals and peasants illustrate an interest in animal husbandry that deepened and became the focus of his work in and around the forest of Fontainebleau. In 1847 Jacque befriended Jean-François Millet, and together they moved to Barbizon in 1849. Although Jacque may have helped Millet by introducing him to influential figures in the art world, Millet had a greater influence on Jacque's art, and Jacque owned a large collection of Millet's drawings.[2]

Whereas Millet aggrandized the laborer—the human presence—and Corot the mythic wonder of the landscape, Jacque focused on animals and their activity. Although the animals are embedded in the landscape (as his human figures often are), they unify or organize the composition. In the Museum's landscape, it is the line of sheep that pulls the eye into the bleak distance, encouraged by the line of the riverbank, which is articulated by straying sheep and a more distant cow. KZ

1 Although Jacque dated his etchings, he rarely dated his paintings and drawings, and it is difficult to establish a chronology. His work does seem to move from a tighter composition to a looser organization and line, with greater light—frequently indicated, as here, with pure white.

2 Robert Herbert, "Les Faux Millet," *Revue de l'Art* (1973), vol. 21, pp. 56–65. This article discusses Jacque's copying of Millet drawings for a commission without acknowledging Millet, and the subsequent cooling of their relationship in the 1850s.

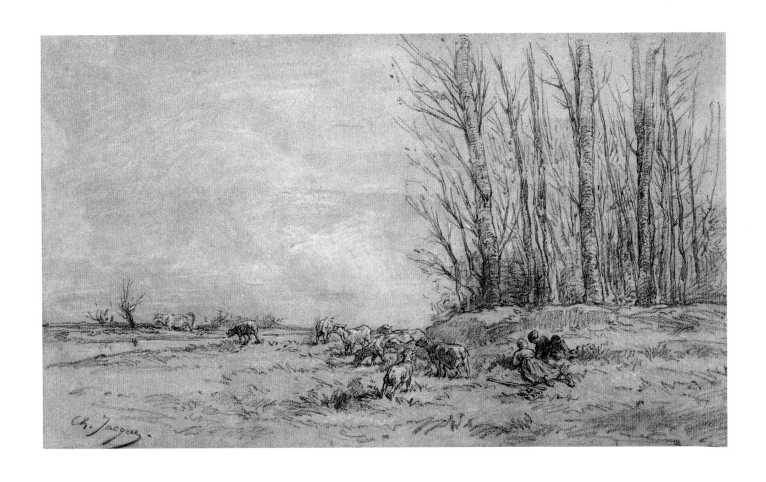

Charles-Albert Lebourg
1849–1928

61 *Chien endormi (Sleeping Dog)*, circa 1870

Charcoal and white chalk on tan laid paper, 10⅛ x 9 (26.0 x 22.5); signed in lower right

88.139, Purchased with funds given by Karen B. Cohen

Provenance Collection Roger Miles, Paris; German art market, 1988; Jill Newhouse, New York, 1988; Purchased with funds given by Karen B. Cohen, 1988.

Exhibitions Brooklyn 1988–89.

References Benedite, L., *Albert Lebourg*, Paris, 1923, cat. no. 2089.

SLEEPING DOG is an unusual drawing in Albert Lebourg's oeuvre, for he is primarily known as a painter of romantic landscapes. This work belongs to an early group of his drawings, mostly still lifes, that are characterized by a more concrete, realistic style. Lebourg inscribed several drawings that are similar in style and subject "A Mustapha" or "Algiers," which would date them to about 1872, when Lebourg taught at the Société des Beaux-Arts in Algiers.[1] After his return to Paris, he exhibited with the Impressionists in 1879 and 1880. Included in the exhibitions were several paintings from Algiers.[2]

Lebourg drew this dog in a variety of textured circular strokes, creating a wonderfully dense, black circle of strong graphic quality. His decision to place the dog in the upper half of the composition, floating its form amid charcoal lines of shadow and light, enhances the abstract power of the form. KZ

1 Gabriel Weisberg, *The Realist Tradition*, exhibition catalogue, The Cleveland Museum of Art, 1981, p. 298. Lebourg's art caught the eye of a French patron living in Algeria, who invited him to come teach at the school. The Brooklyn drawing is similar to several seen by the author at private dealers in Paris and at auction.

2 Washington, D.C. 1986, pp. 268–69, 312.

Alphonse Legros
1837–1911

ALPHONSE LEGROS is perhaps best known as an academic teacher at the Slade School in London from 1876 to 1892. Enjoying greater success in England than in France, he moved to London in 1863. Although a good friend of Whistler, Degas, and Fantin-Latour, Legros maintained an academic, conservative approach to his art.

A prolific printmaker and painter, Legros also executed several metalpoint drawings, of which The Brooklyn Museum has two examples. Despite the precision and limitations of the technique, Legros used it to sketch studies of the human anatomy, perhaps even drawing from the model. Legros frequently repeated motifs in his paintings and prints, examining the effects of different media.

Although Legros lived in England for many years, his students claimed that he never learned English. Consequently, he often conducted his classes by drawing rather than lecturing.[1] He always insisted on the autonomy of

62 *Study for a Child's Head*, undated

Metalpoint on pale green wove paper, 7⁹⁄₁₆ x 6¾ (19.2 x 17.2); signed in upper right

43.117.2, Gift of J. Gettinger

Provenance Collection J. Gettinger, New York; Gift of J. Gettinger, 1943.

Exhibitions Brooklyn 1969. Brooklyn 1988–89.

63 *Study of a Foot*, undated

Metalpoint on heavy wove paper, 5 x 6⅝ (12.8 x 16.8); signed in pencil in lower right

43.117.1, Gift of J. Gettinger

Provenance Collection J. Gettinger, New York; Gift of J. Gettinger, 1943.

Exhibitions Brooklyn 1969. Brooklyn 1988–89.

line and the importance of learning how line alone could create volume, light, and shadow. The two metalpoint drawings may be examples of studies Legros executed before his students. KZ

1 William Rothstein, *Men and Memories*, London, 1931, vol. 1, pp. 22–23, quoted in Richard Thomson, *French Nineteenth Century Drawings in the Whitworth Art Gallery*, Manchester, 1981, p. 23.

Henri Lehmann (Karl-Ernst-Rodolphe-Heinrich-Salem Lehmann)

1814–1882

HENRI LEHMANN was a student of Ingres who painted in a conservative academic style, but his sketches have a warmth and freedom that are closer to the romantic manner of Delacroix than to the style of Ingres. These three studies of a kneeling figure are characteristic of his lively drawing style.

This sheet is one of a group of studies done for a mural commissioned by the city of Paris for one of the arms of the transept of the church of Sainte-Clothilde in 1854. The decorations completed in 1859 consisted of illustrations of the Pater Noster in six compositions, but Lehmann was dissatisfied with the works and ordered them destroyed.[1] The subject of each of the murals is known through full cartoons that were passed down in the family of the artist, and through numerous studies for specific figures, such as this one.

The kneeling figure in this drawing is found in the cartoon for the mural illustrating *Sanctificetur nomen tuum*, which was located on the east side of the transept on the northern wall, lower register, below the study for *Pater noster qui es in coelis*. The figure illustrated in Brooklyn's drawing is at the lower right of the mural, somewhat to the back.[2] LKK

1 Aubrun 1984, vol. 1, p. 212.
2 Ibid., vol. 2, p. 206, cat. no. D919B; p. 208, cat. no. D928.

64 *Études de personnage agenouille tourné vers la gauche (Studies of Kneeling Figure Turned Left for Church of Sainte-Clothilde)*, 1854–59

Pencil and conté crayon on tan laid paper, 11¾ x 9 (29.8 x 22.8); estate stamp in lower left; annotated in lower left in pencil, "5 mai"

87.164, Purchased with funds given by Stephen Katz and the Alfred T. White Fund

Provenance Lehmann family; Galerie de Bayser, Paris, 1987; Jill Newhouse, New York, 1987; Purchased with funds given by Stephen Katz and Alfred T. White, 1987.

Exhibitions Paris, Galerie de Bayser, *Henri Lehmann—Dessins*, June–July 1983, cat. no. 38. Brooklyn 1988–89.

References Aubrun 1984, p. 208, cat. no. D928, illus.

Léon-Augustin Lhermitte
1844–1925

65 *La Soupe du vieux faucheur* (*Old Harvester's Meal*) (*Le Repas du moissonneur* [*The Reaper's Meal*]), January 1886

Pastel on brown wove paper mounted on fabric, 29¾ x 35 (75.6 x 88.9); signed in lower right, "L. Lhermitte"

03.326, Bequest of Henry W. Maxwell

Provenance Boussod, Valadon et cie/Goupil et cie, Paris and London (no. 13056, *Le Déjeuner du faucheur*); Collection Maxwell family, 1887; Bequest of Henry W. Maxwell, 1903.

Léon Lhermitte, along with Bastien-Lepage and Jules Breton, carried the pictorial tradition of peasant life into the 1890s. Lhermitte usually spent his winters in Paris and part of the year in the village where he was born, Mont Saint-Père, and customarily depicted landscapes or buildings in the area of the town such as the church of Saint-Eugène. Although he here chooses figures and a site familiar to him, the composition and modeling reflect the influence of Dutch seventeenth-century art.

The masterful handling of charcoal in *The Church of Saint-Eugène* indicates some of the reasons why Lhermitte helped to establish black-and-white drawings as finished works.[1] The same charcoal stick and white paper

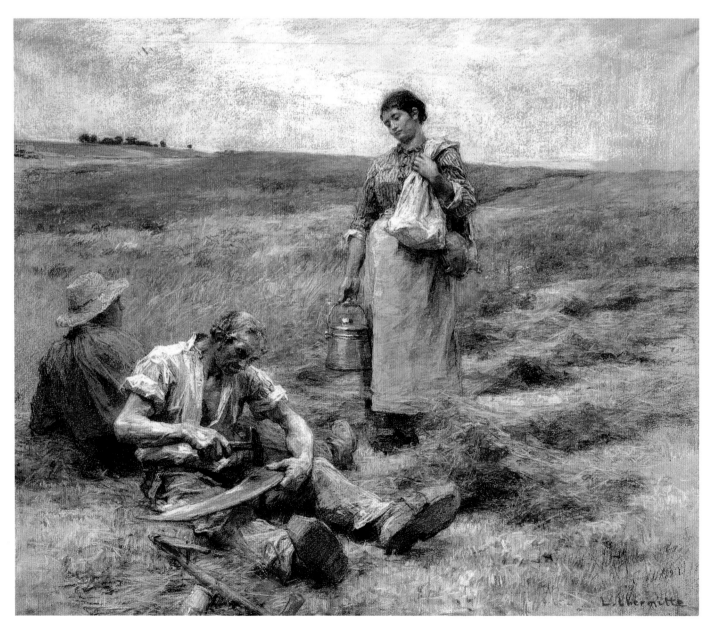

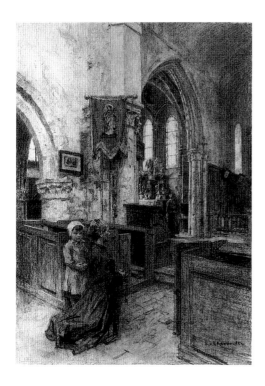

Exhibitions Glasgow, Institute of Fine Arts,
*Twenty-fifth Exhibition of Work of Modern
Artists*, n.d., cat. no. 133 (Collection of
Andrew Maxwell, Esq.). Paris, *Éxposition des
pastellistes*, 1887, cat. no. 92. London, The
Goupil Gallery, *Pictures, Pastels and Drawings
by Léon Lhermitte*, 1901. Brooklyn 1921, cat.
no. 142. Brooklyn 1988–89.

References Alexandre, Georget, *Echo de Paris*
(April 9, 1887). *Bulletin of the Brooklyn
Institute of Arts and Sciences* (1918). Dalligny,
A., *Journal des Arts* (April 8, 1887). De B. G.,
Le Libéral (April 23, 1887). Deuzem, *L'Art et
la mode* (April 8, 1887). Hamel, Mary Michele,
"A French Artist, Léon Lhermitte (1844–1925),"
Ph.D. diss., Washington University, St. Louis,
1974, cat. no. 150, illus. p. C-153. Le Pelley-
Fonteny 1991, cat. no. 9, p. 164, illus.
Monnecove, Félix de, *Revue septentrionale*
(1896), p. 135. *Le Parti national* (April 11, 1887).

66 *L'Église de Saint-Eugène (The Church of Saint-Eugène)*, June 1884

Charcoal on laid paper, 19 x 13⅜ (48.2 x 34.0);
signed in charcoal in lower right

1989.87, Purchased with funds given by Karen B.
Cohen

Provenance Collection Lanckroski, Vienna;
Galerie d'Art Ancien, Zurich, 1980; Pyms
Gallery, London, 1984; Sandorval and Co.,
Inc., New York, 1989; Purchased with funds
given by Karen B. Cohen, 1989.

Exhibitions London, Pyms Gallery, *Rural and
Urban Images, An Exhibition of British and
French Paintings 1870–1920*, October 24–
November 30, 1984, cat. no. 9, p. 31, illus.

References Le Pelley-Fonteny 1991, cat. no.
739, p. 453, illus.

create the eerie shadows of the dim church light and the rough texture
and massive weight of the stone architecture. The precise detail and
subtle modulating of light and form reflect Lhermitte's early studies with
Lecoq de Boisbaudran at the École Impériale de Dessin, where memory-
training theories and value drawing were emphasized.[2]

In the later 1880s Lhermitte began using pastel and became equally
well known for his command of this medium. In *Old Harvester's Meal*,
Lhermitte depicts figures frequently found in his work. The man with the
scythe and the standing woman appear in other works by Lhermitte; for
instance, the figure of the woman is in *Harvesters at Rest* (Private collec-
tion, Philadelphia). Closely related in composition to an oil painting that
Lhermitte contributed to the Salon of 1887, our pastel seems to be a vari-
ation in another medium.[3] It is also similar to a drawing from the series
Lhermitte executed as illustrations to André Theuriet's *Vie rustique*, pub-
lished in 1888. Shortly after Lhermitte exhibited the drawings for this pub-
lication, the first exhibition of his pastels opened at the Société des
Aquarellistes Français, where the artist continued to exhibit frequently.

KZ

1 Monique Le Pelley-Fonteny, letter to the author, July 7, 1989, The Brooklyn
Museum, Department of Painting and Sculpture, Supplementary Accession File.
The author is grateful to Le Pelley-Fonteny, who compiled the recently published
catalogue raisonné, for generously sharing her identification of the subject of this
drawing and other research about The Brooklyn Museum's drawing and pastel
before publication.

2 Gabriel Weisberg, *The Realist Tradition*, exhibition catalogue, The Cleveland
Museum of Art, 1981, p. 301.

3 Mary Michele Hamel, who wrote a dissertation on Lhermitte, suggested that
Lhermitte executed the pastel in his studio from unidentified plein air studies
(Hamel to Lenore Sundberg, November 1971, The Brooklyn Museum, November
1971, Department of Painting and Sculpture, Supplementary Accession File).

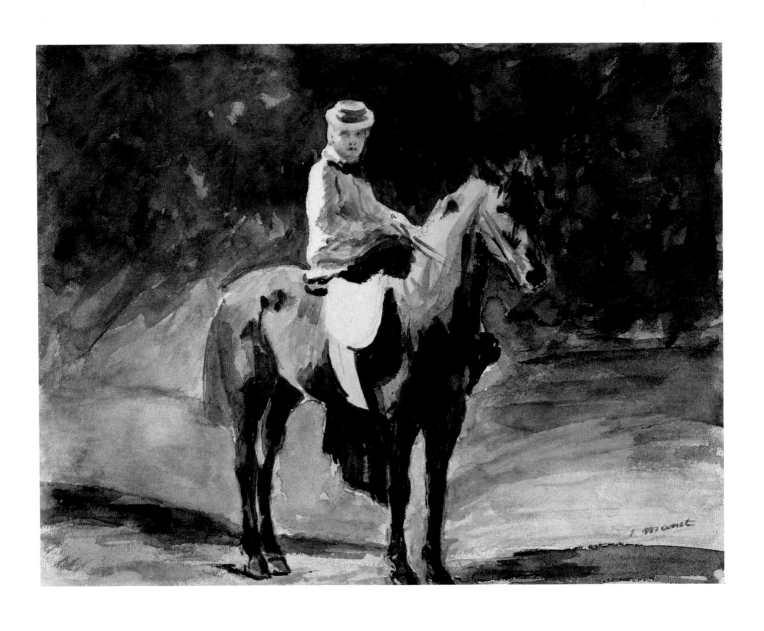

Édouard Manet
1832–1883

*A*MAZONE WAS THE TEASINGLY ironic term current during the Second Empire for the ladies of fashion who, not content simply to be borne through the Bois in their carriages to display their finery, preferred the more challenging activity of equestrian sport. The term referred partly to the traditionally masculine skill involved in mastering a horse and partly to the quasi-masculine elegance of the all-black riding habit, worn usually with a black bowler or top hat. Manet depicted that costume type in two other paintings (Pearlman Collection, New York, and Thyssen Collection, Lugano), but here we see a variant on the style: a light brown jacket over a long black skirt and a perky, flat boaterlike hat, with the black bow at the collar perhaps the most masculine element of the costume. Manet loved to observe Parisian styles of dress, the shapes of fashionable hats, the way that ribbons fell, skirts draped, and jackets shaped the waist. It was part of his study of modern life, and of his project to bring the life of Parisian streets, parks, cafés, and theaters into the visual repertoire of his culture. This project was particularly successful—until his early death at fifty-one—during the decade when Paris came to life again after the ravages of the Franco-Prussian War and the Commune. Manet once remarked that he had never painted the "essential woman" of the Second Empire, only of the Third Republic: this may have been his way of saying that although he certainly painted modern subjects before 1871, he was less inspired by the Paris of the despised Napoleon III than he was by the freedom of life under the new Republican government.[1]

Manet used watercolor as a form of quick, vivid drawing, and he was a master of setting down line, shape, and tone with a rapid, varied stroke. Here the equestrian figure is modeled in patches of dark ultramarine and the brilliant white light of the untouched paper. With a minimum of means, the artist has managed to convey the sense that the rider, while lingering to pose for him, is eager to be off. SF

1 John Richardson, *Manet*, London, 1969, p. 28.

67 *L'Amazone*, circa 1875–76
Watercolor and pencil on tan wove paper, 8³⁄₁₆ x 10⅝ (20.9 x 27.2); signed in lower right
23.45, Gift of Frank L. Babbott

Provenance Mme Manet, Paris; Ambroise Vollard, Paris, 1894; Collection Baron Vitta, Paris; Galerie Barbazanges, Paris; Collection Meyer Goodfriend, New York; Collection Sale, American Art Galleries, New York, January 4–5, 1923, no. 63; Knoedler & Co., New York; Collection Frank L. Babbott, Brooklyn; Gift of Frank L. Babbott, 1923.

Exhibitions The Brooklyn Museum, *A Loan Exhibition of Brooklyn Art Treasures and Original Drawings by American Artists*, November 20, 1924–January 1, 1925, catalogue with introduction by W. H. Fox, cat. no. 63. Bloomfield Hills, Michigan, Museum of Cranbrook Academy of Art, *Light and the Painter*, September 5–28, 1952, cat. no. 32. The Philadelphia Museum of Art and The Art Institute of Chicago, *Édouard Manet Retrospective*, November 3, 1966–December 11, 1966, catalogue with text by Anne Coffin Hanson, p. 178, illus. Traveled to The Art Institute of Chicago, January 13–February 19, 1967. Brooklyn 1988–89. Brooklyn 1990–91.

References De Leiris, Alain Weiner, *The Drawings of Édouard Manet*, Berkeley, 1969, cat. no. 455. Rosenblum, Robert, "Varieties of Impressionism," *The Art Digest* (October 1, 1954), vol. 29, p. 7, illus. Rouart, Denis, and Daniel Wildenstein, *Édouard Manet: Catalogue Raisonné*, Lausanne, 1975, p. 150, cat. no. 403, p. 151, illus. Tabarant, Adolphe, *Manet et ses oeuvres*, Paris, 1947, p. 277, cat. no. 618. Tschudy 1932, p. 104, illus.

Jean-François Millet
1814–1875

68 Study for a Ceiling Decoration,
Autumn, 1864–65

Chalk on wove paper, 12 x 8 (30.5 x 20.3);
annotated in pencil in lower left, "offert a W.P.
Babcock/croquis de J.F. Millet mon père/J.
Millet fils"

1989.133, Purchased with funds given by
Karen B. Cohen

Provenance Collection W. P. Babcock;
Spencer A. Samuels, New York; Purchased
with funds given by Karen B. Cohen, 1989.

69 Studies for *Harvesters Resting*,
undated

Conté crayon on wove paper, uneven, 7½ x 11⅝
(19.2 x 29.9)

X39, Museum Collection

Provenance Unknown

Exhibitions Brooklyn 1969. Brooklyn 1988–89.

References Laughton 1991, pp. 87–89, p. 88,
illus. fig. 6.19 (titled *Ruth and Boaz*).

70 *Study of Two Men*, undated

Conté crayon on newspaper pulpboard, 12¼ x
7⅞ (31.0 x 20.0)

41.689, Gift of the Estate of Mrs. William A.
Putnam through Walter A. Crittenden

Provenance Collection Mr. and Mrs. William
A. Putnam, Brooklyn; Gift of the Estate of
Mrs. William A. Putnam through Walter A.
Crittenden, 1941.

Exhibitions Brooklyn 1969. Brooklyn 1988–89.

References Laughton 1991, p. 38, illus. fig.
3.24 (titled *Two Men in Conversation*).

Dᴿᴀᴡɪɴɢ ᴡᴀs ᴀɴ ɪɴᴄᴇssᴀɴᴛ and impassioned activity for Millet. Contemporary accounts describe the artist as "always drawing," walking about with small notebooks in which to record his observations. Millet drew on scraps of paper, letters, documents, and books, as well as in sketchbooks and on drawing paper. His paintings frequently depended on completed underdrawings, and contemporaries claimed that as his paintings progressed, it was only with regret and at the last minute that Millet painted over the underlying sketch.[1]

The three drawings in The Brooklyn Museum reveal not only the many functions and values of drawing for Millet, but also his play with artistic process and style. The earliest drawing in the collection is the undated sheet of studies for *Harvesters Resting*, 1848–53.[2] Like most artists, Millet sometimes used the same sheet over and over again, cropped his own drawings, or purposely left sketches unfinished. Scattered across this sheet are several figures. Two figures of the standing male—on the left, clothed, and on the right, nude and smaller—illustrate Millet's classical training and his early method of first drawing, and then clothing, a nude figure, even when drawing from memory.[3] Paler lines underneath the more fully defined figure on the left reveal the anatomy Millet first drew. In the less-finished figure of the standing female at the left, Millet plays with her position and her relationship to the standing male, perhaps to determine how most to emphasize the act of charity. Drawn from life, the dog behind the male figure becomes less ferocious and dominant in the finished painting, receding further to hide behind the woman.

Turning the sheet upside down, Millet drew two sketches of a laborer carrying faggots over his shoulder—a typical lone figure of Millet's art. The flat plain of Chailly, a favored setting for the artist, is indicated by the briefest line and stretches out behind the laborer. A few brief horizontal and vertical strokes evoke the chapel and buildings of the village.

In a more cohesive drawing, *Study of Two Men*, Millet examines road workers during a respite from their labor. Although not related to a particular painting, it is similar to two works: a drawing of the same subject in the Ashmolean Museum, Oxford, and *Le Briquet*, a pastel in the Armand Hammer collection, Los Angeles.[4] One can more clearly recognize in the pastel the same two figures lighting their pipes with a stone and flint, or *briquet*, as was the custom in the 1850s before matches were in use. At the lower left corner of the Brooklyn drawing leans a stick or shovel to establish depth—a common device of Millet's. As noted, Millet used any scrap of paper for sketching: this study's paper is made from magazine pulp, and type is scattered throughout. In addition, the board seems to

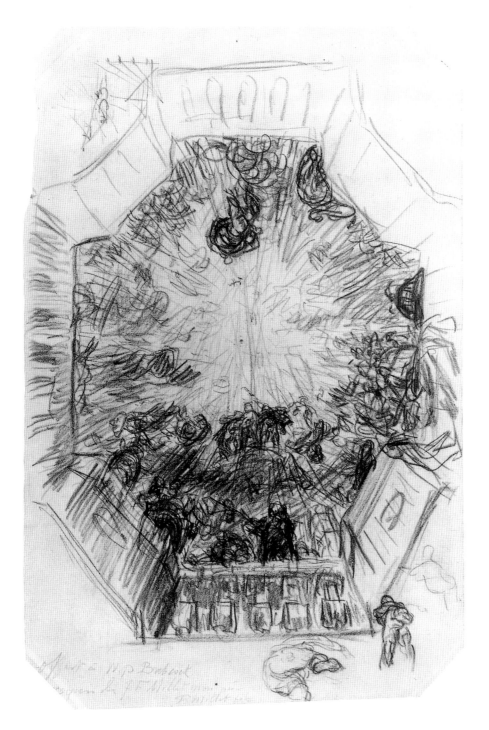

have been cut from a larger drawing, for on the verso are cropped sketches of the standing female from *Harvesters Resting.*[5]

The third, and most recently acquired, drawing in The Brooklyn Museum is uncharacteristic of the work we usually associate with Millet, but is just as indicative of his aesthetic and classical training. The study is for part of a decorative commission for the dining room of the Hôtel Thomas, a new townhouse on the boulevard Beaujon. The owner, Thomas of Colmar, hired Alfred Feydeau, an avid supporter of Millet, to design the house, and Feydeau secured the commission for Millet.[6] This work was the first such commission Millet received, and its style and subject matter were uncharacteristic of Millet's art.

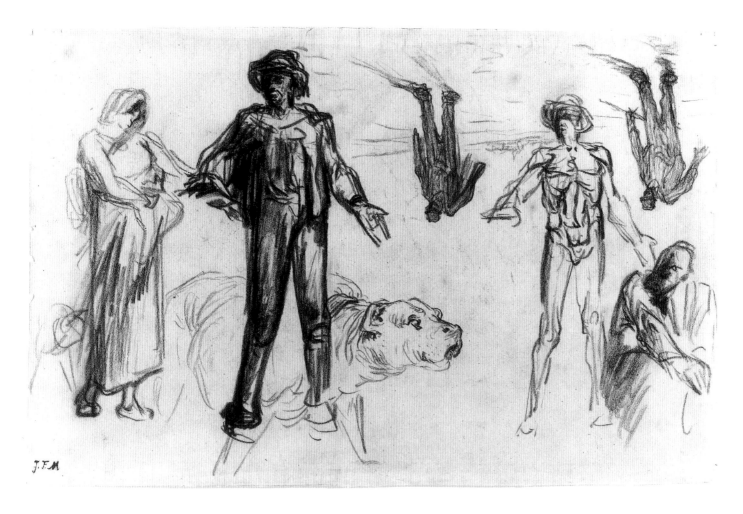

Millet chose the four seasons as the theme of the dining room; the ceiling for which the drawing is a study depicted Autumn.[7] The sketch suggests the vague allegory of the final work, a scene of numerous putti and spirits soaring through the clouds and clinging to the edges of the border. The composition indicates Millet's knowledge of French eighteenth-century ceiling painting by artists such as Antoine Coypel, as well as the earlier work of Correggio. Millet left the center empty, as in earlier ceiling paintings. Repeated, jagged pencil lines, shading the corners, create a sense of ascension and illusionistic space. Full of sketchy lines and outlined figures, the drawing seems to be more an attempt to work out the space and organization of the composition than a study of the figures and forms. Nevertheless, Millet's characteristic reworking of forms can be seen in the figures at the lower edge of the sheet and around the outline of the ceiling. KZ

1 Robert Herbert, "A Note on Four Millet Drawings," *Yale Art Gallery Bulletin* (Spring 1987), p. 66, and Robert Herbert, *Jean-François Millet*, exhibition catalogue, London, 1976, p. 111.

2 Millet's composition of *Harvesters Resting* began as the story of Ruth and Boaz. Although he changed the title, the story was clearly recognized by the public.

3 Notes from the author's meeting with Robert Herbert, January 1989, The Brooklyn Museum, Department of Prints and Drawings files. Millet employed this process until the mid-1860s.

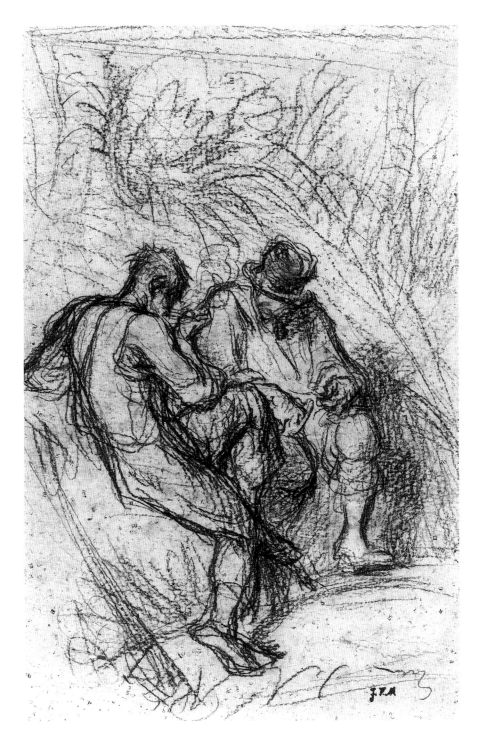

4 For this analysis, the author is indebted to Robert Herbert, meeting January 1989, and Robert Herbert to the author, April 1989, The Brooklyn Museum, Department of Prints and Drawings, Artist's File.

5 This could date the drawing to the 1850s.

6 Herbert, *Millet*, pp. 156–57, and E. Moreau-Nelaton, *Millet raconté par lui-même*, Paris, 1921, p. 151.

7 The ceiling painting was destroyed by fire at the end of the nineteenth century.

71 Study for *La Musique*, 1893

Charcoal on laid paper, 16¾ x 15½ (43.0 x 40.0); atelier stamp in lower right

1991.160, Gift of Mrs. Carl L. Selden

Provenance Atelier Morisot; Collection Mme Ernest Rouart (Julie Manet, the artist's daughter), Paris; Charles E. Slatkin Galleries, New York, 1960; Collection Mr. and Mrs. Carl Selden, New York; Gift of Mrs. Carl L. Selden, 1991.

Exhibitions Boston, Museum of Fine Arts, *Berthe Morisot, Drawings, Pastels, Watercolors, Paintings*, October 10–November 8, 1960, catalogue with text by Elizabeth Mongan, Denis Rouart, Elaine Johnson, and Regina Shoolman, p. 159, illus. plate 63. Traveled to Charles E. Slatkin Galleries, New York, November 12–December 10, 1960; California Palace of the Legion of Honor, San Francisco, December 20–January 18, 1961; Minneapolis Institute of Fine Arts, January 25–February 23, 1961. Brooklyn 1990–91.

THIS DRAWING, a study for the painting *La Musique*, circa 1893, depicts the artist's daughter, Julie Manet, and her cousin Jeanine Gobillard;[1] Morisot often depicted the two cousins together at play. The drawing reveals Morisot's graceful line and ability to evoke at once serenity, complex space, and personal relationships with just a few short strokes. Although Morisot always focused her art on interpretations of women in the confines to which society relegated them, about the time this drawing was executed she began to devote her art almost entirely to depictions of Julie. In the drawing, as in her paintings, the definition of space depends on the figure rather than articulation of a setting.

The composition is also similar to that of a series of paintings by Auguste Renoir dated 1892. Morisot and Renoir maintained a long-standing friendship,[2] and several instances of mutual influence can be found in their art from this time. KZ

1 The painting is in the Algiers Museum. Marie-Louise Bataille and Georges Wildenstein, *Berthe Morisot: Catalogue des peintures, pastels et aquarelles*, Paris, 1961, cat. no. 336.

2 Ann Distel, John House, and John Walsh, et al., *Renoir*, exhibition catalogue, Arts Council of Great Britain, London, Grand Palais, Paris, and Museum of Fine Arts, Boston, 1985, cat. nos. 89–91.

72 *Nu debout en profil* (*Nude Standing in Profile*), 1906

Charcoal on laid paper, 21⅛ x 14¼ (53.6 x 36.2); signed in lower right

43.178, Gift of Arthur Wiesenberger

Provenance A. Drouant, Paris; Ernest Brown and Phillips, Ltd.; The Leicester Galleries, London; Collection Arthur Wiesenberger, New York; Gift of Arthur Wiesenberger, 1943.

Exhibitions The Art Gallery of Toronto, *Picasso and Man*, January 11–February 16, 1964, catalogue by Jean Sutherland Boggs, cat. no. 41. Traveled to Montreal Museum of Fine Arts, February 28–March 31, 1964. Brooklyn 1988–89. Brooklyn 1990–91 (exhibited January 15–June 3, 1991).

References Brooklyn 1988, p. 189, no. 141, illus. Kramer 1987, p. 105, illus. Zervos, Christian, *Pablo Picasso*, vol. I, *Works from 1895–1906*, Paris, 1932, p. 176, no. 369.

THIS DRAWING IS ONE of a number of studies for the painting *Two Nudes*, 1906 (The Museum of Modern Art, New York).[1] Although the figure is related to those in the painting through its sculptural, blocky form and stylized features, the pose of the nude in Brooklyn's drawing was not used in the final painting. It is, however, very close to the standing figure in another charcoal drawing of this series entitled *Woman Seated, Woman Standing*, 1906 (Philadelphia Museum of Art).[2]

The painting *Two Nudes* and the studies for it are now recognized as significant transitional works that mark the path from the saltimbanques of Picasso's Rose Period to *Les Demoiselles d'Avignon*. In October 1905 Picasso had seen Cézanne's *Baigneurs au Repos* in the Salon d'Automne and was affected by the monumentality of the figures. He had also been impressed by the stylizations he had observed in the recently excavated Iberian sculptures exhibited at the Louvre in the spring of 1906.[3] The sculptural forms and stylized features of the figures in his 1906 studies of nudes show how quickly Picasso could absorb and adapt sources.

In these studies can be found the sources for the poses of the figures in *Les Demoiselles d'Avignon*. The strong geometric profile and heavily demarcated shading, hairstyle, expression, and body position of the figure at the far left in *Les Demoiselles d'Avignon* are similar to those seen in Brooklyn's drawing.

In fact, this drawing, a masterpiece in its own right, represents the strong female profile to which Picasso returned again and again throughout every phase of his long and varied career. LKK

1 Pierre Daix and Georges Boudaille, *Picasso, The Blue and Rose Periods, A Catalogue Raisonné of the Paintings, 1900–1906*, Greenwich, Connecticut, 1966, p. 324, no. XVI5, p. 323., illus.

2 Ibid., p. 325, illus., no. XVI7.

3 William Rubin, ed., *Pablo Picasso, A Retrospective*, exhibition catalogue, The Museum of Modern Art, New York, 1980, p. 59.

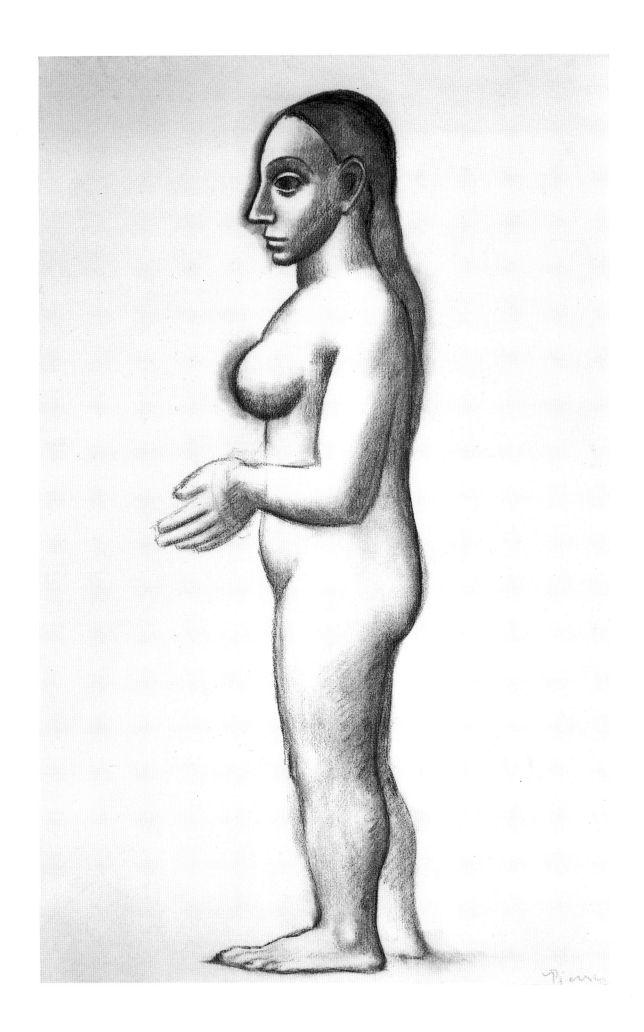

105

Isidore-Alexandre-Augustin Pils
1813–1875

73 *Enfants kabyles (Kabyle Children)*, 1860s

Pencil and gouache on brown wove paper, 10⅝ x 13⁷⁄₁₆ (27.0 x 34.1); studio stamp in lower right (very faint, without ink)

33.39, Gift of Mrs. Henry Wolf, Austin M. Wolf, and Hamilton A. Wolf

Provenance Atelier Pils; Sale, Hôtel Drouot, Paris, March 20, 1875–April 1, 1876, no. 277; Collection J. Peoli; Collection Sale, American Art Galleries, New York, May 8, 1894, no. 2435; Gift of Mrs. Henry Wolf, Austin M. Wolf, and Hamilton A. Wolf, 1933.

Exhibitions Brooklyn 1988–89.

THIS WATERCOLOR, recently attributed to Isidore Pils, belongs to the artist's series of sketches executed during a four-month trip to Algeria in the 1860s.[1] Pils received many commissions from Napoleon III and is particularly well known for his depictions of the military. This watercolor was done when he was sent to Algeria as part of a group gathering information about the Kabyle tribes.

The Brooklyn Museum's sketch reveals Pils's keen observation not only of costume, mannerism, and facial structure, but also of expression. Roughly outlining the body and limbs, he then worked the figures in detail, beginning with the face. Requested to gather information about the Kabyle, Pils tended to depict only figures in his sketches, as here, isolating his portraits from the landscape or other settings and rendering them as costume and character studies rather than as records of the culture or milieu. KZ

1 The author thanks Neil Fiertag, Paris, for bringing this information to her attention.

Camille Pissarro
1830–1903

74 *Paysanne remassant des pommes de terre (Peasant Woman Pulling Potatoes)*, 1880s?

Charcoal and wash on wove paper, 7¹³⁄₁₆ x 6¹⁄₁₆ (19.9 x 15.4); signed in charcoal in right foreground, "C.P."

61.120.1, Gift of Lillian Malcove

Provenance Pissarro family; Sale, Hôtel Drouot, Paris, December 7–8, 1928; Georges Seligmann, New York; Collection Dr. Lillian Malcove, New York; Gift of Lillian Malcove, 1961.

Exhibitions Brooklyn 1988–89.

75 *Pont de Pierre, Rouen* (for soft-ground etching), 1883

Pencil on light wove paper, 7½ x 8⅞ (19.1 x 22.5); signed in lower right (similar to one of the artist's stamps but apparently gone over with brown-black ink)

85.40.1, A. Augustus Healy Fund and Carll H. De Silver Fund

Provenance Pissarro Family; Purchased in Paris art market, 1936; Collection Elizabeth Osborne Sweet; Museum Purchase, 1985.

Exhibitions The Brooklyn Museum, *Impressionist Prints from The Brooklyn Museum Collection*, March 6–May 5, 1986. Brooklyn 1988–89.

Pissarro worked in graphic media more avidly than anyone else of his generation except perhaps Edgar Degas. Three-quarters of his graphic work dates from between 1880 and 1890, as do all of the Museum's works by him. Beginning in 1870, drawing played an increasingly important role in Pissarro's art, but as the Museum's four works suggest, his work during the 1880s is difficult to categorize according to style or development, since he worked in several styles, media, and subjects simultaneously.[1]

The earliest drawing in the collection, *Pont de Pierre, Rouen*, 1883, was executed during Pissarro's first extended trip to Rouen. This visit was important to Pissarro for many reasons, including its stimulation of a renewed interest in topographical views, which he pursued in both prints and drawings. Our drawing is a preparatory study for a soft-ground etching, of which the Museum owns both states.[2] The straightforward drawing of precise lines is identical, though in reverse, to that of the print; the residue of brown ground also remains on the verso, adhering where the pressure of the pencil drawing was applied to the recto in transferring the

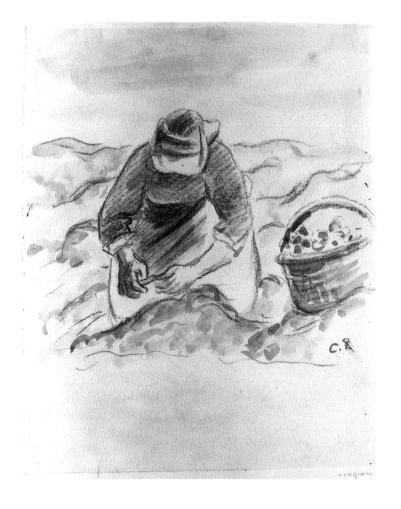

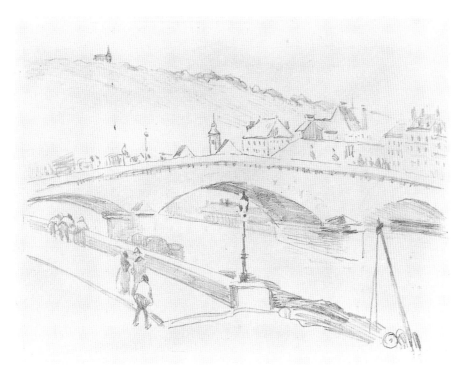

composition to the plate.[3] From 1879 to 1882 Pissarro had worked closely with Degas, experimenting and sharing ideas about printmaking, including this soft-ground technique.

Drawn in the linear style characteristic of Pissarro's prints of the time, the work depicts the town from the far side of one of the westernmost bridges across the Seine, looking toward Bon Secours. Pissarro's early art education stressed the topographical tradition of the early nineteenth century, and thus he was well aware of the popular views of Rouen.[4] Although he was influenced by earlier artists' views—compositions remarkably similar to those by Bonington and others can be found in his work—he focused more often, as in the Museum's drawing, on the modern life of the city than on familiar views or historic monuments.

Although Pissarro made extensive use of preparatory drawings for prints, integrating them into the process, as in the Rouen view, his drawings of the 1880s for the most part became increasingly independent of his paintings and prints. The charcoal-and-ink-wash drawing *Peasant Woman Pulling Potatoes* incorporates many characteristics of Pissarro's drawing at this time. He was increasingly concerned with depicting the human figure in loose, fluid strokes, often repeating the same contour. Pissarro diminished any elaboration of the setting and raised the horizon line. He showed the figure engaged in a specific activity, usually seated or in contact with the ground (as here, where this interaction between the woman and the earth more fully suggests the otherwise vaguely articulated setting). Many of these elements, including the subject matter, reflect the influence of Millet.

In the Museum's drawing the upper and lower thirds of the paper (background and foreground) are left empty (even the signature is raised) as

76 *La Dindonnière* (*Girl in Field with Turkeys*), 1885

Gouache on silk mounted on board, fan-shaped, 25⅝ x 8³⁄₁₆ (65.1 x 20.7); signed and dated in lower left, "C. Pissarro 1885."

59.28, Gift of Edwin C. Vogel

Provenance Collection Mme Bonoy, Paris, 1948; Galerie Roux-Hentschel, Paris, 1948; Collection Weil, Paris, 1950; Collection Gas, Paris, 1950; Collection Matthey, Paris, 1951; Galerie de l'Élysée, Paris; E. Silberman Galleries, New York; Knoedler and Co., New York, 1959; Gift of Edwin C. Vogel, 1959.

Exhibitions Brooklyn 1922–23, cat. no. 184. London 1980–81, cat. no. 211. Staatsgalerie Stuttgart, *Fan Painting*, July 1–September 2, 1984, cat. no. 56, p. 107, illus. Traveled to Bellerive, Zurich, September 12– November 4, 1984. Brooklyn 1988–89. Brooklyn 1990–91.

References Gerstein, M., "Impressionist and Post-Impressionist Fans," Ph.D. diss., Harvard University, Cambridge, Massachusetts, 1978, pp. 169–70, cat. no. 39, illus. Lloyd 1981, p. 87, illus. Needham, Gerald, *Japonisme: Japanese Influence on French Art 1854–1910*, Cleveland Museum of Art, n.d., p. 119, illus. (reprinted in Barbara Ehrlich White, *Impressionism in Perspective*, Englewood Cliffs, New Jersey, 1978, p. 130, illus.).

77 *Vue de Bazincourt*, 1889

Gouache on silk, 8¹⁄₁₆ x 10¹⁄₁₆ (20.5 x 25.5); signed in lower center; inscribed in left, "A mon cher Fred souvenir d'affection"

27.389, Gift of Frank L. Babbott

Provenance Collection Frédéric Pissarro, Paris; Collection Alfred Isaacson (his nephew); Purchased in London art market, 1927; Collection Frank L. Babbott, Brooklyn; Gift of Frank L. Babbott, 1927.

Exhibitions New York, Wildenstein and Co., Inc., *Camille Pissarro and His Place in Art*, October 24–November 24, 1945, catalogue with text by Georges Wildenstein, cat. no. 27. Brooklyn 1988–89. Brooklyn 1990–91.

References *The Brooklyn Museum Bulletin* (Fall 1954), vol. 16, p. 24. *Catalogue of Paintings Exhibited by Inter-State Industrial Exposition of Chicago*, Chicago, 1890, cat. no. 237. Pissarro, Ludovic, and Lionello Venturi, *Camille Pissarro*, Paris, 2 vols., vol. I, p. 279, cat. no. 1430, illus. Tschudy 1932, p. 106.

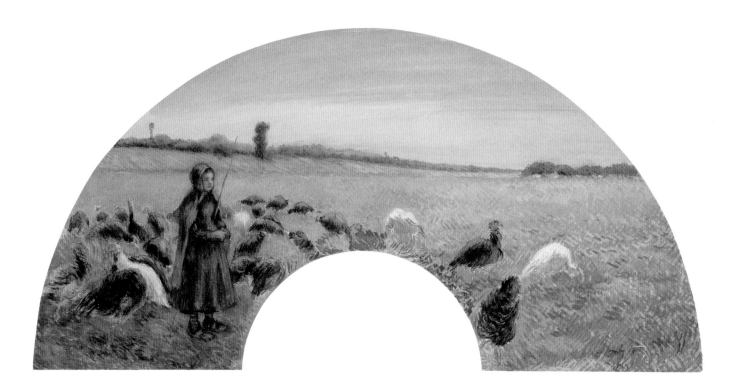

Pissarro reduces his composition with loose line to a small space. The variation of wash and its play with the white paper modulate the light and depth. The setting, suggested by pale, fragile lines, is better established by the weighty volume of the kneeling woman at work. The peasant woman, bent over the ground, hides her face, as do most of the artist's figures. Her anonymity reinforces the focus on her activity, as well as the emphasis on formal qualities.

Girl in Field with Turkeys is a beautiful example of Pissarro's fans painted on fabric.[5] It employs a subject similar to the wash drawing's, but for a decorative effect; unlike the peasants the artist depicted in other media, the figure and turkeys here adopt a miniaturist aspect. Pissarro's earliest fans date from 1879, just when he began to work with Degas, who probably interested him in the decorative format as yet another art form with which to experiment. The shape, which allowed him to incorporate some of his favorite devices, appealed to Pissarro. The off-center composition, as well as the high horizon line that he favored in such wash drawings as *Peasant Woman*, were emphasized by the arc of the fan.

Vue de Bazincourt, a gouache on silk, is an example of one of Pissarro's late landscapes. Although his graphic output suggests a greater concern with depicting the human form, and his letters suggest a break with the Impressionist landscape, this gouache reveals Pissarro's distinct working styles in different media. Although at this time he painted in a Neo-Impressionist style, the work is painted with long, sketchy strokes. Dedicated to the artist's nephew, the gouache depicts the view across the meadows of Eragny-sur-Epte, the artist's home, toward the next village, Bazincourt. One can see the spire of Bazincourt's church reaching up above the trees at the left. Pissarro often depicted similar views in the late 1880s and early 1890s as he increasingly remained at home, often because of illness.[6] KZ

1 Richard Brettell and Christopher Lloyd, *Catalogue of Drawings by Pissarro*, London, 1980, p. 19. The authors suggest that Pissarro cultivated this diversity.

2 Loys Delteil, *Le Peintre-Graveur illustré*, Paris, 1923, vol. 27, Delteil 66. Some prints of the image, such as the impression of the second state in The New York Public Library, are dated 1884, and others are dated later. As the NYPL impression is dated in Pissarro's own hand, it has been suggested that perhaps Pissarro printed some of his Rouen images when he returned to Paris.

3 Another example of this is the drawing of *Côte Ste. Catherine, Rouen* (Brettell and Lloyd, *Catalogue*, no. 287) in the Ashmolean Museum, Oxford. Barbara Stern Shapiro, "Pissarro as Printmaker," in London 1980–81, pp. 214–15.

4 The tradition was established, in particular, by Baron Taylor's *Voyages pittoresques et romantiques dans l'ancienne France*, Paris, 1820–78.

5 The lower edges of the fan were originally angled, and later the artist leveled off edges and filled in the gap.

6 For instance, a drawing (Ashmolean Museum, Oxford; Brettell and Lloyd, *Catalogue*, no. 231) and an etching (D. 79) depict the same view; the print, 1888, depicts the same scene in winter.

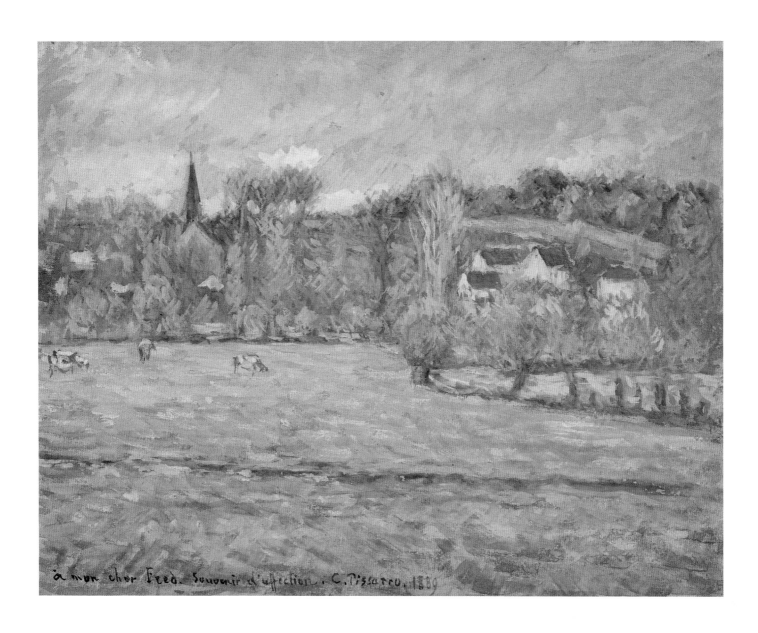

78 *Projet de décoration pour les galeries cintrées, Musée Picardy, Amiens (Study for Mural for Arched Galleries)*, 1864–65

Gouache, ink, pencil, and red chalk on thick wove paper with additional pieces attached, 11⅝ x 52⅞ (29.5 x 134.3)

22.61, Smith Memorial Fund

Provenance H. Anglade; Adam-Dupré, Paris; Durand-Ruel Galleries, New York, 1913; Galeries Durand-Ruel, Paris, 1913; Durand-Ruel Galleries, New York, 1922; Museum Purchase, 1922.

Exhibitions Brooklyn 1922–23, cat. no. 180. Brooklyn 1924–25, cat. no. 67. The Brooklyn Museum, *The First Exhibition of the National Society of Mural Painters*, February 4–March 1, 1925, catalogue with text by H. van Buren Magonigle, cat. no. 121. Brooklyn 1988–89.

References "English and French Paintings of Today; The Recent Exhibition," *The Brooklyn Museum Quarterly* (January 1923), vol. 10, pp. 15–16. Foucart-Borville 1976, pp. 63–64, 66, illus. fig. 16.

79 *Study of a Standing Male Nude*, circa 1880

Black chalk on gray-green laid paper, 12 x 9 (30.5 x 22.8)

1989.90, Purchased with funds given by Karen B. Cohen

Provenance Spencer Samuels and Co., Ltd., New York; Purchased with funds given by Karen B. Cohen, 1989.

80 *Portrait de Madame Montrosier*, circa 1890

Pencil on buff-colored wove paper, 19½ x 13⅛ (49.5 x 33.3); signed in pencil in lower right, "Madame Montrosier/bien affectueusement/ P. Puvis de Chavannes"

88.51, Purchased with funds given by Karen B. Cohen

Provenance Private collection, France; Galerie Heim, Paris; Jill Newhouse, New York, 1988; Purchased with funds given by Karen B. Cohen, 1988.

Exhibitions Brooklyn 1988–89.

THE THREE WORKS ON PAPER by Puvis de Chavannes in The Brooklyn Museum reflect the variety of concerns and approaches the artist considered throughout his career. Puvis's most famous works are his decorative mural projects, and critics and historians have characterized his art by simplified forms, soft hues, universal themes, and Arcadian settings. In his own time Puvis's work aroused controversy; artists and critics, including both academics and members of the avant-garde, admired him, were puzzled by him, and misunderstood him. While he was often criticized for not knowing how to draw, his high regard for draftsmanship is recorded not only in the thousands of drawings he left behind, but also in a comment to his biographer, Vachon, that "the sketch is the libretto, the painting, the opera."[1]

In Puvis's drawings, an interest emerges in the subtleties of human form, movement, and light, elements subsumed in his painting style. His sketches, almost exclusively figure studies, are usually preparatory studies for decorative projects. Puvis customarily drew from a model, but often he traced or worked from another drawing.

The earliest of his works in the collection, *Study for Mural for Arched Galleries*, 1864–65, is an unexecuted design for galleries in the Musée de Picardie in Amiens.[2] When that museum purchased Puvis's canvases *Peace* and *War*, which had been exhibited in the Salon of 1861, and later commissioned the rest of the mural cycle, the artist's reputation for decorative projects was established. The Brooklyn Museum's study reveals Puvis's consideration of the architecture as part of his design, as well as his amalgamation of classical forms from a variety of sources, including Poussin, Bellini, and contemporaries such as Théodore Chassériau and Henri Lehmann. Its imagery and figures recall the themes and style of Puvis's murals now located in Amiens: *Work, Repose, Peace,* and *War*. The mural reveals many motifs Puvis would explore and favor throughout his career. For instance, the triumphant horsemen from *War*, the forgers from *Work*, the doves of *Peace*, and the bows and arrows of *War* are integrated into The Brooklyn Museum's study.[3] Puvis depicts two series of vignettes, Arcadian themes, in which he portrays universal ideas and ideals on both an earthly and an otherworldly level. Indicated only in outline, all the figures lounge, frolic, or work in nature.

Study of a Standing Male Nude, circa 1880, is a more typical example of Puvis's figural studies and may even be a study for a figure for *Ludus Pro*

Patria, 1880, the last mural added to the cycle at the Musée de Picardie. Puvis drew from a model and always preserved in his drawings a certain human awkwardness, which is masked in his idealized, graceful painted figures.

The third drawing in The Brooklyn Museum is a portrait of a friend, Madame Montrosier, dedicated in Puvis's hand. Puvis also drew a companion portrait of her husband, Eugène Montrosier, the art critic and collector, who often wrote about the artist.[4] The Museum's drawing is a beautiful profile, the attitude Puvis often chose for his portraits, perhaps because the silhouette appealed to him or perhaps because of the resulting simplified form. The silhouette's reinforcement of the profile line and the modeling of hair, neck, and shoulders are all qualities of Pre-Raphaelite work, which attracted Puvis at this time. KZ

1 Marius Vachon, *Puvis de Chavannes*, Paris, 1895, p. 97.

2 Foucart-Borville 1976. Foucart discusses the mural cycle in detail, using the Amiens archives. Aimee Brown-Price discusses the Brooklyn design in detail in her forthcoming book. The author is extremely grateful to Ms. Brown-Price for sharing her research and insight into all the works by Puvis in the collection (Brown-Price to Linda Konheim Kramer, June 3, 1991, The Brooklyn Museum Department of Prints and Drawings, Artist's File). In her manuscript, Ms. Brown-Price suggests that the Brooklyn mural study is the first design for the project.

3 Brown-Price, unpublished manuscript.

4 Last known to be in the hands of a gallery in Paris (1989).

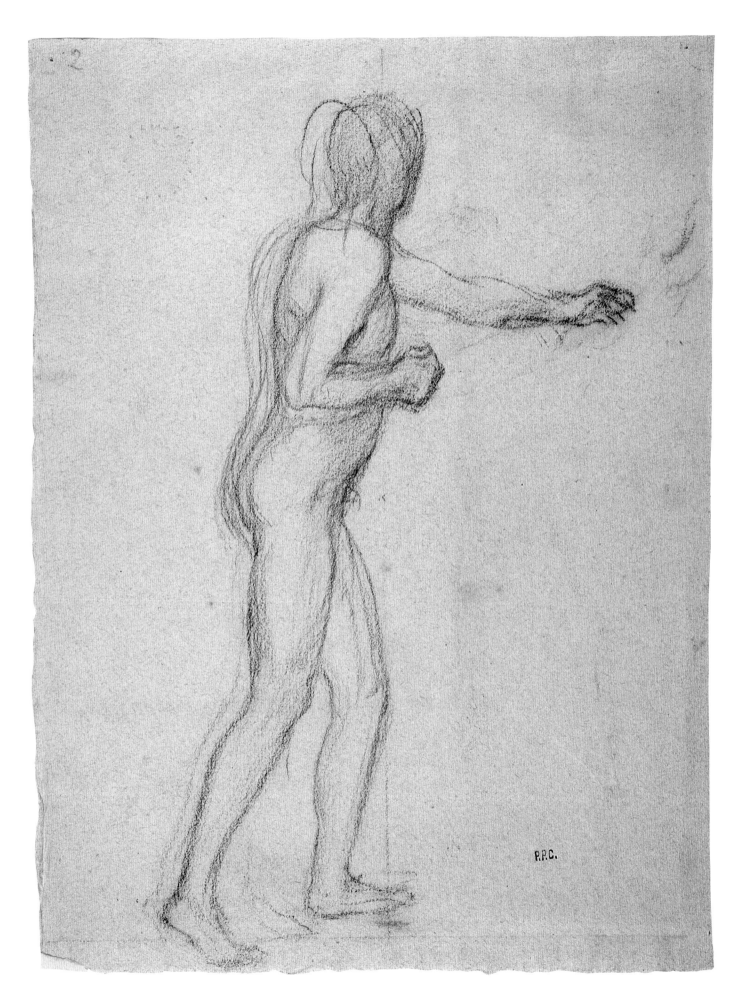

114

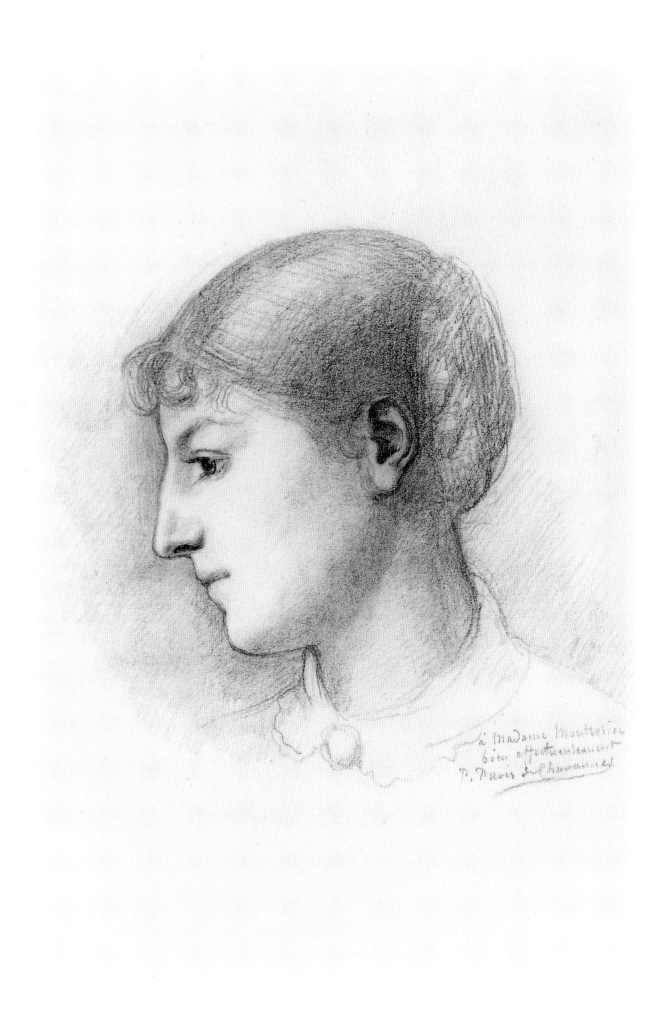

à Madame Mautrosier
bien affectueusement
P. Puvis de Chavannes

81 *Anémones et tulipes*, 1902–3

Pastel on tan paper, 21⅞₆ x 18¼ (54.7 x 46.4); signed in lower right

42.198, Gift of Mrs. Horace Havemeyer

Provenance Bernheim-Jeune, Paris, 1907; J. Dubourg, Paris; Chester H. Johnson Galleries, Chicago; Sale, American Art Association, Anderson Galleries, New York, Nov. 14, 1934, p. 12, no. 31, illus.; H. O. Havemeyer Collection, New York; Gift of Mrs. Horace Havemeyer, 1942.

Exhibitions Brooklyn 1988–89. Brooklyn 1990–91 (exhibited January 15–June 3, 1991).

References Berger 1965, p. 215, cat. no. 447. Wegener 1954, pp. 21, 25.

82 *Fleurs dans un vase (Flowers in a Jug)*, circa 1909?

Pastel on tan paper, 21⅝ x 16½ (54.9 x 41.9); signed in pencil in lower right

71.171, Anonymous gift in memory of Horace Havemeyer

Provenance Étienne Bignou, Paris; Galerie Druet, Paris, 1923; Chester H. Johnson Galleries, Chicago; Sale, American Art Association, Anderson Galleries, New York, November 14, 1934, p. 23, no. 61; Collection Horace Havemeyer; Collection Mr. and Mrs. Richard Perkins (Mrs. Adelina Havemeyer), New York; Anonymous gift in memory of Horace Havemeyer, 1971.

Exhibitions Paris, Galerie Druet, *Oeuvre d'Odilon Redon*, June 11–30, 1923, cat. no. 78. Brooklyn 1988–89.

LATE IN HIS LIFE, perhaps stimulated by his wife's gardens, Odilon Redon turned to an exhaustive study of bouquets of flowers.[1] The process became an exploration of relationships of color, space, fantasy, and reality as Redon would freely, often almost imperceptibly, mix real and fantastic flowers in the same composition. "It is possible that halfway toward a realization," Redon wrote, "a sudden aid to my memory sometimes forced me to stop certain works . . . finding them formed and organized according to my wish: flowers at the confluence of two river banks, that of representation and that of memory. It is the soul of art itself, the good earth of the real, harrowed and tilled by the spirit."[2]

Redon's interest in flowers first appears to a lesser degree in his early work and was probably also encouraged by his close friend and mentor, the botanist Armand Clavaud.[3] His late flower studies, however, are part of his investigation of color, which began only in the last twenty-five years of his life. This change in Redon's art, accompanied by various financial and personal crises, was explored through his affinity for pastel.[4] Pastel possessed many of the qualities that appealed to Redon in charcoal, a frequent medium of his earlier work. Rather than subsume the medium's characteristics in his composition, as Gauguin sometimes did (see cat. no. 42), Redon exploited the medium's myriad powdery textures and abilities to blend and build up color. Redon wrote that pastel rejuvenated him "materially and morally," noting that "color contains a joy which relaxes me."[5]

The contrast between the two pastels in The Brooklyn Museum reveals some of the many ways that Redon attempted to render his medium and subject—and how various they could be. Executed within the same few years, the two rely on different qualities of pastel and different uses of the background for their impact, even though both bouquets are arranged, as always in Redon's work, in jugs with no accoutrements or setting. In *Flowers in a Jug*, circa 1909(?), the empty brown paper, the heavy jug, and the tiny scale of the flowers give the composition a more modest appearance. In contrast, *Anémones et tulipes*, 1902–3, more ostentatiously leaps from its paper, with loose pastel lines energetically racing in every direction around the flowers. The composition has more light, emanating from the center or the top of the jug of flowers. In addition, the large flowers overwhelm and obscure the more graceful vase. Although the colors of both are saturated, the pastel is used in the later work to create a more solid, weightier effect. The anemones and tulips have a greater variety of textures, particularly a sense of velvety delicacy in the dominant, vibrant petals.

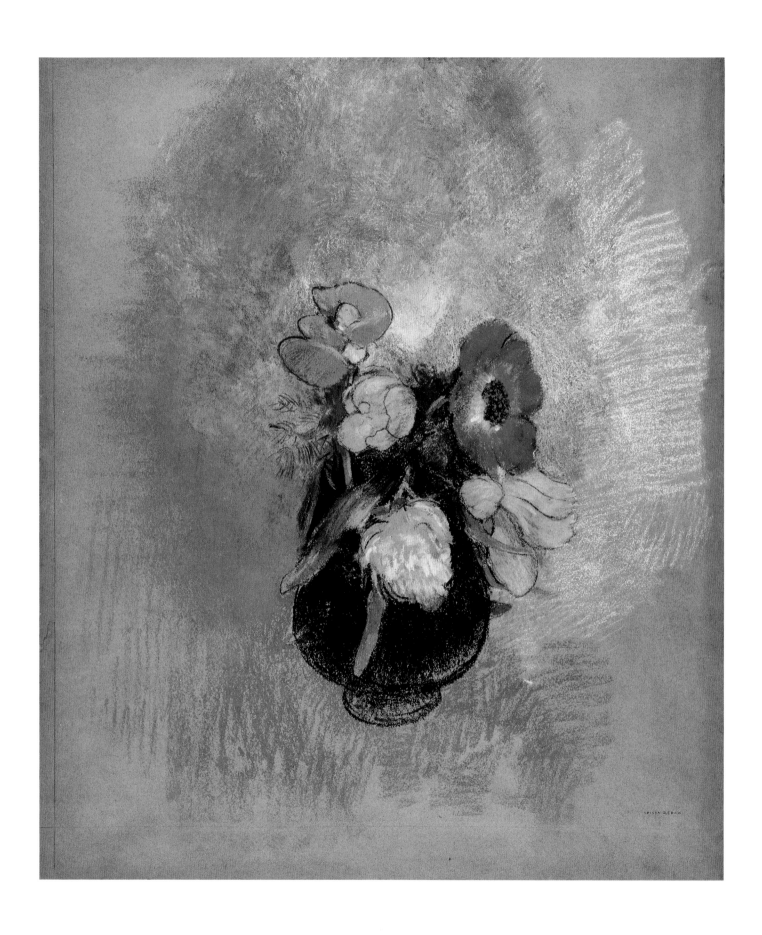

Redon's association with the realm of the magical, spiritual, and mystical —the eerie worlds of dream and imagination—is apparent in these still lifes, not only in his subtle mixing of the most careful, accurate studies of natural and fantastic form, but in his isolation of these forms. His compositions are not just exercises in still life, but an evocation of a world of color and form and an examination of medium and motif. He takes a seemingly objective world and in his masterful way reveals it as subjective and otherworldly. KZ

1 Berger 1964, in an attempt to compile a chronology of Redon's flower compositions as well as a catalogue of the various kinds of jugs or vases Redon used.

2 Odilon Redon, *A Soi Même Journal 1867–1915*, 1922, reprint Paris, 1961, p. 120.

3 Nannette V. Maciejunes, "Odilon Redon: An Art According to Myself," in *Odilon Redon: The Ian Woodner Family Collection*, Memphis, Tennessee, 1990, p. 19.

4 At this time, following the death of close friends such as Rodolphe Bresdin, Redon experienced a deep mystical crisis, as well as a financial crisis that led to the sale of his family home.

5 Maciejunes, p. 20.

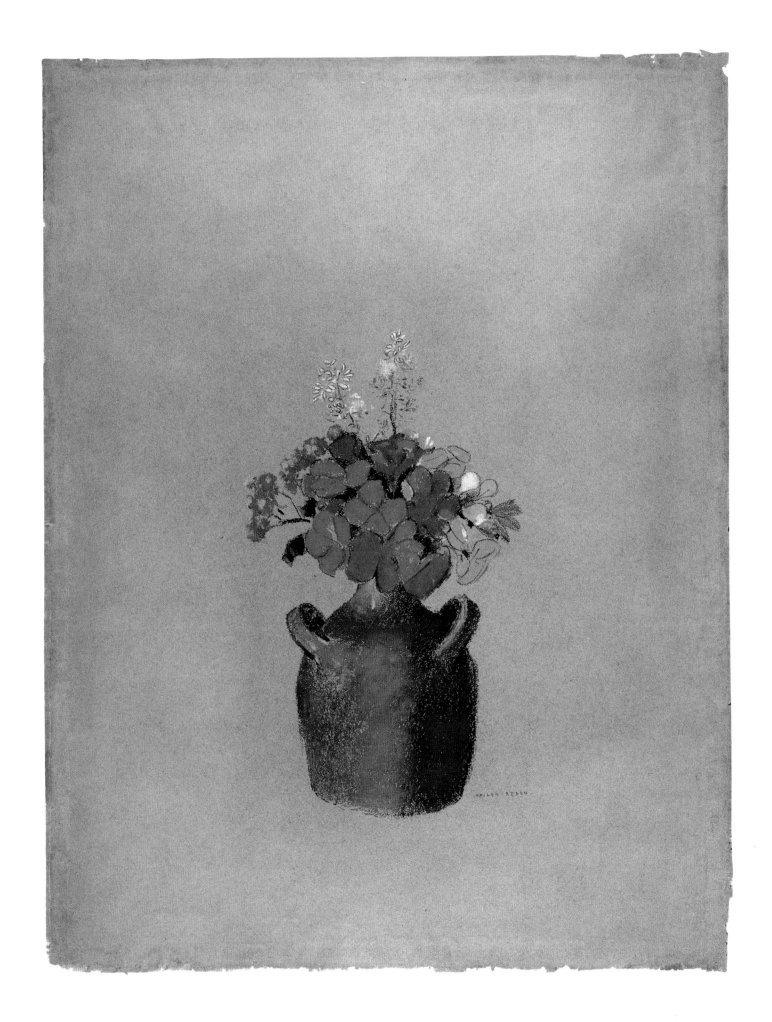

Auguste Rodin
1840–1917

83 *Jean Simpson, debout (Jean Simpson, Standing)*, 1903

Pencil on cream wove paper, 12¹³⁄₁₆ x 9¹³⁄₁₆ (32.6 x 25.0); signed in pencil in lower right

87.94.2, Gift of the B. Gerald Cantor Art Foundation

Provenance Jean Walker Simpson, East Croftsbury, Vermont; Sale, Sotheby's, New York, December 10, 1982; Collection Mr. and Mrs. B. Gerald Cantor; Gift of the B. Gerald Cantor Art Foundation, 1987.

Exhibitions Brooklyn 1988–89.

THE MODEL FOR THESE DRAWINGS by Rodin was Jean Simpson, the daughter of John Woodruff Simpson and Kate Seney Simpson, patrons of the artist and of Edward Steichen.[1] In 1902 Rodin made a marble bust of Mrs. Simpson that is now in the National Gallery of Art, Washington, D.C., along with the rest of her collection of the artist's work.

These drawings can all be dated to 1903, the date that Rodin inscribed on one of them. At this time, the year after the completion of her mother's portrait, Jean Simpson was still a child. We know from a letter of 1912 to her from Rodin that she continued her friendship with him.[2]

These warm and personal sketches express an intimacy rarely found in Rodin's work. LKK

1 These drawings were in the possession of Jean Simpson at the time of her death and were sold in 1982 with other items from her estate at Sotheby's in New York.

2 Two letters from Rodin to Jean Simpson are in the collection of The Brooklyn Museum. Both are thank-you notes for cards she sent him, and one is dated 1912.

83

85

84

84 *Mlle Jean Simpson, assise (Miss Jean Simpson, Seated)*, 1903

Pencil and watercolor on cream wove paper, 12¹³⁄₁₆ x 9⅞ (32.5 x 25.1); signed in pencil in lower right; annotated in upper right, "Mademoiselle Jean/28 Sept. 1903"

87.94.4, Gift of the B. Gerald Cantor Art Foundation

Provenance Jean Walker Simpson, East Croftsbury, Vermont; Sale, Sotheby's, New York, December 10, 1982; Collection Mr. and Mrs. B. Gerald Cantor; Gift of the B. Gerald Cantor Art Foundation, 1987.

Exhibitions Brooklyn 1988–89.

85 *Tête de Jean Simpson (Head of Jean Simpson)*, 1903

Pencil on cream wove paper, 12¹⁵⁄₁₆ x 9¹³⁄₁₆ (32.9 x 25.0); signed in pencil in lower right

87.94.3, Gift of the B. Gerald Cantor Art Foundation

Provenance Jean Walker Simpson, East Croftsbury, Vermont; Sale, Sotheby's, New York, December 10, 1982; Collection Mr. and Mrs. B. Gerald Cantor; Gift of the B. Gerald Cantor Art Foundation, 1987.

Exhibitions Brooklyn 1988–89.

James Jacques Joseph Tissot
1836–1902

86 *Life of Christ*, 1886–94

Series of 344 gouaches and 164 ink drawings on wove paper, various sizes; each signed in lower left

00.159.1–.351, Purchased by Public Subscription

Provenance Purchased by Public Subscription, 1900

Exhibitions Brooklyn 1924–25, cat. no. 69. Brooklyn 1988–89. The Brooklyn Museum, *A Selection from Tissot's "Life of Christ": Watercolors from The Brooklyn Museum*, December 15, 1989–February 19, 1990.

References Wentworth, Michael, *J. James Tissot and His Life of Christ*, Washington, D.C., 1984, published in conjunction with the traveling exhibition *The Biblical Paintings of J. James Tissot*, organized by Norman Kleeblatt, The Jewish Museum; Annette Blaugrund, The Brooklyn Museum; and Elizabeth Driscoll, The Smithsonian Institution Traveling Exhibition Service, illus. *The Journey of the Magi, Jesus Ministered to by Angels*, and *The Annunciation*.

By THE MID-1880s Tissot had become a noted painter of both the surface and the tensions of upper-bourgeois life in Paris and London. In the course of that decade, however, he underwent a spiritual crisis that led him first to spiritualism and then to a return to the Catholic Church. He became determined to devote his life to the depiction of the life of Christ. Believing, as many did in the late nineteenth century, that there was an unbroken link between the life of the contemporary peoples living in Palestine and the life of biblical times, Tissot went to Palestine in October 1887 and remained for six months, returning again in 1889. There he studied the myriad details of topography, archaeology and architecture, costume, ritual, and physiognomy of what was known as the Holy Land. From these studies he composed the 344 works in gouache on paper that served as illustrations to a publication that came to be known as the Tissot Bible. In addition, he made 164 black-and-white ink drawings, which served as vignettes, initial decorations, and other designs for the Bible, which was first published in 1896–97 and was reissued in several later editions. In 1898 Tissot arranged for all of these illustrations, both gouaches and drawings, to tour the United States, where they were received with great enthusiasm. In 1900 The Brooklyn Museum raised funds by public subscription in order to purchase the whole collection. A few of the gouaches have been published in the catalogues of Tissot exhibitions in recent years, but publication of the series as a whole has occurred only in the Bible itself. SF

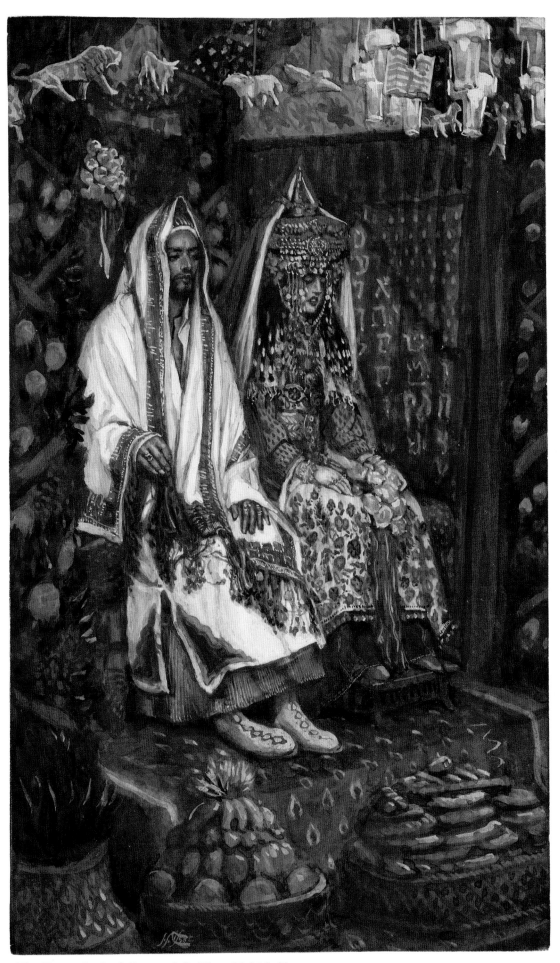

The Betrothed of Cana of Galilee, 00.159.61

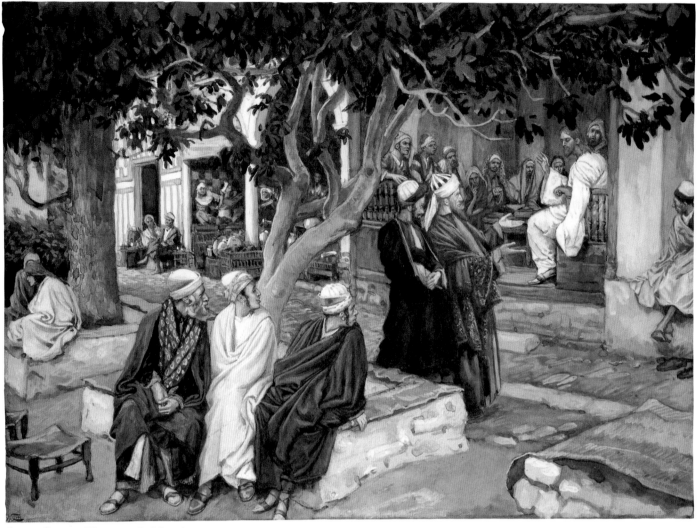

Jesus Sat at Meat with Matthew, 00.159.94

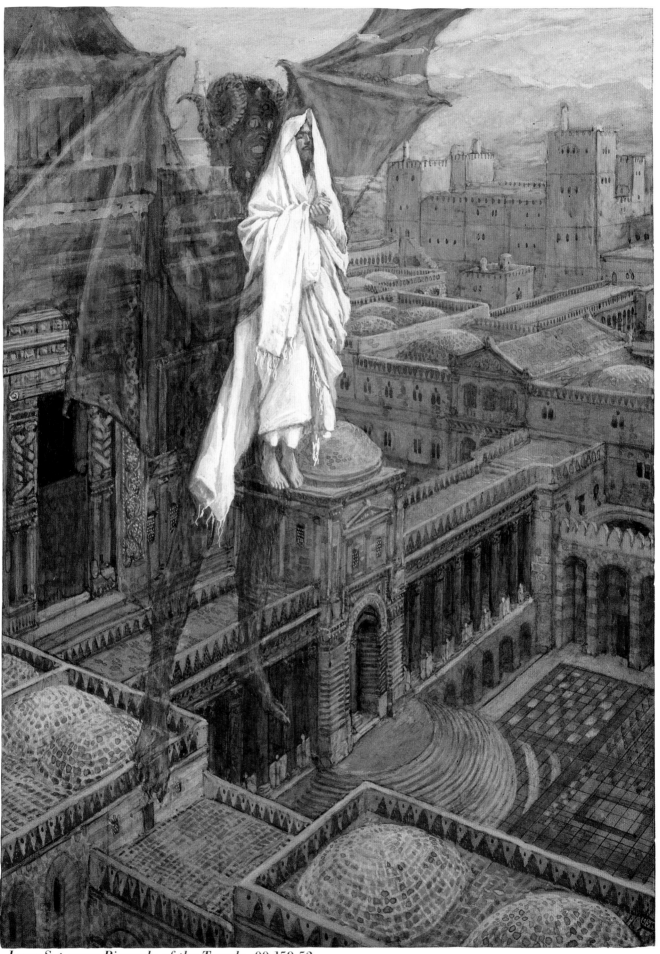

Jesus Set upon Pinnacle of the Temple, 00.159.52

87 *Album de voyage à Jerusalem,* 1888–89

Sketchbook of 76 double-sided sheets in pencil and colored washes on wove paper, 9 x 6 (22.9 x 15.2); inscribed throughout with various notations by the artist

1992.20, A. Augustus Healy Fund, Healy Purchase Fund "B" and Alfred T. White Fund

Provenance Estate of the artist, 1902; Collection Jeanne Tissot (the artist's niece); Sale, Château de Buillon, Besançon, November 14–15, 21–22, 1964; Sale, Hôtel Drouot, Paris, November 24, 1989, no. 24; Collection Farid Andraos, Westmount, Quebec, Canada.

IN THIS SKETCHBOOK, Tissot appears to be planning the design for the publication of his gouaches and drawings for the *Life of Christ*. It contains compositional studies after the original works with notations as to their order in the book and comments on the illustrations and on the artist's travels and finances, as well as drafts of two letters. Beyond the insights this document offers into Tissot's method of working on his "Bible," it demonstrates another aspect of Tissot's extraordinary technical skill: his ability to capture in these rapidly drawn and loosely rendered sketches the essence of his meticulously studied, polished gouaches. LKK

Henri de Toulouse-Lautrec
1864–1901

88 *Madame la Comtesse Adèle de Toulouse-Lautrec* (the artist's mother), 1882

Charcoal on L. Berville Salanne paper, 25¾ x 17 (65.5 x 43.0)

38.39, Anonymous gift to commemorate the 75th birthday of Edward C. Blum

Provenance Collection Comtesse Adèle de Toulouse-Lautrec, Malrome; Collection Tapié de Céléyran; Sale, Hôtel Drouot, Paris, May 3, 1935, no. 19, illus.; Jacques Seligmann and Co., Inc., New York, 1938; Anonymous gift to commemorate the 75th birthday of Edward C. Blum, 1938.

Exhibitions New York, Wildenstein and Co., Inc., *A Loan Exhibition, Toulouse-Lautrec for the Benefit of the Goddard Neighborhood Center*, October 23–November 23, 1946, cat. no. 38. San Francisco 1947, cat. no. 126. Philadelphia Museum of Art and The Art Institute of Chicago, *Toulouse-Lautrec*, organized in collaboration with the Albi Museum, October 29–December 11, 1955, cat. no. 79, illus. Traveled to The Art Institute of Chicago, January 2–February 15, 1956. New York, The Museum of Modern Art, *Toulouse-Lautrec, Paintings, Drawings, Posters and Lithographs*, March 20–May 6, 1956, cat. no. 7. Rotterdam 1958, cat. no. 191, illus. pl. 178. Newark 1961, cat. no. 47, illus. Ann Arbor, The University of Michigan Museum of Art, *A Generation of Draughtsmen*, April 22–May 29, 1962. New York, Wildenstein and Co., Inc., *Paintings and Drawings of Toulouse-Lautrec*, February 5–March 14, 1964. New York 1964, illus. pl. 15. Brooklyn 1969. Brooklyn 1988–89.

References "Accessions," *The Brooklyn Museum Quarterly* (April 1938), vol. 25, no. 2, p. 63. Brooklyn 1988, p. 186, no. 138, illus. Dortu, M. G., *Toulouse-Lautrec et son oeuvre*, New York, 1971, p. 425, no. D.2.635. Jewell, Edward Alden, *French Impressionists and Their Contemporaries Represented in American Collections*, New York, 1944, p. 108, illus. Joyant, Maurice, *Henri de Toulouse-Lautrec 1864–1901, dessins, estampes, affiches*, Paris, 1927, vol. II, p. 184. Kramer 1987, p. 105. Mack, Gerstle, *Toulouse-Lautrec*, New York, 1938, p. 260.

Henri de Toulouse-Lautrec drew this portrait of his mother in 1882, when he was eighteen years old. He had begun his art studies in March of that year in the studio of Léon Bonnat, a highly successful portrait painter in the academic tradition. There his training consisted primarily of drawing careful and precise charcoal studies from plaster casts or nude models.

Returning home in the summer of 1882, Lautrec began to make large charcoal drawings of his family (of which at least ten are known) and the workers on the family estate at Albi.[1] These informal and intimate studies are quite removed from the academic precision taught by Bonnat. It would appear that Lautrec had become familiar with the work of the Impressionists, especially Degas's sensitive and relaxed portrait style: "One senses in these family portraits a pleasurable release, a fine surge of power and sensibility totally foreign to the dry copyist techniques of the academic studies. These direct, penetrating studies of the Toulouse-Lautrec and Tapié de Céléyran families, sincere and powerful in their patrician presence, comprise an intimate portrait gallery, warmly and candidly revealing the lineal traces of a proud and ancient race."[2]

This portrait of his mother and others of the period contain the incisive psychological insights and sensitivity characteristic of Lautrec's mature style, without the bitter caricature and pointed observations we have come to associate with his work. LKK

1 Seven of these, not including the Brooklyn portrait, were exhibited at the Rennes Museum, *Toulouse-Lautrec et son milieu familial*, February 5–March 17, 1963.

2 New York 1964, p. 31.

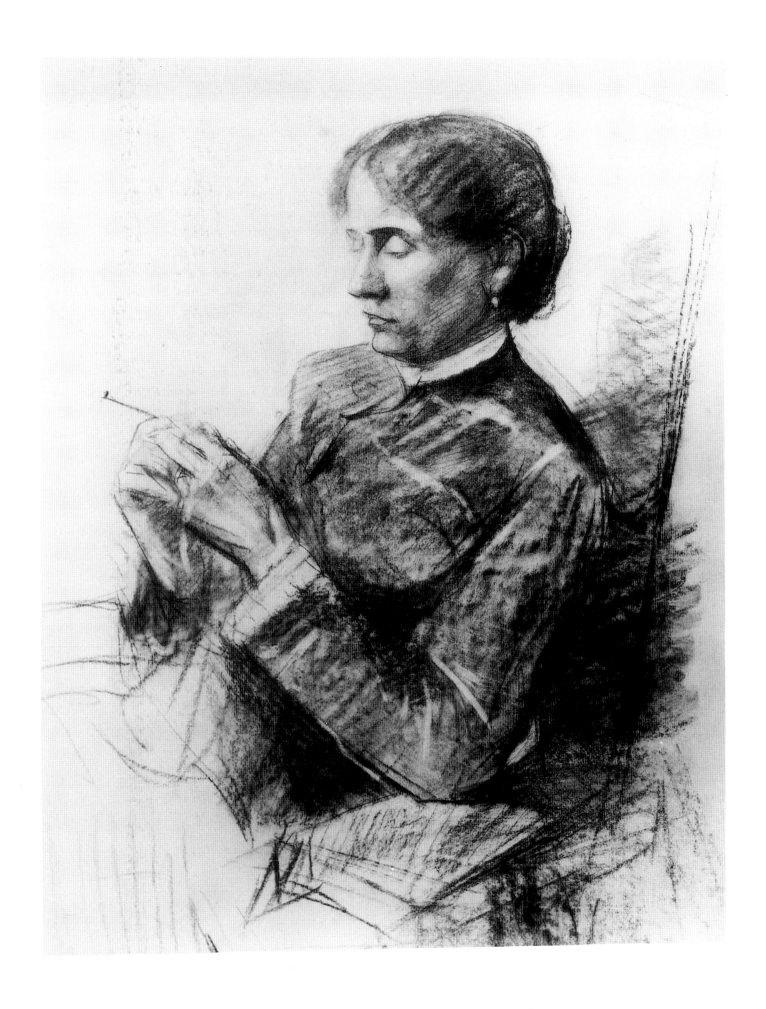

Suzanne Valadon
1865–1938

89 *Nude*, 1908

Charcoal on cream laid paper, 16⅝ x 16¾
(42.3 x 42.5); signed and dated in pencil
in lower right

44.125.1, Carll H. De Silver Fund

Provenance Weyhe Gallery, New York; Museum
Purchase, 1944.

Exhibitions Brooklyn 1988–89.

Suzanne Valadon, née Marie Clementine Valadon, was the illegitimate daughter of a laundress. She managed to survive in Paris on her own at a very young age. In 1883, at the age of eighteen, she too had an illegitimate child, the painter Maurice Utrillo. Soon thereafter, Valadon became an artist's model, posing for such artists as Federigo Zandomeneghi, Puvis de Chavannes, Toulouse-Lautrec, and Renoir. Under these influences, she began to draw. Although she was not his model, she became friendly with Degas about this time, and it was with him that she began making prints. They remained friends until his death in 1917.

This drawing appears to owe a great deal to Degas's bathers. The high viewpoint, coarse features of the model, strong charcoal outline, and awkwardness of the pose are all characteristic of Degas's drawings of bathers. However, unlike his figures of this kind, which appear to have been caught bathing, Valadon's model is merely posing. LKK

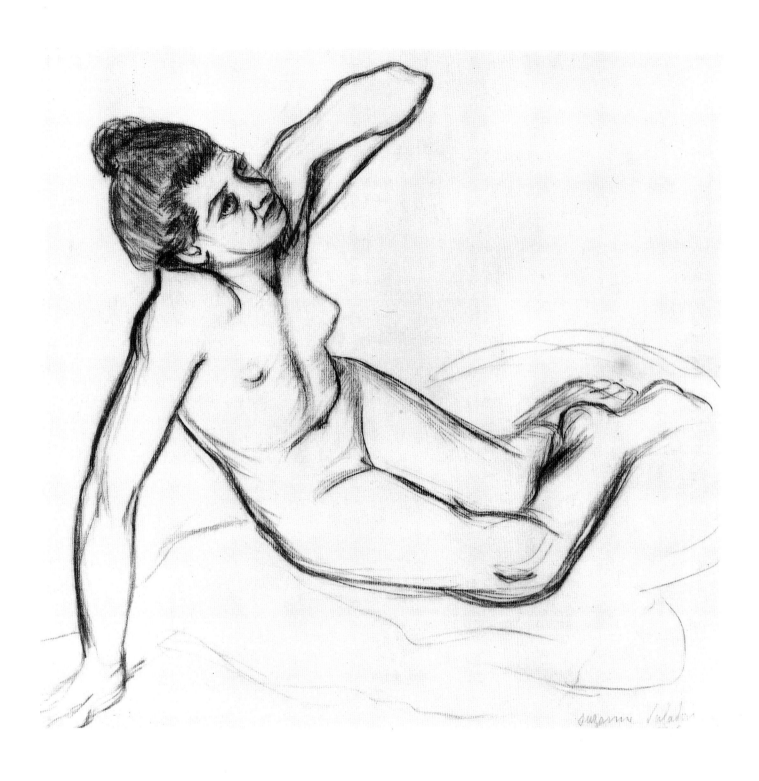

Vincent van Gogh
1853–1890

90 *Les Cyprès (Cypresses)*, June 1889

Pencil, quill, and reed pen, brown and black ink on white wove paper, 24½ x 18⅞₆ (62.2 x 47.1)

38.123, Frank L. Babbott and A. Augustus Healy Funds

Provenance (according to de la Faille and Knoedler) Collection Mme J. van Gogh-Bonger, Amsterdam (artist's sister-in-law); Collection Sir M. E. Sadler, Oxford; Private Collection, Germany; M. Knoedler and Co., New York; Museum Purchase, 1938.

Exhibitions Amsterdam, Municipal Museum, 1905. New York, The Museum of Modern Art, *Vincent van Gogh*, November–December 1935, catalogue with introduction and notes selected from the letters of the artist, ed. by Alfred H. Barr, Jr., cat. no. 119, illus. (collection M. Knoedler and Co., New York). New York, Wildenstein and Co., *Art and Life of Vincent van Gogh*, loan exhibition in aid of American and Dutch War Relief, October 6–November 7, 1943, catalogue with text by Georges de Batz with introduction by Alfred M. Frankfurter, cat. no. 77, p. 121, illus. San Francisco 1947, cat. no. 137. The Cleveland Museum of Art, *Work by Vincent van Gogh*, November 3–December 12, 1948, catalogue with text by Henry Francis, cat. no. 50, illus. plate XLV. New York, The Metropolitan Museum of Art, *Van Gogh Paintings and Drawings, A Special Loan Exhibition*, October 21, 1949–January 15, 1950, catalogue with notes by Theodore Rousseau, Jr., cat. no. 136, p. 80, illus. Traveled to The Art Institute of Chicago, February 1–April 15, 1950. Houston, Contemporary Arts Museum, *Vincent van Gogh*, February 4–25, 1951, catalogue with text by Theodore Rousseau, Jr., cat. no. 16, p. 42, illus. Minneapolis Institute of Fine Arts, *Van Gogh and Modern Painting*, October 6–November 4, 1951. Seattle Art Museum, 1952. Montreal Museum of Fine Arts, *Five Centuries of Drawings*, October–November 1953, catalogue with introduction by Regina Shoolman, cat. no. 217. New York 1953, cat. no. 80. Paris, L'Orangerie, *Van Gogh et les peintres d'Auvers-sur-Oise*, November 26, 1954–February 28, 1955, catalogue with text by L. van Ryssel, Germain Bazin, and Albert Chatelet (not in catalogue). Hamburg, Kunstverein, 1963. New York 1986–87, cat. no. 18, p. 114, illus. Otterlo 1990, cat. no. 231, p. 309, illus. Brooklyn 1990–91.

References Chaet, Bernard, *The Art of Drawing*, New York, 1978. Faille, J.-B. de la, *L'Oeuvre de Vincent van Gogh; catalogue raisonné*, Paris and Brussels, 1928, vol. 3, no. 1525, illus. Hulsker, Jan, *The Complete van Gogh: Paintings, Drawings, Sketches*, Oxford and New York, 1980, no. 1747.

"**I** HAVE FALLEN IN LOVE with drawing, instead of regarding it as a burden" (Vincent van Gogh to Theo van Gogh, The Hague, August 1882).[1]

The Brooklyn Museum's *Cypresses* is one of ten large drawings Vincent van Gogh executed in Saint-Rémy and sent to his brother, Theo, in July 1889. In a letter of June 25, van Gogh included a quick sketch of a cypress and mentioned a painting and two drawings of the same motif, probably Brooklyn's drawing and the related drawing in The Art Institute of Chicago.[2]

While in Saint-Rémy, van Gogh explored three motifs: olive groves, mountains, and cypress trees. He worked on all three in series, as was his wont, recording each in different weathers, seasons, and times of day; from different perspectives; and in different compositions. Van Gogh wrote to his brother, "The cypresses are always occupying my thoughts, I should like to make something of them like the canvases of the sunflowers, because it astonishes me that they have not yet been done as I see them." Describing the cypresses as "beautiful of line and proportion as an Egyptian obelisk," he noted that they presented "a splash of *black* in a sunny landscape, but it is one of the most interesting black notes, and the most difficult to hit off exactly that I can imagine."[3]

The Brooklyn Museum's drawing is slightly narrower than the painting that the artist mentions in his letter. Without the domestic details of a house and farm life seen in The Art Institute of Chicago's drawing, the cypress here takes on a more powerfully graphic and monumental quality.

In his drawings, van Gogh loved to mix media, as can be seen here, to compensate for missing properties in each material. He favored the broad stroke of the reed pen to the finer line of other pens. In *Cypresses* van Gogh uses short, curling, reverberating strokes to evoke the distinctive green or mysterious black of the cypress. Perhaps less legible without the establishment of setting or scale, the drawing vividly evokes the eeriness of the tree's form, isolated against the sky. KZ

1 *The Complete Letters of Vincent van Gogh*, vol. 1, Boston, 1958, no. 226.
2 New York 1986–87, p. 113, cat. no. 18.
3 *Letters*, no. 596, p. 184.

Félix François Georges Philbert Ziem
1821–1911

91 *Harbor in Marseilles*, circa 1864
Watercolor on heavy cream wove paper, 8⅞ x
12½ (22.5 x 31.8); signed in lower right
21.87, Bequest of William H. Herriman
Provenance Collection William H. Herriman,
Rome; Bequest of William H. Herriman, 1921.
Exhibitions Brooklyn 1988–89.

Félix Ziem took for his subject matter the maritime life of Mediterranean ports, primarily Marseilles and Venice, as well as Constantinople. Throughout his life, Ziem visited these cities, spending months or even years living in each place.

The Brooklyn Museum's watercolor, dated circa 1864, depicts the port of Marseilles, specifically the Quai de l'Hôtel de Ville.[1] Although Ziem had a studio in Marseilles only from 1839 to the summer of 1841, he returned to the city often and continued to paint its port throughout his career.

Ziem frequently depicted this site, especially in his oils.[2] In fact, Brooklyn's watercolor may be a study for *Débarquement d'oranges sur un quai à Marseille* (location unknown), an oil that shares its composition.[3] In both, the foreground is occupied by women, children, and men clustered around baskets of oranges. The shipping of oranges in the kind of baskets Ziem depicts can be documented in photographs of the dock from the late nineteenth and early twentieth centuries. In the photographs, one also finds women balancing baskets of oranges on their heads, as depicted in the watercolor.

Ziem's short, colorful strokes evoke the bustle of activity at the port. Although he was thoroughly accurate in his depiction of the city's architecture, costumes, and activities, Ziem carefully constructed his composition, broadening the foreground and using the peripheral architecture to angle the perspective sharply back to a point behind the tallest sail. Ziem abruptly cropped the distance by placing the boats in the harbor horizontally across the composition so that they embrace the activity of the figures amid the produce and smaller boats between the middle ground and foreground. To the left of center, Ziem allows one clear path to the boat that divides the composition and seems to shoot out into the viewer's space.

Ziem's watercolors are marked by their saturated color and fine, loose stroke. The influence of several artists working in watercolor earlier in the century, including Delacroix, Huet, Isabey, Bonington, and Turner, is apparent in the composition's organization and perspective, in Ziem's treatment of subject matter, and in his preference for intense hues. KZ

1 The author is grateful to Sylvie Nicollin, Musée Ziem, Martigue, for her assistance in identifying the subject.

2 Pierre Miquel, *Félix Ziem 1821–1911*, Maurs-la-Jolie, 1978, cat. nos. 1343, 1537.

3 Anne Burdin-Hellebranth, letter to author, September 12, 1990, The Brooklyn Museum, Department of Painting and Sculpture, Supplementary Accession File. The author is grateful to Mme Burdin-Hellebranth for bringing this oil to her attention. The oil last appeared in a sale at the Hôtel Drouot, May 17, 1944.

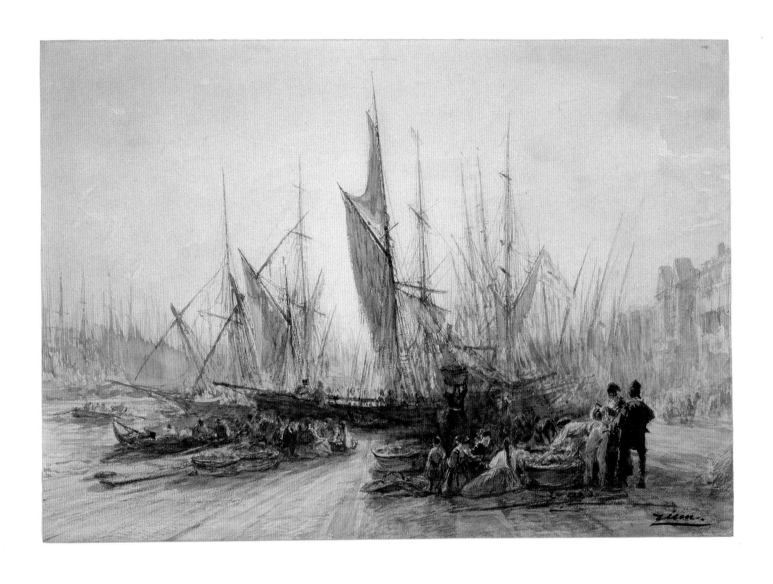

Artist unknown
(attributed to Eugénie Tripier-Le Franc, 1805–1872)

92 *Portrait d'Eugénie Tripier-Le Franc*, 1820s

Pencil, sepia, and gouache on paper, 6¾ x 5 (17.0 x 12.7)

71.138.10, Gift of Louis B. Thomas

Provenance Collection Louis B. Thomas, New York; Gift of Louis B. Thomas, 1971.

ONCE ATTRIBUTED TO Elisabeth Vigée-Lebrun (1755–1842), this drawing is more likely by her niece, Eugénie Tripier-Le Franc, née Lebrun, a portrait painter and student of Jean-Baptiste Regnault (1754–1829).[1] Although Tripier-Le Franc was officially a student of Regnault, Jacques-Louis David's rival, she was influenced by her aunt in choice of subject matter and style.

The costume of the sitter—the leg-of-mutton sleeve, lowered waistline, and flat, typically velvet, beret that became popular daytime wear around 1825—date this drawing to the 1820s, when Tripier-Le Franc would have been in her twenties.[2] The date supports Museum records indicating that the subject of the drawing is the artist herself. The skillful drawing and delicate wash, the sweet, dreamy eyes, and the slight tilt of the head present an engaging image of an eager young artist, enamored of her profession. Tripier-Le Franc may have been following the example of other female artists of the time, including her aunt Vigée-Lebrun *(Self-Portrait,* 1789–90, Uffizi) and Adelaide Labille-Guiard *(Self-Portrait with Students,* The Metropolitan Museum of Art), in proudly portraying herself as a painter.

Perhaps somewhat of a prodigy, Tripier-Le Franc first exhibited at the Salon from the ages of fourteen to nineteen, under the name Lebrun; the similarity of name and painting style may have led to later misattributions of her work to her more famous aunt.[3] However, the drawing's delicate modeling and tight line contrast with Vigée-Lebrun's broad, painterly style.

After marrying the writer and friend of her aunt Justin Tripier-Le Franc, the artist did not exhibit again until 1831, but thereafter she exhibited frequently, under the name Tripier-Le Franc, until 1842, the year her aunt Vigée-Lebrun died.[4] KZ

1 Paintings and drawings by Tripier-Le Franc are very difficult to locate or to find in reproduction. Her best-known painting is the *Portrait of Mlle Duchesnois,* n.d., Musée de Valenciennes.

2 Millia Davenport, *The Book of Costume,* New York, 1948, vol. 2. The author would like to acknowledge Margaret Smith, intern in the Department of Painting and Sculpture, 1988, for this citation and preliminary research on this watercolor. Department of Painting and Sculpture, Supplementary Accession File.

3 Because of Vigée-Lebrun's popularity and influence, her style was widespread, and her oeuvre is filled with misattributed paintings and drawings. However, she rarely executed preparatory studies such as this one.

4 Bellier-Auvray, *Dictionnaire général des artistes de l'école française,* New York, 1979, reprint, vol. 4.

93 *Head of Napoleon,* undated

Sepia ink and pencil on wove paper, 5⅞ x 5³⁄₁₆ (14.9 x 13.2); annotated in sepia ink in lower left, "L. Coignet"

29.233, Bequest of Marion Reilly

Provenance Collection Marion Reilly, Bryn Mawr, Pennsylvania; Bequest of Marion Reilly, 1929.

Exhibitions Brooklyn 1969.

T HIS SKETCH BY AN UNKNOWN ARTIST presents in a confident flourish of strokes a copy of the head of the heroic Napoleon from Jacques-Louis David's *Napoleon at St. Bernard Pass*, 1801. Perhaps executed by a student of David, the drawing possesses the fluid linearity characteristic of David's draftsmanship.[1]

Although annotated "L. Coignet," this drawing is difficult to attribute. Both the style of drawing and the name Coignet were very popular. The history painter Léon Cogniet (1794–1880) subscribed to David's tenets and studied with Pierre Guérin, but spelled and signed his name differently from the way it appears here. The other documented artist with the same name is the landscapist Jules Coignet (1798–1860), who painted in another style and genre, and whose signature also varies.

The drawing came to the Museum as part of a bequest from Marion Reilly, an esteemed mathematician and a professor at Bryn Mawr College, Pennsylvania; she collected books, illustrations, and other objects relating to Napoleon during her travels in Europe and the United States.[2] KZ

1 The drawing is perhaps most similar to the drawings of Baron Gros. See Alexander Fyjis-Walker, "A Recently Discovered Drawing by Antoine-Jean Gros," *Burlington Magazine* (September 1985), pp. 620–22.

2 Also see cat. nos. 15 and 25. The collection was displayed just after its arrival at the Museum in April 1933.

Exhibitions Frequently Cited

Paris 1889	Paris, École des Beaux-Arts, *Antoine-Louis Barye*, 1889.
New York 1889–90	New York, American Art Galleries, Barye Monument Association, *Antoine Louis Barye*, November 15, 1889–January 15, 1890.
New York 1909	New York, Grolier Club, *Exhibition of Bronzes and Paintings by Antoine-Louis Barye*, March 11–27, 1909.
Brooklyn 1921	The Brooklyn Museum, *Paintings by Modern French Masters*, March 26– April 1921, catalogue with text.
Brooklyn 1922–23	The Brooklyn Museum, *Paintings by Contemporary English and French Painters*, November 29, 1922–January 2, 1923, catalogue with text.
Brooklyn 1924–25	The Brooklyn Museum, *A Loan Exhibition of Brooklyn Art Treasures and Original Drawings by American Artists*, November 20, 1924–January 1, 1925, catalogue with introduction by W. H. Fox.
Paris 1933	Paris, Musée de l'Orangerie, *Exposition Chassériau 1819–1856*, May–June, 1933, catalogue by Charles Sterling with preface by Jean-Louis Vaudoyer.
Springfield 1939	Springfield, Massachusetts, Museum of Fine Arts, *The Romantic Revolt: Gros, Géricault, Delacroix, Daumier and Guys*, February 7–March 5, 1939, catalogue with text by Alice K. Bausman.
Brooklyn 1944–45	The Brooklyn Museum, *Eighty European Paintings Selected from the Museum Collection*, November 9, 1944–January 1, 1945.
San Francisco 1947	San Francisco, California Palace of the Legion of Honor, *19th Century French Drawings*, March 8–April 6, 1947, catalogue with text by John Rewald.
Newark 1948	The Newark Museum, *Seeing Modern Art*, January 5–February, 1948.
Detroit 1950	Detroit Institute of Arts, *French Painting from David to Courbet*, February 1– March 5, 1950, catalogue with text by Paul L. Grigaut.
New York 1953	New York, The Pierpont Morgan Library, *Landscape Drawings and Watercolors, Brueghel to Cézanne*, January 31–April 11, 1953, catalogue with text by Felice Stampfle.
Rotterdam 1958	Rotterdam, Museum Boymans van Beuningen, *De Clouet à Matisse*, August 2– September 28, 1958, catalogue with text by Agnes Mongan. Traveled to Musée de l'Orangerie, Paris, October 2, 1958–January 2, 1959; The Metropolitan Museum of Art, New York, February 3–March 15, 1959.
Newark 1961	The Newark Museum, *Nineteenth-Century Master Drawings*, March 16–April 30, 1961, catalogue with text by Elaine Evans Gerdts and William H. Gerdts.
Brooklyn 1962	The Brooklyn Museum, *Drawings from the Museum Collection*, January 19– February 18, 1962.
Minneapolis 1962	Minneapolis, University of Minnesota Art Gallery, *The Nineteenth Century: One Hundred Twenty-five Master Drawings*, March 26–April 23, 1962, catalogue with text by Lorenz Eitner and Sidney Simon. Traveled to Solomon R. Guggenheim Museum, New York, May 15–June 30, 1962.
Boston 1963	Boston, Museum of Fine Arts, *Barbizon Revisited*, March 14–April 28, 1963, catalogue with text by Robert L. Herbert. Traveled to California Palace of the Legion of Honor, San Francisco, September 27–November 4, 1962; Toledo

	Museum of Art, November 20–December 27, 1962; The Cleveland Museum of Art, January 15–February 24, 1963.
New York 1964	New York, Charles E. Slatkin Galleries, *Henri de Toulouse-Lautrec 1864–1901, Portraits and Figure Studies, The Early Years*, an exhibition commemorating the hundredth anniversary of his birth, November 14–December 15, 1964, catalogue with text by Peter Wick. Traveled to Fogg Art Museum, Harvard University, Cambridge, Massachusetts, January 5–February 5, 1965.
Brooklyn 1969	The Brooklyn Museum, *French Graphic Art of the Nineteenth Century*, through June 1, 1969.
College Park 1977	College Park, Maryland, University of Maryland Art Gallery, *From Delacroix to Cézanne, French Watercolor Landscapes of the Nineteenth Century*, October 26–December 4, 1977, catalogue by Carol Hynning Smith with text by Alain de Leiris. Traveled to J. B. Speed Art Museum, Louisville, January 9–February 19, 1978; The University of Michigan Museum of Art, Ann Arbor, April 1–May 14, 1978.
London 1978	London, Thomas Agnew and Sons, Ltd., *Fragonard Drawings for Orlando Furioso*, October 31–December 15, 1978, catalogue with text by David Wakefield and Gabriel Naughton.
Washington, D.C. 1978–79	Washington, D.C., National Gallery of Art, *Drawings by Fragonard in North American Collections*, November 19, 1978–January 21, 1979, catalogue with text by Eunice Williams. Traveled to Fogg Art Museum, Harvard University, Cambridge, Massachusetts, February 16–April 1, 1979; The Frick Collection, New York, April 20–June 3, 1979.
Tokyo 1980	Tokyo, The National Museum of Western Art, *Fragonard*, March 18–May 11, 1980, catalogue with text by Denys Sutton. Traveled to Kyoto Municipal Museum, May 24–June 29, 1980.
London 1980–81	London, Arts Council of Great Britain, *Camille Pissarro: 1830–1903*, Hayward Gallery, October 30, 1980–January 11, 1981, catalogue with text by Christopher Lloyd.
Williamstown 1984	Williamstown, Massachusetts, The Sterling and Francine Clark Art Institute, *Alexandre Gabriel Decamps*, March 2–April 29, 1984, catalogue with text by David B. Cass and Michael M. Floss.
New York 1986–87	New York, The Metropolitan Museum of Art, *Van Gogh in Saint-Remy and Auvers*, November 25, 1986–March 22, 1987, catalogue with text by Ronald Pickvance.
Paris 1987–88	Paris, Galeries Nationales du Grand Palais, *Fragonard*, September 24, 1987–January 4, 1988, catalogue with text by Pierre Rosenberg. Traveled to The Metropolitan Museum of Art, New York, February 2–May 8, 1988.
Washington, D.C. 1988	Washington, D.C., National Gallery of Art and The Art Institute of Chicago, *The Art of Paul Gauguin*, May 1–July 31, 1988, catalogue with text by Richard Brettell, Françoise Cachin, Claire Freches-Thory, and Charles F. Stuckey, with the assistance of Peter Zegers. Traveled to The Art Institute of Chicago, September 17–December 11, 1988; Grand Palais, Paris, January 10–April 20, 1989.
Brooklyn 1988–89	The Brooklyn Museum, *Nineteenth-Century French Drawings and Watercolors at The Brooklyn Museum*, December 2, 1988–February 20, 1989.
Otterlo 1990	Otterlo, The Netherlands, Rijksmuseum Kröller-Müller, *Vincent van Gogh: Drawings*, March 30–July 30, 1990, catalogue with text by Johannes van der Wolk, et al.
Brooklyn 1990–91	The Brooklyn Museum, *Monet and His Contemporaries: Impressionism and Post-Impressionism at The Brooklyn Museum*, September 14, 1990–June 3, 1991.

References Frequently Cited

Ananoff 1961 — Ananoff, Alexandre, *L'Oeuvre dessiné de Jean-Honoré Fragonard (1732– 1806)*, catalogue raisonné, Paris, 1961, vol. I.

Aubrun 1984 — Aubrun, Marie-Madeleine, *Henri Lehmann 1814–1882*, Paris, 1984.

Berger 1965 — Berger, Klaus, *Odilon Redon: Fantasy and Color*, New York, 1965.

Brooklyn 1988 — The Brooklyn Museum, *Masterpieces in The Brooklyn Museum*, Brooklyn and New York, 1988.

Chappuis 1973 — Chappuis, Adrien, *The Drawings of Paul Cézanne, A Catalogue Raisonné*, Greenwich, Connecticut, 1973, 2 vols.

Faunce 1982 — Faunce, Sarah, "Modern French Painting: Collecting in the 1920s," *Apollo* (April 1982), pp. 276–81.

Foucart-Bourville 1976 — Foucart-Bourville, Jacques, *La Genèse des peintures murales de Puvis de Chavannes au Musée de Picardie*, Amiens, 1976.

Goodyear 1910 — Goodyear, William Henry, *Museum of The Brooklyn Institute of Arts and Sciences, Catalogue of Paintings*, Brooklyn, 1910.

Grappe 1913 — Grappe, Georges, *Fragonard, peintre de l'amour au XVIIIe siècle*, Paris, 1913.

Kramer 1987 — Kramer, Linda Konheim, "The Significance of Early Drawings: Four Modern Works in The Brooklyn Museum Collection," *Drawing*, The International Review published by The Drawing Society (January–February 1987), vol. 8, no. 5, pp. 104–6.

Laughton 1991 — Laughton, Bruce, *The Drawings of Daumier and Millet*, New Haven and London, 1991.

Lemoisne 1946 — Lemoisne, Paul André, *Degas et son oeuvre*, Paris, 1946, vol. III.

Le Pelley-Fonteny 1991 — Le Pelley-Fonteny, Monique, *Léon-Augustin Lhermitte Catalogue Raisonné*, Paris, 1991.

Lloyd 1981 — Lloyd, Christopher, *Camille Pissarro*, Geneva and London, 1981.

Maison 1967 — Maison, K. E., *Honoré Daumier: Catalogue Raisonné of the Paintings, Watercolors and Drawings*, London, 1967.

Mongan 1945 — Mongan, Elizabeth, Philip Hofer, and Jean Seznec, *Fragonard: Drawings for Ariosto*, New York, 1945.

Mosby 1977 — Mosby, D. F., "Alexandre-Gabriel Decamps 1803–1860," New York, 1977, Ph.D. dissertation, Harvard University, Cambridge, Massachusetts, 2 vols.

Newberry 1950 — Newberry, John, "Two Portrait Drawings by Théodore Chassériau in American Collections," *Art Quarterly* (Spring 1950), vol. 13, pp. 161–63.

Philadelphia 1978 — Philadelphia Museum of Art and Grand Palais, Paris, *The Second Empire*, exhibition catalogue, 1978.

Rewald 1985 — Rewald, John, *Paul Cézanne: The Watercolors*, New York, 1983.

Rosenblum 1954 — Rosenblum, Robert, "Varieties of Impressionism," *Art Digest* (October 1, 1954), p. 7.

Sandoz 1986 — Sandoz, Marc, *Portraits et visages dessinés par Théodore Chassériau*, Paris, 1986, cahiers Théodore Chassériau, vol. II.

Tschudy 1932　　　　Tschudy, Herbert B., *Catalogue of the Watercolor Paintings, Pastels and Drawings in the Permanent Collection of The Brooklyn Museum*, Brooklyn, 1932.

Venturi 1936　　　　Venturi, Lionello, *Cézanne, son art, son oeuvre*, Paris, 1936, 2 vols.

Washington, D.C. 1986　　Washington, D.C., National Gallery of Art, *The New Painting*, exhibition catalogue with text by Charles Moffett, Barbara Lee Williams, and Fronia Wissman, 1986.

Wegener 1954　　　　Wegener, Hertha, "French Impressionist and Post-Impressionist Paintings in The Brooklyn Museum," *The Brooklyn Museum Bulletin* (Fall 1954), pp. 10–12.

Zieseniss 1954　　　Zieseniss, Charles Otto, *Les Aquarelles de Barye*, Paris, 1954.

144